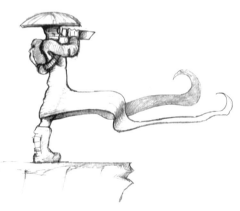

CHARACTER DESIGN

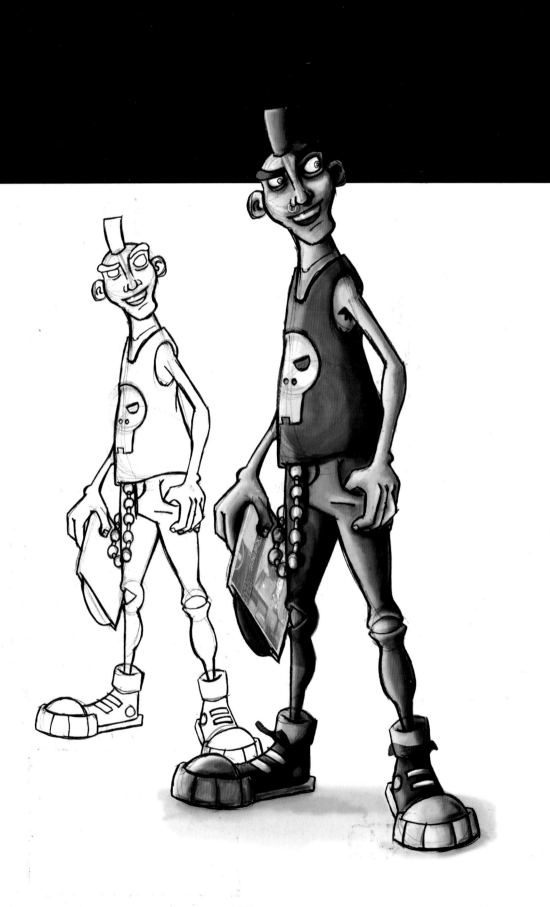

CREATE CUTTING-EDGE CARTOON FIGURES

FOR COMICBOOKS, COMPUTER GAMES

AND GRAPHIC NOVELS

CHARACTER
DESIGN

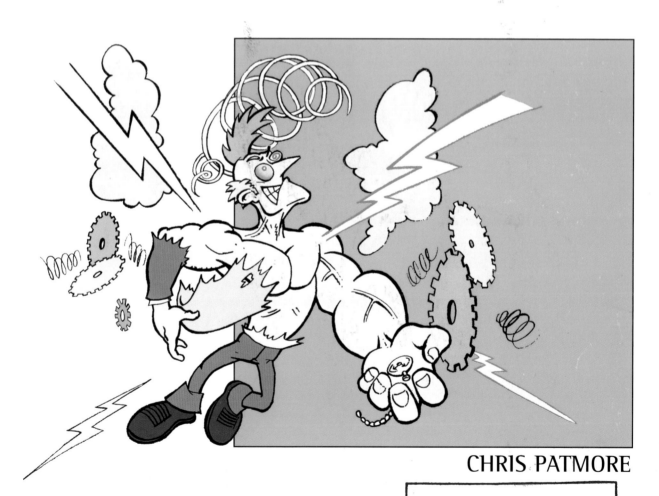

CHRIS PATMORE

A QUARTO BOOK

First published 2005
A & C Black Publishers Limited
37 Soho Square
London W1D 3QZ
www.acblack.com

Copyright © 2005
by Quarto Publishing plc

ISBN-10: 0-7163-7381-8
ISBN-13: 978-0-7163-7381-4

QUAR.DTO

Conceived, designed and produced by
Quarto Publishing plc
The Old Brewery
6 Blundell Street
London N7 9BH
United Kingdom

Project Editor: *Paula McMahon*
Senior Art Editor: *Penny Cobb*
Designer: *Karin Skånberg*
Photographer: *Martin Norris*
Picture Researcher: *Claudia Tate*
Copy editor: *Sue Viccars*
Proofreader: *Carol Baker*
Indexer: *Geraldine Beare*

Art Director: *Moira Clinch*
Publisher: *Piers Spence*

Manufactured by PICA Digital,
Singapore
Printed by Star Standard Industries
Pte., Singapore

CONTENTS

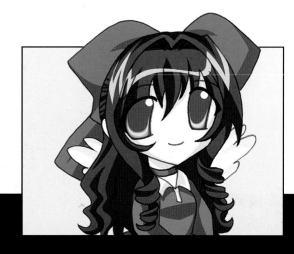

MENTOR: *The Hero's guiding voice of wisdom.*

HERO: *Heroes come in all shapes and sizes and with different motivations. Everyone is the Hero in their own story.*

THRESHOLD GUARDIAN: *Is there to test the Hero's resolve and hinder his or her journey.*

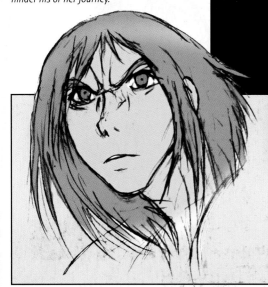

INTRODUCTION

Illustrated stories – whether comics, graphic novels or animations – are filled with fantastic characters that come from the fertile imaginations of their creators. Anyone starting out in this field of storytelling is probably brimming over with ideas influenced by their heroes – either those on the page, or those artists who created them. These are great jumping-off points for developing your own characters, which is the intention of this book – to inspire you to create strong, believable characters by studying the techniques and ideas of other artists.

This book isn't just about drawing, though, because your characters need to be more than just muscles and fancy costumes. The people who inhabit your fictional world need purpose and direction. They have strengths, weaknesses and other traits that you, as the creator, have to invent. It is for this reason that this book is structured on the archetypal model.

HERALD: *Announces the arrival of the Hero and often accompanies him or her on the journey.*

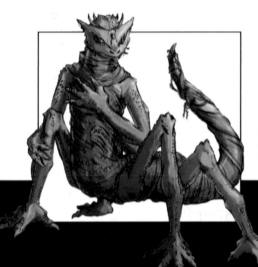

SHAPESHIFTER: *Appearances can be deceptive. They shouldn't be taken at face value.*

The initial chapter is dedicated to the background of the subject, and the remainder of the book is divided into seven sections, one for each of the principal archetypes originally outlined by such luminaries as C. G. Jung and Joseph Campbell. Each chapter offers a diverse cast of characters illustrated in a multifarious range of styles by an equally diverse number of artists, not only to show you what is possible, but also how to achieve it.

Bolstered by this foundation of knowledge and techniques, I hope you will be inspired to create great characters that can sustain great stories, and that their journeys of self-discovery will also be yours.

SHADOW: *The bad guy. The dark side. The forces of evil. You get the picture.*

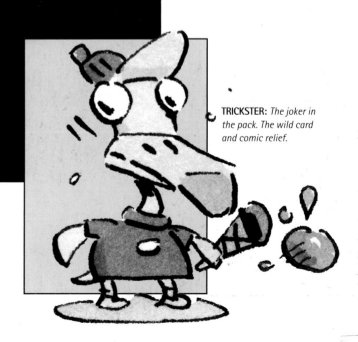

TRICKSTER: *The joker in the pack. The wild card and comic relief.*

TRADITIONAL TOOLS

As a visual storyteller, your first requirements are imagination and some talent. Unfortunately you can't buy these, or find them on the Internet – you either have them, or you don't. The fact you are reading this book would indicate that your head is full of ideas and that you are looking for a way to express them.

Paper and pencils are the fundamentals of creative endeavours. Spiral-bound notebooks and sketchpads of varying sizes are ideal. You can carry them in your pocket or bag, and scribble away whenever the muse visits you. The notebooks can be cheap, lined reporters' pads, ideal for jotting down your ideas and stories. Sketchpads should be of a decent quality, and can be obtained easily from an art supply store.

For your finished drawings you'll need some large sheets of heavy paper or, better still, art board, such as Bristol board or CS10. Ideally you should work as large as you can, but if you intend to scan your work at home, you will be limited to letter- (A4-) sized paper, as larger format scanners are expensive.

SOME LEAD IN YOUR PENCIL

Pencils are still the mainstay of comic and animation artists, despite the advances in digital tools. A full range of graphite (lead) pencils from 5H through HB to 5B should be in your studio kit, either wooden ones or mechanical (propelling) ones with replaceable leads. A single mechanical pencil will do for when you are on the road, so you won't need to carry a sharpener. A non-repro blue pencil is a vital tool for laying down lines when you are making your final drawings. Erasers are also invaluable.

There is a multitude of possibilities for inking, all of them valid. The important thing is to get consistently black lines. You can choose anything from a traditional Japanese brush or reed pen to a technical pen, such as a Rapidograph, or any of the proprietary pens and markers available in your local stationery or art store. Brushes and dip pens with Indian ink are another option, but have plenty of

PAPER CHASE: *For flexibility, portability and archival longevity (no technical obsolesce) you can't beat paper. It is organic and tactile and adds texture to your drawings. Make sure you have a good supply of it in pads and sheets of different types and weights.*

ERASERHEAD: *Keep a good supply of pencils, from soft to hard, either traditional wood covered or replaceable lead technical style, which can also take non-repro blue "leads". And always keep the original "undo" tool, an eraser, handy – either a hard plastic one or a soft putty one. For pen work, a wide range is available, including technical pens, rollerballs and fibre-tips.*

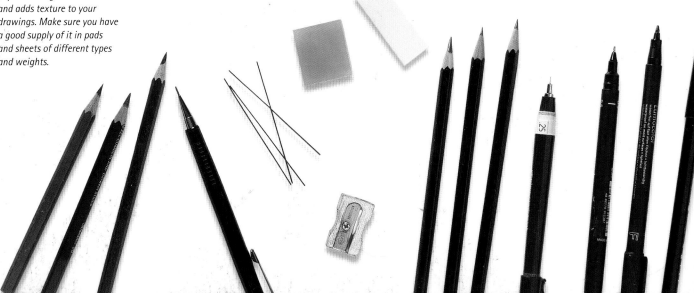

▶ **OVER TO YOU**

Draw up an equipment list and a budget. Welcome to the real world! Now prioritize the list. Remember that there is no shame in buying secondhand – apart from paper, obviously.

BRUSHING UP: *Quality sable brushes will serve you well if you keep them properly cleaned. Water-soluble paints and inks such as gouache (bottom right) or watercolour (below) are best. For large jobs needing consistent colour then animation paints such as ChromaColor are best.*

practise before you attempt to finish an important drawing. None of these methods has the luxury of the "undo" command that you have with digital brushes.

COLOUR YOUR WORLD

For colouring your images you can still work with inks, paints, brushes and airbrushes, although most people work digitally now. Apart from the advantage of the aforementioned "undo", most images end up on a computer before going to print anyway, so you might as well get them digitized as soon as you can. If you do want to work with paints, your choice will be determined by the effect you want to achieve. Working with water-soluble products – poster paint, gouache, watercolour, acrylics or drawing ink – is preferable to oils, but ultimately it's your decision.

Whatever method you go for, you need to create a proper workspace. This means a desk with a decent chair, a good light source (both natural and artificial), a drawing board, and storage space. A light box can be useful too. If you are working with liquids (such as paints and inks) try to keep them separate from your dry goods (such as paper). If you have the luxury of a dedicated work area or studio fill it with material that will help inspire you, such as comics, posters, reference books, artists' mannequins, DVDs and music.

However you set it up it has to be comfortable, both physically and mentally, because you will be spending a lot of intense time there – and don't forget to have suitable space for taking a break.

PEN AND INK: *Black ink can be applied with any of the tools shown above – from bamboo pen to Japanese brush. Alternatively you could use technical pens, nib pens, soft-tip pens or reed pens.*

PAINTS: *Keep a good range of paints, from gouache and acrylics to watercolours and poster paints.*

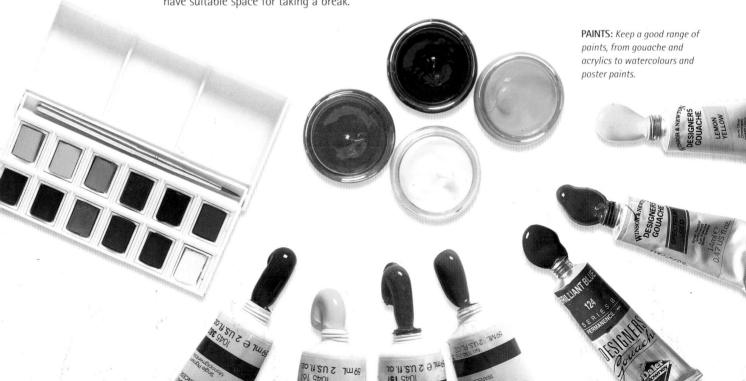

DIGITAL TOOLS

Along with all the traditional tools already mentioned, you are also going to need some digital ones: computer, scanner, graphics tablet and some software. A printer and digital camera are also useful.

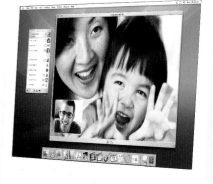

Your choice of computer is down to your operating system preference, which will be either Mac OS or Windows. Macintosh is the preferred system in the creative world, but most of the industry-standard software is available on both platforms and files can be easily transferred between them. If you don't have a computer already I recommend a Mac, as all the current creative software was originally developed for Mac. Its hardware is not only innovative but also looks so much cooler. Which model you choose is really down to your budget. Nearly all computers come with CD burners as standard, which are indispensable for making back-ups, although a second external hard drive is also advisable for this purpose. When it comes to monitors, size is everything. Even though the latest flat screens are very sexy, you can get a very large CRT monitor for a lot less, and it will give you a better, more accurate colour image.

When buying a computer always get as much RAM as you can afford. Graphics applications, such as Photoshop, will use all the memory you have and still want more.

KEEPING YOUR RESOLUTION:
A scanner is a must for transferring your pencil or inked drawings onto the computer. If you are intending to only scan line work check the scanner's optical resolution. Even the very cheap scanners have very high resolution now, but may not be suitable for colour work.

COMPUTER *The Apple iMac is an ideal computer for artists. Its fast processor, 20 in. (51 cm.) flat-screen monitor and DVD writer are all you need for producing illustrations, animations or pursuing any other creative activity.*

SCANNERS

Most scanners – even the cheapest – have very high optical resolutions that are more than adequate for scanning line work to be coloured digitally. Getting decent colour scans is another matter, and if you have handpainted your images you may be much better off getting them scanned professionally, particularly if they are going to press.

A graphics tablet is vital for digital artwork, as it is a more natural way of working than using a mouse (which is a bit like drawing with a bar of soap). They are pressure-sensitive, so you can emulate working with real pencils and brushes. Wacom produce a range of models in various sizes to cover a variety of uses and budgets.

SOFTWARE

For pixel-based software almost everyone uses Adobe Photoshop, but there are alternatives. Corel Procreate Painter is excellent if you want to imitate "natural media" such as watercolour or pastels. Though Photoshop can reproduce some natural media, it is no

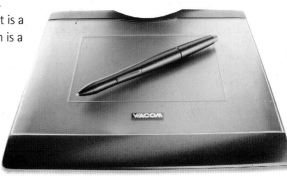

GRAPHICS TABLET *A tablet and stylus are essential if you are going to be working digitally, as it is just like working with a pencil or any other hand-held drawing tool.*

match for Painter. Vector programmes, such as Adobe Illustrator or Macromedia Freehand, are great for working with flat colour and precise lines. They produce small, resolution-independent files that can be reproduced at any size. Other programmes such as Corel Draw and Deneba Canvas have a dedicated following and integrate pixel and vector tools into a single package. There are also some very good shareware and freeware programmes if you are on a limited budget.

Another useful programme is Curious Labs Poser. Originally designed as a digital version of an artist's wooden mannequin, it has developed into a very sophisticated 3D-character-creation tool that will help you with body shapes, poses and proportions. It also produces stunning images in its own right, and animations too.

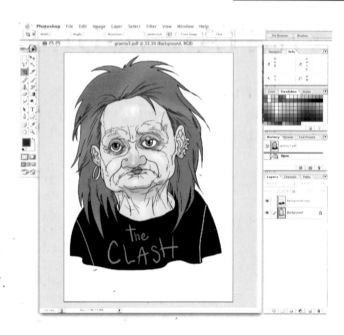

MANIPULATE YOUR IMAGE: *The ubiquitous Adobe Photoshop will probably be your major image-editing-and-painting software. Limited editions are often bundled with scanners. It is a powerful programme that is easy to use at a basic level, but has a complex range of tools that can take a long time to master.*

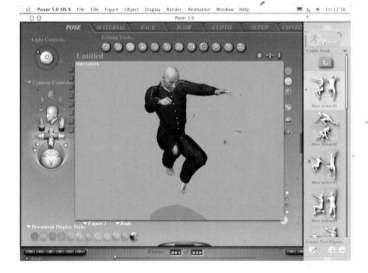

STRIKING A POSE: *Poser is fantastic programme and will become an indispensable guide for drawing characters in complex poses. Each model is completely editable so you can create almost any body type. It includes many poses and also has multiple cameras to help you get interesting points of view, with correct perspective. Be careful not to abandon your pencils to this software's delights.*

OTHER PERIPHERALS

A digital camera can be extremely useful for taking reference shots of people and places. A colour printer is also handy, for checking your work. Ink jets are the most affordable and give some of the best results, but if you have no previous experience be very wary about what you buy. It pays to do some research before you purchase; the initial cost of the printer may seem like a bargain, but a set of ink cartridges could cost the same again – and again – again.

Keep your digital studio or workdesk separate from your drawing area, especially if you are working with inks, paint or other liquids (that goes for drinks, too) as they don't mix well with electricity and computer equipment.

While it is nice to have the latest digital toys – I mean tools – if you are short of cash then buying a used computer is not a bad idea. It may not have the power of today's machines, but remember that in its day it was probably a cutting-edge piece of hardware and the work produced on it was no different to what you want to do now.

Whatever computer equipment you buy try to keep reminding yourself that they are just creative tools, like your pencils, and no matter how powerful the computer it is not going to make you more imaginative or talented.

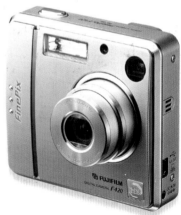

FOR TAKING SNAP DECISIONS: *A pocket-sized digital camera is great for taking reference shots of scenery and people. The pictures can be loaded onto your computer immediately and used as a tracing image.*

TECHNIQUES

Though the main purpose of this book is to show you how to develop characters rather than how to draw them, some basic guidelines may be helpful if you are just starting out. The artists whose work appears on the following pages have all developed their own style, or have chosen to work within an existing style and given it their personal vision. Behind these styles – often developed over many years and resulting from a mix of influences – lies a grounding in the fundamentals of anatomy, draughtsmanship and computer technology. You have to learn the rules before you can break them. This is called "learning your craft".

USING YOUR HEAD: *An early sketch of a character, made mostly with blue pencil, establishing its proportions and appearance. The head shapes are used for measuring the body size. A correctly proportioned person is usually drawn at eight heads high (the height of the head from crown to chin, multiplied by eight). Heroic figures are drawn at nine heads. This one – T-Ganna – is drawn to the proportions of a child (six heads high), which suits his personality (see pages 62–63).*

One of the problems facing many budding artists, especially figurative artists, is finding anywhere that still teaches the proper skills, with schools and colleges today giving more emphasis to "expression". Look for a life-drawing class, as this will not only give you the opportunity to work with a variety of models, but the teachers will also be more technique-focused and willing to help and correct you. Even if you take a course in comic art, life-drawing skills are still essential.

PENCILS AND INKS

When you start work on a character, make lots of sketches until you are happy with how it looks. Now you can start working on a finished image. Always work as big as you can. For practical purposes – if you intend to go down the digital route – this will be the size of your scanner (letter or A4). Use a smooth board, like CS10 or Bristol board, and do your initial sketch with a non-repro blue pencil, or a very hard (5H) graphite pencil. When you're satisfied you can clean up the lines with a softer pencil (2B).

You are now ready to ink the lines. You have two main choices: you can go manual or digital. You can draw over your pencil lines with any of the pens

TENGU: *Everyone has a different approach to drawing. Artist Al Davison produced the character on page 84 by drawing it in Photoshop, using a stylus and graphics tablet, with the line work coloured in a non-repro blue. The finished drawing was printed in colour onto board and inked using a traditional Japanese brush and ink.*

The inked image was scanned into Photoshop and placed on a transparent layer. A new layer was placed below the line image to add the colour. A variety of Photoshop brush tools were used, including the airbrush. The picture shows the finished colouring with the line-work layer hidden.

The complete picture with both layers visible.

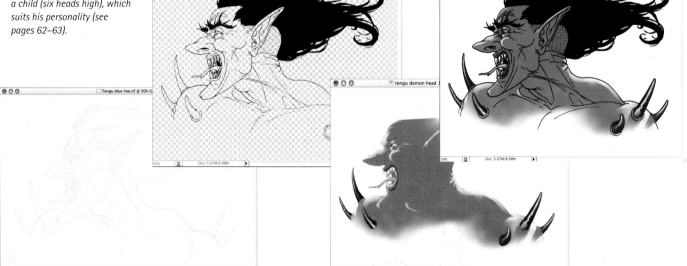

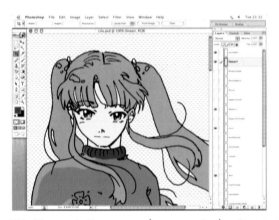

LILA: *Manga artist Emma Vieceli prefers to use a separate layer for each flat colour as she builds up shade and highlights, making editing much easier.*

mentioned on page 8, or you can scan the pencil drawing and "ink" it in Photoshop, using a stylus and graphics tablet. Working with a mouse is not a satisfactory solution, unless you are working with a vector program like Illustrator or Freehand. If you aren't confident about using pens and have a computer, going digital does have lots of advantages, especially the multiple undos.

COMPUTER COLOURING

Nearly all comic art, and animation, is coloured digitally these days. The aforementioned undo facility is one great advantage over the manual approach, along with those of consistent colour and no mess. The Tengu and Lila illustrations show different approaches to using Photoshop.

PERSONAL DATA: *Make your own profile sheets to record all your characters' traits. File them together with any sketches you've made. A list of suggested questions is shown below, but this is by no means a definitive list. Add or remove categories as needed. The more you can write about the character's history the better. Try completing the sheet by role-playing an interview with the character.*

▶ OVER TO YOU

Apart from learning drawing techniques, there are some other things you can do to improve your character creation skills. Taking a creative writing course can be useful, particularly one based around short stories. Comics are essentially made up of a mix of short stories and screenplays, so learning either of these disciplines will help. Writing courses provide the opportunity for you to get feedback on your storytelling and to compare your abilities with those of other writers.

One useful tool – especially in the context of this book – is the character profile sheet. This lists all the information about each character to help you make them believable and prevent you making continuity errors. You can adapt it to your story's genre, adding and deleting categories as you see necessary. In the end all techniques come down to practice, but learning from experienced professionals can aid the process by showing you the right methods and short cuts which cannot be covered fully in this book.

Character profile

Archetype
Role.............
Age............... DoB........... Name......

Appearance
Height............... Gender....
Hair colour............... Weight............... Physique....
Distinguishing marks (natural or inflicted)....... Eye colour.....
How did they get there?.....

Clothing
Style......
Accessories (hats, jewellery, etc)........... Material....
Weapons and their use......

Family
Mother's name......
Place of birth............... Father's name....
Details of birth (events, etc).....
Siblings (names and relationship).....

Education
School (name and type, level of schooling, special teachers or subjects)....
Languages......
School friends and relationships.....

Occupation
Type of work.....
Economic status.....

Beliefs
Religion/spiritual path............... Skills....
Ambitions...........
Other philosophies........... Politics....

Personality
Motivations (needs/wants).....
Weaknesses/flaws.....
What causes: Fear............... Strengths....
Happiness............... Anger....
Lesson to be learnt.....

Details
Favourite: Colour.....
Music............... Food.....
Art............... Drink....
Hobby/Sport.....

LOOKING FOR INSPIRATION

The old adage of "10 percent inspiration, 90 percent perspiration" is something to be taken seriously when embarking on any creative project. Moments of true inspiration are rare and usually happen when you least expect them. For this reason, carrying a notebook is always a good idea, so you can jot down your ideas before they disappear.

COMICS AND GRAPHIC NOVELS: *Being made up of stories and art, you have two influences to consider when buying or reading. Try to extend yourself beyond your favourite genres or art styles, to realism or manga fantasy, for example.*

To recap, most inspired ideas come from an area of the psyche known as the "collective unconscious", though some ideas come from the subconscious or the supraconscious. Inspiration usually strikes when the mind is free from extraneous thoughts, when you are relaxed or involved in other activities. The mind is also receptive first thing in the morning, before it becomes too active. Unfortunately these situations are hard to control, but when the moment comes you have to grab it – and that's when things start to hot up. It's important to understand, however, that inspiration does not come from taking alcohol or drugs.

Not all inspiration comes spontaneously; it can be triggered by something you've read or seen. These sources can act as catalysts for ideas that have been floating around in your head. Taking an existing concept and adding your own personality to it can set you off in directions you might never have explored. Although at times this may seem like plagiarism, consider the fact that all characters come from archetypes, and the whole debate about original ideas seems a little futile.

BUILDING ON THE PAST

Working with existing characters is a good way of learning, and part of this book's aim is to supply you with those very foundations on which to build. Generations of comic artists have grown from taking their favourite heroes and making their own stories. *Star Wars* is an excellent example of how "fan fiction" has developed into an industry in its own right, with new, original characters being added to that universe.

Reading the legends and mythology of other cultures will also serve as jumping-off points for your ideas. Once you are aware of the various archetypes you will begin to recognize them regardless of their ethnic origins, but their different outer forms will give you something new to think about.

STRANGER THAN FICTION

Inspiration comes from all sorts of influences, so it is a good idea to read a lot (this is the basic advice given to all writers). Try to read beyond your favourite genres. For example, if you like fantasy try reading biographies – a great way of adding a new reality to your characters.

INSPIRATION AND RESEARCH: *Newspapers, magazines, novels, classic literature, movies and audio books are all sources of ideas for creating new stories as well as information about foreign people and places.*

KEEPING NOTES: *A tear-off notebook or drawing pad is always a useful thing to keep in your pocket or bag, for jotting down ideas or making quick sketches.*

Also expand your type of reading; if you only read comics then try novels (not graphic ones) and newspapers. A lot of great story ideas can be culled from the pages of the daily papers. Truth is often stranger than fiction (to which Mark Twain added, "Fiction has to make sense."). Then there are the hundreds of conspiracy and alternative news web sites, where fact and imagination can blur into an incredible source of stories and characters. "What if..." is a great way to get the creative juices flowing.

ALTERNATIVE NEWS WEB SITES: *Conspiracy web sites are a great source of information, whether imagined or real, as the basis for sci-fi and thriller stories. www.disinfo.com is a good place to start.*

WRITE IT DOWN

No matter how you get the initial idea for your stories and characters the important thing is to keep notes, either in notebooks or on index card sheets. Use both written ideas and sketches to help build up a full picture.

Try to keep your stories accurate by doing proper research. If you are setting your story in a city make sure you represent it correctly. Your research should also apply to cultural and historical references, if these are part of your story. By paying attention to these details your fantasy will have more impact when juxtaposed against reality, making your job of getting the reader to suspend disbelief much easier. A pocket digital camera is very useful for recording lots of details. However, you arrive at your ideas and choose to portray them, let reality and its rules infuse your fantasy worlds to give them maximum impact.

▶ OVER TO YOU

A fun exercise is to sit in a café, or some other public place, and indulge in some serious people-watching; not just the attractive ones that catch your eye, but the more "interesting" ones too. Make up a story about them, how they arrived, why they are there. Have they come to meet a lover or kill an enemy? Do they even know why they are there? Do they have secret powers? It doesn't matter what you come up with; ideas will just come to you when you focus on someone. Doing this with a friend, bouncing ideas off each other, is even more fun.

DIGITAL RECORDING:
Photographing interesting people and places you visit will serve as a useful resource that will last a lot longer than your own memory.

MYTHOLOGY AND ART

Almost everybody loves a good story. A small percentage of the population are storytellers, while the rest provides a willing audience. The place of the storyteller has always been elevated in society. In ancient times the mystics, oracles and shaman held this position; today authors, screenwriters/filmmakers and musicians fill the role. Among this contemporary group can be found the comic artist and the animator, who hold a special place as visual storytellers.

DREAMTIME: *Australian Aboriginal myths were painted onto prepared strips of tree bark using natural pigments from their environment.*

Telling stories with pictures has been part of our heritage since the first drawings on cave walls, predating the written word (and probably even the spoken word). As civilization developed and became more sophisticated, so did the methods and subjects of storytelling. From the Australian Aborigines and ancient Egyptians to the Mesopotamians, Chinese and Aryans of the Indus Valley, and up to the time of the Greeks and Romans, pictures were used to record and recount tales of valour and to teach the lessons of the gods.

The mysteries of the world were revealed and the inexplicable explained through metaphor and symbolism, with the artists supplying their visions as clues and prompts. It was from these mystical roots that mythology – and also the archetypal characters that populated the stories – developed.

RELIGIOUS ICONS

As the millennia passed and figurative art developed in the West it was subverted into serving the Church. A very small minority of people, Michelangelo being one example, stood up to this repression and produced stunning original works that

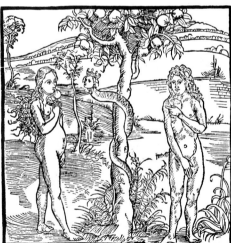

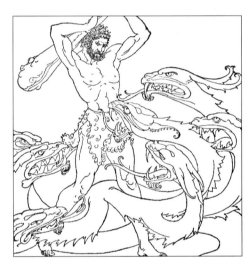

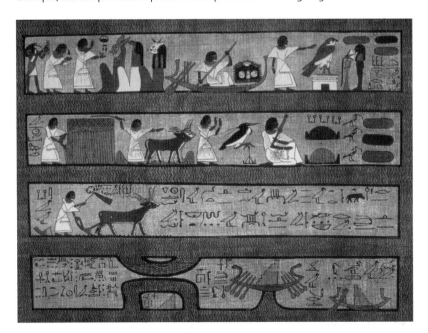

GODS AND MONSTERS: *To tell good stories characters are made to appear differently than they really are. The Egyptians (left) made their pharaohs into gods, while the Greeks (top) made their gods more humanlike. And the story of Adam and Eve (above) simply defies logic in the name of a good story with a strong moral.*

FANTASTICAL ALLEGORICAL: *Art and illustration at the end of the nineteenth century was heavily influenced by myths and legends. The PreRaphaelites (below) offer a more romantic view compared to the "darker" visions of Doré (right) and Crane (far right).*

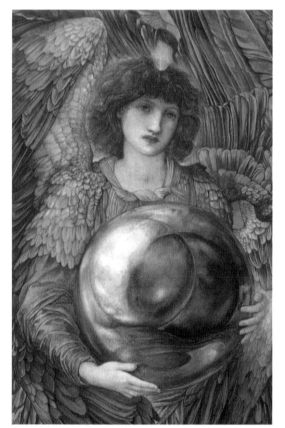

still managed to please the Papacy. As the Church began to lose its grip, especially in Britain, artists such as William Blake started to create their own mythologies filled with truly visionary images.

By the beginning of the twentieth century there was a resurgence in allegorical painting, with schools such as the Symbolists and the PreRaphaelite Brotherhood producing figurative paintings based on traditional myths. This new fascination for myths and legends, coupled with improved education and printing, saw the rise of illustrated mythologies by great draughtsmen such as Gustave Doré, Arthur Rackham and Walter Crane.

BRAVE NEW WORLD

With the rise of technology and ease of travel the world seemed to grow and shrink simultaneously and different cultures were introduced to whole new sets of legends, mythologies and religions that were diverse, yet somehow similar. Though these discoveries and integrations were brought together by great minds such as Carl Jung, the harsh realities of global warfare soon changed people's perceptions. Ordinary people were carrying out heroic deeds on a daily basis. New mythical heroes were wanted, in easily digestible and affordable formats: movies and comics provided the solution. Hollywood superstars and pulp-paper superheroes supplied the much-needed escapism. But while the Hollywood actors became legendary, they were far too human when compared to the mythological comicbook heroes.

PULP FICTION

Decades on these same comicbook heroes are still agelessly fighting the good fight as they adapt to the everchanging world and new generations of storytellers and audiences. It is these modern mythologies that are the last bastion for figurative artists looking for an outlet for their talents; and so our primordial need to tell stories and explain mysteries through words and pictures continues.

EVERYDAY HEROES: *People, such as firemen, who are involved in selfless acts of bravery, are commonly thought of as modern-day heroes, yet everyone on a journey of self-improvement is an archetypal hero. The word hero comes from the root of a Greek word meaning "to protect and to serve" – the motto of the LAPD.*

WHAT ARE ARCHETYPES?

According to C. G. Jung, the great psychologist, archetypes are the primordial models upon which we, as humans, are fashioned. He applied this idea not only to our behaviour but also to our tradition of myths, legends and storytelling. The blurring of the boundaries between myth and reality, through the concept of archetypes, makes storytelling a powerful medium for teaching us about life. By recognizing the various facets of the archetypal characters within our own psyche we can identify with the characters in a good story, and hopefully learn something about ourselves from their tale.

Each of the archetypes has a role to fulfil, and that role invariably centres on the Hero and their journey, the adventure. Each of the subsequent chapters will explain these roles in detail, to give you a clearer understanding of what to consider when developing the inner and outer characteristics of your creation.

As a storyteller you need to understand the roles of the different archetypes in order to give your stories substance. Unfortunately a little knowledge can be dangerous. The best stories are inspired – the idea comes in a flash, without any thought on your part. They emanate from an area known as the "collective unconscious", a storehouse of great and eternal ideas. This is also where the archetypes reside. When real inspiration lies behind a story the archetypes are there, all correct and accounted for. The problem comes when you know the theory of archetypes and try to concoct a tale with the right combinations of characters and actions. You can end up with something contrived and lifeless. The trick is to achieve a balance between knowing mentally what should be there, and emptying your mind to enable that spark of inspiration to kindle your imagination.

IT TAKES ALL TYPES:
Archetypes are defined by their character and their role rather than by their physical appearance, as will be apparent from the examples below and on the following pages. This does not mean they are not represented by stereotypical views, but if they are it is on purpose.

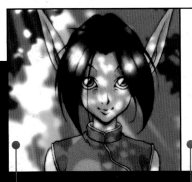 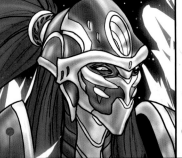 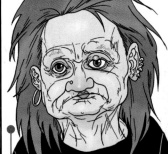

HERO

Characteristics: A real person full of contradictions – strong and determined yet weak and uncertain. The Hero is the one that takes the journey of discovery.

Role: To find meaning in life and bring that meaning to the lives of the people in their world.

MENTOR

Characteristics: Wise and learned. Selfless and generous. Often portrayed as an old person.

Role: To teach and advise the Hero on his or her journey. Will often give a gift that helps the Hero in their quest.

THRESHOLD GUARDIAN

Characteristics: Aggressive, obedient menial of the villain.

Role: To obstruct the Hero's progress and test their resolve on the path.

HERALD

Characteristics: Friendly, loyal, and sometimes outspoken. Can be the Hero's lover or partner.

Role: The Hero's messenger for the, both bringing messages and making announcements on the Hero's behalf. Helps motivate the Hero.

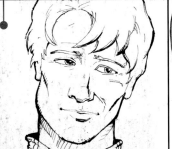 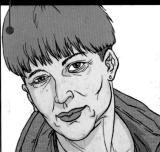 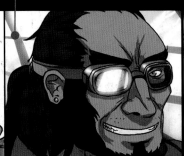

WE CAN BE HEROES

The role of each archetype is determined by its relationship with the hero (protagonist) of the story. Because the archetypes are all aspects of the universal psyche they exist, to a greater or lesser degree, in everyone. We are the Heroes in the myth that is our own life. Not only do the people we encounter on a daily basis fulfil the archetypal roles for our own story, we also fill a different role in theirs. It is even subtler than that because our own thoughts can act in archetypal roles too; a doubt or negative thought could be interpreted as a Threshold Guardian preventing us from fulfilling our destiny. Keeping in mind that one character can play several roles in a story will help you to build more complex personalities.

There are many different archetypes, but this book will concentrate on the seven principal ones that feature in most mythical stories: the Hero, Mentor, Threshold Guardian, Herald, Shapeshifter, Shadow and Trickster. The following examples should give you an idea of how each role works, and will help you to avoid creating stereotypes, rather than archetypes. If you want to investigate this complex subject further look at the writings of Carl Jung, Joseph Campbell (*Hero with a Thousand Faces*) or Christopher Vogler's contemporary, movie-centric distillation, *The Writer's Journey*.

▶ OVER TO YOU

▶ Before reading any further jot down your ideas about what you think each archetype represents, then make a quick sketch of a character for each one.

▶ After reading the descriptions of each archetype in this book, make a list of characters from books or films that you think fit those roles.

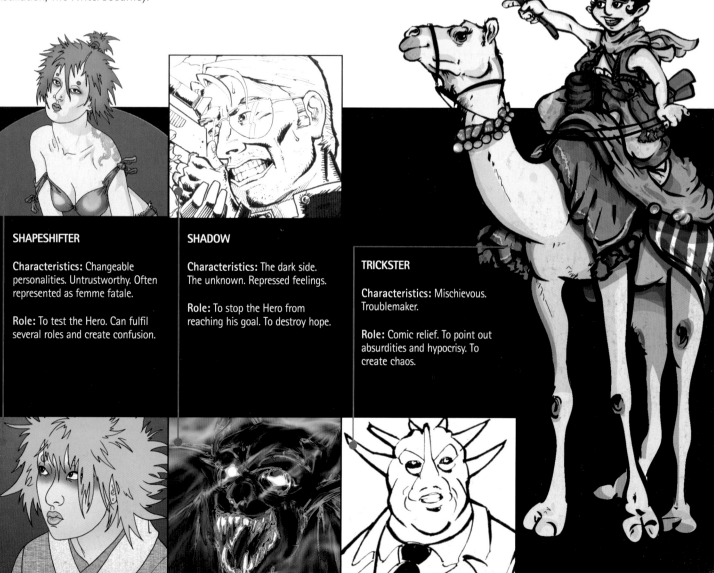

SHAPESHIFTER

Characteristics: Changeable personalities. Untrustworthy. Often represented as femme fatale.

Role: To test the Hero. Can fulfil several roles and create confusion.

SHADOW

Characteristics: The dark side. The unknown. Repressed feelings.

Role: To stop the Hero from reaching his goal. To destroy hope.

TRICKSTER

Characteristics: Mischievous. Troublemaker.

Role: Comic relief. To point out absurdities and hypocrisy. To create chaos.

MAKING STORIES WORK – USING MYTHICAL STRUCTURE

The premise of this book is that comics are the new mythology. As such, an understanding of the basic principles of mythical story structure will help you construct more interesting comics, graphic novels and animations. This structure is known as the "Hero's Journey" because it describes just that: what happens to a Hero during his adventure, the types of encounters he has, the types of characters he meets.

HERO'S JOURNEY: *Although twelve stages of the Hero's journey are shown here, it is not necessary to use them all, though you may find that they do appear in some form in your story. In the example shown, from the AIT/PlanetLAR comic "Nobody" created by Alex Amado, Sharon Cho and Charlie Adlard, the Hero's journey really begins when she is a child (shown in flashback). For the purpose of this story her ordinary world is already extraordinary and the adventure is not a single defining one, even if it does have major repercussions on her life. All the various stages are present in the story arc but not in quite as linear a way as shown by the diagram.*

If you look at any of the traditional myths and legends from around the world, you will see a pattern in all of them. This is no coincidence—the mythical structure is embedded in the deepest core of the human psyche, in an area described by Carl Jung as the "collective unconscious".

At the most basic level of storytelling there has to be at least one character – which we will call the Hero – and a beginning, middle and end to the story. Even monthly comicbooks follow this pattern, whether as a single episode or a continuing series. The story will start in the ordinary world, where we set the scene (to use movie-speak). Spider-Man's tale, for example, begins in Peter Parker's school. Here we meet the protagonist of the story, leading a life dogged by troubles, or boredom and dissatisfaction.

The soon-to-be-Hero is capable of leading a happy, contented life, but some significant event is required to motivate him to make the journey. This event is known as the "Call to Adventure", and sets the whole story in motion. It can be anything from a spider bite, to a murder, to a holographic message from a princess. Whatever it is, it has to motivate the protagonist to leave, or simply change, his current existence for a new adventure. Sometimes the Hero is

QUIXOTIC QUEST: *The classic story of Don Quixote is what can happen when one invests literally in the Hero's quest. Even while tempered by Sancho Panza's grounding in reality Don Quixote becomes lost in his own myth, until the end of his life.*

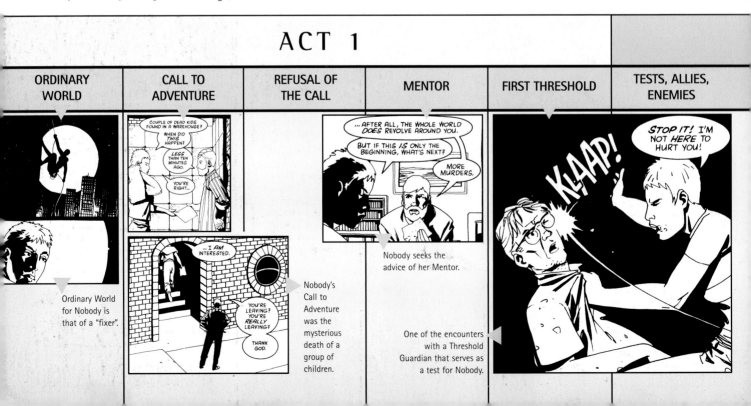

ACT 1

ORDINARY WORLD	CALL TO ADVENTURE	REFUSAL OF THE CALL	MENTOR	FIRST THRESHOLD	TESTS, ALLIES, ENEMIES

COUPLE OF DEAD KIDS FOUND IN A WAREHOUSE?

WHEN DID THIS HAPPEN?

LESS THAN TEN MINUTES AGO.

YOU'RE RIGHT...

...AFTER ALL, THE WHOLE WORLD *DOES* REVOLVE AROUND YOU.

BUT IF THIS *IS* ONLY THE BEGINNING, WHAT'S NEXT?

MORE MURDERS.

STOP IT! I'M NOT *HERE* TO HURT YOU!

KLAAP!

...I AM INTERESTED.

YOU'RE LEAVING? YOU'RE *REALLY* LEAVING?

THANK GOD.

Ordinary World for Nobody is that of a "fixer".

Nobody's Call to Adventure was the mysterious death of a group of children.

Nobody seeks the advice of her Mentor.

One of the encounters with a Threshold Guardian that serves as a test for Nobody.

overcome by fear or doubt ("Refusal of the Call") as he faces his first challenge, but some other event will usually occur to spur him on his way. It is around this point that the Mentor arrives to advise the Hero and help him on his journey into the unknown. The Mentor's counsel can be taken at other times, but this first contact is the most significant.

So the Hero starts his adventure by "Crossing the First Threshold", when he leaves his mundane world and enters the "Special World" of the quest. It is here that he will encounter the Threshold Guardian (see page 56). In movie terms this is where the second act, and all the action, begins, and the bulk of your story will unfold. Joseph Campbell calls this "Descent, Initiation, Penetration", and it is where the Hero's resolve is tested to its fullest. It is where he not only faces his bête noir but also encounters the thing he is seeking. These two events can often occur at the same time, and so the Hero is rewarded with whatever he has set out to find.

This is an oversimplification of the main body of the story, but this part gets the most embellishment and will most test your storytelling skills. It could, however, also be viewed as the easiest part of the process. In the beginning you have to lure the reader into wanting to take the journey with the Hero – and quickly. Once your audience is empathizing with the Hero you can put them through almost any ordeal without losing them (providing you don't insult their intelligence). A good ending is also vital, especially with animations/movies, as this will be the first thing the audience remembers. If you leave your audience/reader with a bad ending, it will tend to override everything that went before.

In using mythical structure you are working with a storytelling form, not a formula. Storytelling has to be instinctive and cannot be created simply by filling in the various stages (outlined below). You can use this chart, however, as a guide to restructuring your first draft, or for giving you direction when you lose your way in your plot.

MODERN MYTHS: *Comics, such as Judge Dredd, and the host of other superhero variations, carry on the tradition of mythology for recent generations. Even though they all tend to be variations on the same theme they still manage to consistently and fervently capture the imagination of readers.*

ACT 2			ACT 3		
APPROACH TO THE INMOST CAVE	ORDEAL	REWARD	THE ROAD BACK	RESURRECTION	RETURN WITH THE ELIXIR

HURT ME? *ME*? Heh*eeheeh*eh.

THE FOOD'S POISONED...

... DO YOU REALLY WANT TO TAKE THAT RISK?

Having returned home, barely surviving yet solving the case, Nobody goes on to be faced with a new challenge.

WHA—?

OH, JESS. GLAD YOU'RE UP. I WAS GETTING TIRED OF SITTING HERE.

SEE YOU GOT MY *MESSAGE*.

YUP, CAME THROUGH AS AN E-MAIL AT *FIRST*. I THOUGHT IT WAS AN EX-BOYFRIEND, WITH *THAT* KIND OF OPENING. *"NOBODY NEEDS YOU..." INDEED!*

YOU'VE HURT *THEM!* YOU KILLED THEM! YOU... YOU...

Nobody's inmost cave, a prison, proved to her greatest ordeal.

CRISIS

CLIMAX

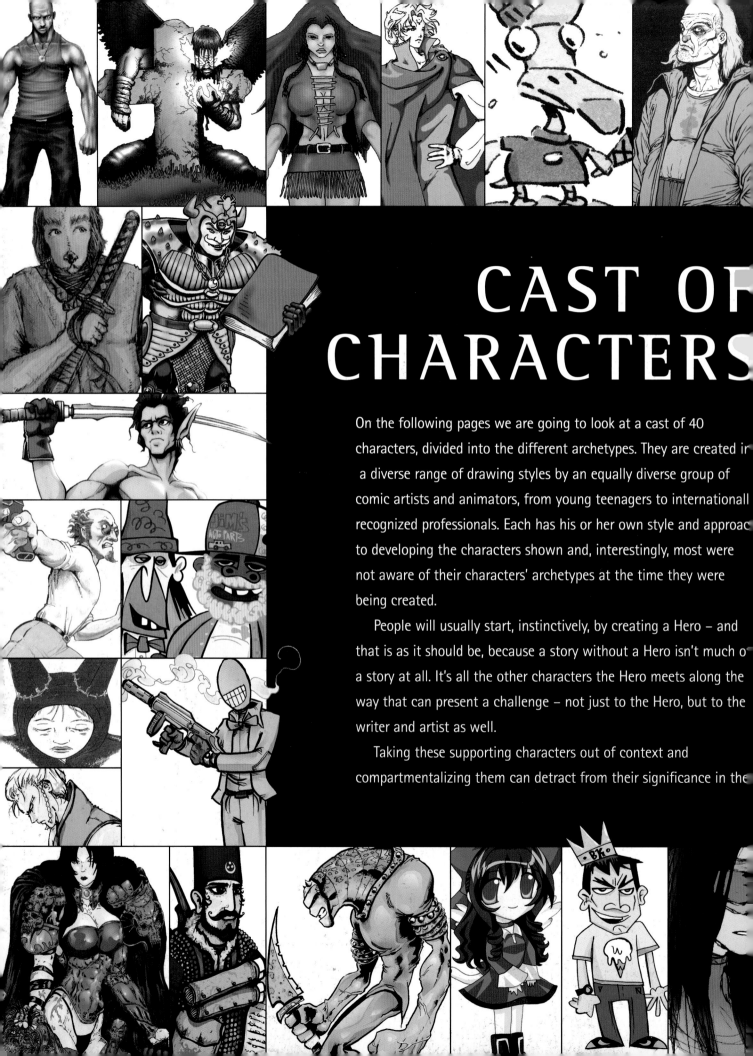

CAST OF CHARACTERS

On the following pages we are going to look at a cast of 40 characters, divided into the different archetypes. They are created in a diverse range of drawing styles by an equally diverse group of comic artists and animators, from young teenagers to internationall recognized professionals. Each has his or her own style and approac to developing the characters shown and, interestingly, most were not aware of their characters' archetypes at the time they were being created.

People will usually start, instinctively, by creating a Hero – and that is as it should be, because a story without a Hero isn't much o a story at all. It's all the other characters the Hero meets along the way that can present a challenge – not just to the Hero, but to the writer and artist as well.

Taking these supporting characters out of context and compartmentalizing them can detract from their significance in the

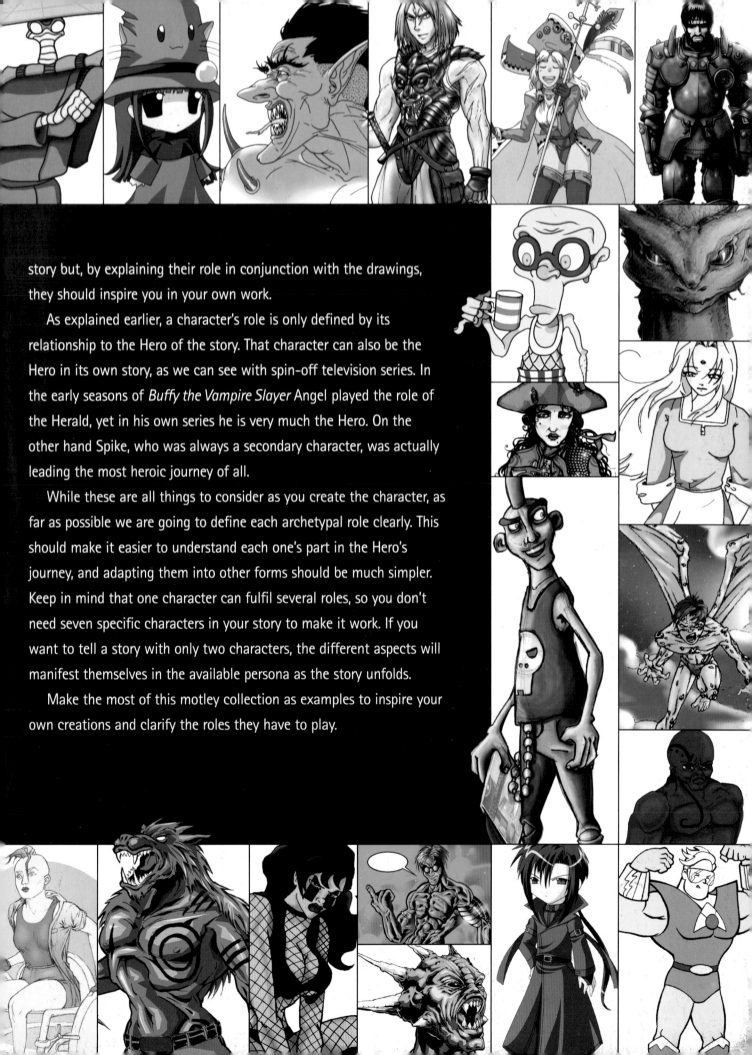

story but, by explaining their role in conjunction with the drawings, they should inspire you in your own work.

As explained earlier, a character's role is only defined by its relationship to the Hero of the story. That character can also be the Hero in its own story, as we can see with spin-off television series. In the early seasons of *Buffy the Vampire Slayer* Angel played the role of the Herald, yet in his own series he is very much the Hero. On the other hand Spike, who was always a secondary character, was actually leading the most heroic journey of all.

While these are all things to consider as you create the character, as far as possible we are going to define each archetypal role clearly. This should make it easier to understand each one's part in the Hero's journey, and adapting them into other forms should be much simpler. Keep in mind that one character can fulfil several roles, so you don't need seven specific characters in your story to make it work. If you want to tell a story with only two characters, the different aspects will manifest themselves in the available persona as the story unfolds.

Make the most of this motley collection as examples to inspire your own creations and clarify the roles they have to play.

HEROES

JUDGE DREDD
Cliff Robinson
One of Britain's longest running original comic book heroes, Judge Dredd is the tough face of justice in the world of the future.

For most people – and especially those in the world of comic books – the word "hero" has become synonymous with "super-hero", that champion of justice and protector of the weak. Then there are our personal heroes, those people we admire and aspire to emulate for their achievements in a given field of endeavour. But what is a Hero?

For our purpose a Hero is the central character in the story. He is the main protagonist, the one whose journey, whose story, we are following. In using the mythic structure for storytelling, that journey has to be one of self-discovery. Even the popular comicbook super-heroes are on that journey, filled with self-doubt and inner conflict, and it is these foibles that endear them to us.

In traditional mythology Heroes are usually endowed with great physical strength as well as resolute will, while others, such as the Buddha, only had their inner strength, determination, and sense of destiny to carry them forward.

When developing the Hero for your story, you need to understand everything about him (or her); you have to know their personal motivations and weaknesses, and how they would act in a situation. One of the advantages of the storytelling process is that your characters can even surprise you; you might create a situation in which the character reacts in a way you had not planned or expected. When this happens you know your character has taken on a life of its own. This spontaneous action isn't the same as contriving a convenient solution to a

JASON
The story of Jason and the Argonauts and the quest for the Golden Fleece (the *Argonautica*) is one of the better known ancient Greek myths (made popular by the Ray Harryhausen animated feature film). This picture shows Jason being carried by Hera, who was the herald that sent him on his journey.

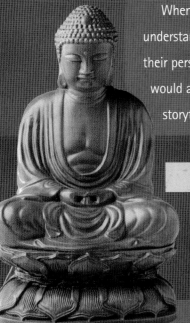

THE BUDDHA
Like the founders of all the great religions, the Buddha's journey was one to enlightenment, filled with as many perils as any other Hero, but the effects of which have resounded throughout the world.

Who are your Heroes and why? Make a drawing of what you consider to be a typical Hero, then draw something completely different and devise a short outline as to why he or she is heroic.

JOAN OF ARC
The French heroine was persecuted for her beliefs and for sticking to them. It is this resolve that establishes them as heroes, when the names of the persecutors are all but unknown.

problem, as is sometimes seen in lower-quality movies (quality having nothing to do with the budget, of course), because the solution comes from the unconscious part of our mind.

What helps to develop the Hero character is his interaction with the other characters in the story. They are defined by the Hero's actions and in turn they contribute to his growth. These characters will take on the roles of the assorted archetypes covered in the following chapters.

It is also possible for the Hero to manifest the other archetypal traits. Batman is a Hero, but he is also a Mentor to Robin. He is a Shapeshifter, alternating between Bruce Wayne and the Dark Knight/Caped Crusader. He could also be called a Shadow in the Dark Knight incarnation, as he struggles with his own inner demons.

Make your Hero multifaceted. Don't make him one-dimensional and perfect; if he was perfect then he wouldn't have to undertake the journey and you wouldn't have a story. He has to try, and to fail sometimes, so he can learn. Make him interesting and complicated, and above all don't fall into stereotypical representations. Give him strength of character and then decide if he needs it in his body too. People usually like to see the underdog win – although after so many corny movies with that theme seeing the underdog lose would make a pleasant change!

Your Hero has to gain the empathy of the reader. If you can achieve that then the Hero's journey becomes the reader's journey, and through that you can impart lessons – ultimately, teaching is the storyteller's art.

Over the following pages you will see a variety of Heroes, some stereotypical in appearance and others that will challenge your conceptions of what a Hero should look like.

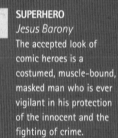

SUPERHERO
Jesus Barony
The accepted look of comic heroes is a costumed, muscle-bound, masked man who is ever vigilant in his protection of the innocent and the fighting of crime.

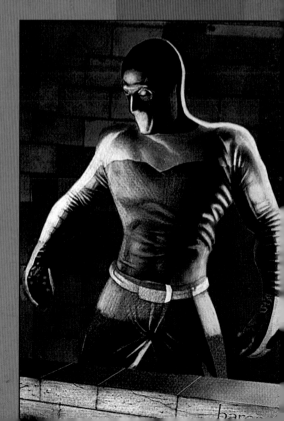

Artist: Ziya Dikbas

CAPTAIN ACTION

OLD-FASHIONED HERO

Although the main aim of this book is to help you look at a whole range of different characters, beyond the usual superhero fare, sometimes the world still needs an indefatigable champion. Unfortunately the genre has been inundated with just about every conceivable combination of costume and powers. Rather than trying to be too sophisticated, going back to basics sometimes can produce the most satisfying results. Add some humour and a sense of the ridiculous and you could have a character that appeals to all age groups.

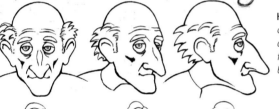

LARGER THAN LIFE: *The initial concept for Captain Action was along Superman lines, with a touch of Tom Strong thrown in: narrow waist, barrel chest and square-jawed head on huge shoulders, all wrapped in a skintight costume. He was drawn to Hero proportions, with a head-to-height ratio of 1:9+.*

HEAD TURNING: *A complete contrast to his alter ego, Mr. Brown's features are all losing their battle with gravity.*

THE CALL TO ADVENTURE: *Little Harold brings Mr. Brown news of an impending disaster. This series of drawings was done to explore how the character works, and was not intended to be part of a story.*

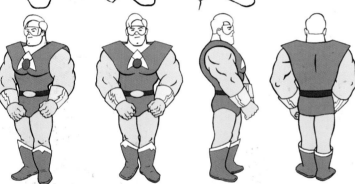

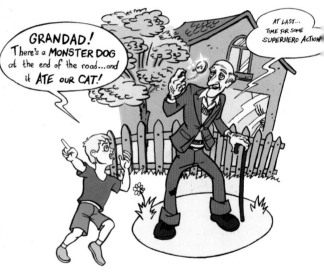

PANTS ON THE OUTSIDE: *Like all the superheroes that came before him, Captain Action has a penchant for wearing tights with underpants over the top, and colour coordinated boots. If it weren't for the big jaw and even bigger biceps he would find himself at the receiving end of some taunts concerning his manliness.*

CAPTAIN ACTION

Age: *83 (as Mr. Brown)*

Height: *1.9 m. (6 ft. 4 in.)*

Hair colour: *Blonde*

Eye colour: *Green*

Distinguishing marks: *Stylized "A" on chest, goggles*

CHARACTERISTICS: Slightly senile and doddery old man who transforms into a fearless superhero.

ROLE: To fight the good fight and save and protect the innocent.

ORIGIN: No one is sure. Mr. Brown has always lived in the same house for as long as his neighbours can remember, but as no one stays in the area for very long that doesn't mean much.

BACKGROUND: Mr Brown is the perennial old man who shuffles around the neighbourhood chatting to everyone. But he has a secret. A chance mixing of Earl Grey tea, Eccles cakes, and a very out-of-date can of "Fight-Hard-Fizz" (a "special" drink that resulted from secret military research, found amongst his army relics) caused him to change into Captain Action. His mental faculties were also enhanced, allowing him to devise a method of

controlling the transformation, through shifting time, with the aid of his gold pocket watch.

POWERS: Incredible strength. Able to distort the space–time continuum.

ASSOCIATES:

Herald: Despite his parents' denials Harold is convinced Mr. Brown is his grandfather, which helps support Harold's suspicions he was adopted.

Shadow: Shadow is the local stray mongrel that mistakenly rolled in toxic waste. His accelerated growth created a new toxic waste that killed trees in the area.

HERO TODAY, GONE TOMORROW

If you want to produce this type of character you have to decide if you want to go for parody or pastiche. Parody is where you deliberately make fun of the genre to the extent it becomes satirical, whereas a pastiche is an amalgam of all these types of Hero characters. The line between the two can be very narrow, so you must examine your intentions and the potential readership. The secret lies more in good writing than in the character's style and appearance. To satisfy the widest audience you need to create simple, heroic tales that appeal to kids, while making verbal and visual gags that only adults will understand. Disney/Pixar's *Toy Story* was a perfect example.

One surefire way of knowing how well your project is working is from the amount of fun you have creating it. Avoid trying to make it too self-indulgent or filled with "in jokes" that only a closed circle will understand. If you want to make it topical try to avoid personalities that will date it, because you just don't know how popular and long-lived it is going to be. Just as your Hero is a composite, you can do the same with the villains/political leaders, as they all seem to come out of the same mould anyway. As long as good triumphs over evil and you get a laugh, you should be onto a winner.

▶ OVER TO YOU

Design your own ultimate superhero. Think about its powers, weaknesses and disguise. Look at it with humour. Just remember that comedy is the most difficult genre to write.

The layout of your comic is vital to the unfolding of the story. Experimenting with story panels is a good exercise, but it is best to design whole spreads rather than creating a series of individual boxes (see page 118).

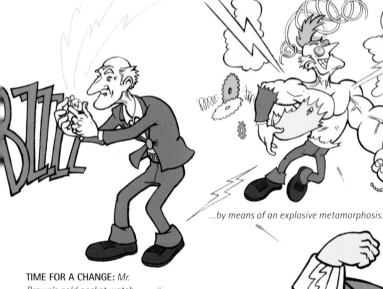

...by means of an explosive metamorphosis...

TIME FOR A CHANGE: *Mr. Brown's gold pocket watch conceals the key that turns him from frail old man...*

...into that fine figure of a man...

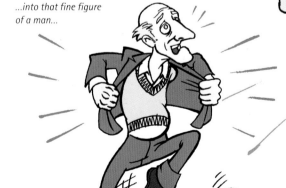

...that is Captain Action.

Animators use lots of methods to infuse a sense of movement into a series of drawings. One of these is anticipation, where the impending action is set up before it actually happens. This can also be used in comics to create a similar effect. In this image you really get the feeling that the character is about to launch himself into the air.

You would not need to show this transformation in your story every time it happened, unless you were intending to build a running gag around it. Because there is such a "cartoony" feel to the images, exaggeration was used and is highly recommended if you are using a similar approach.

Heroes come in all shapes and sizes, and there is no reason why a child shouldn't take on the role, especially as we are dealing with fantasy realms. In the real world the whole of childhood could be seen as a Hero's journey, filled with challenges, lessons and encounters with dark forces (real or imagined). Mix this with wide-eyed innocence and innate wisdom and you have great potential characters to which a huge and enthusiastic audience can relate.

Artist: Wing Yun Man

LOLLIPOP

SWEET LITTLE WITCH

TWO IN ONE: *Lollipop is essentially two characters in one because her hat has a personality of its own. Establishing a dynamic between them required lots of sketching.*

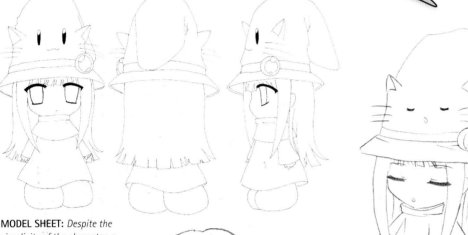

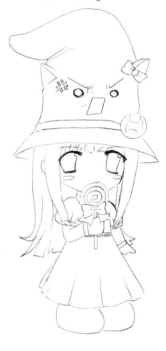

MODEL SHEET: *Despite the simplicity of the character, a model sheet is still a vital element of the design process, especially for animation.*

SKETCHING ON THE GO: *Keeping a small pad with you will enable you to make lots of sketches of your developing characters whenever you have a spare moment. It will also build up your confidence and improve your line work. All these pencil sketches were made without preliminary or construction lines.*

GOING SOLO: *Even though Lollipop is rarely without her hat/pet, it was important to have some reference drawings of her alone.*

 LOLLIPOP

Age: *7*

Height: *1.1 m. (3 ft. 7 in.)*

Hair colour: *Brown*

Eye colour: *Black*

Distinguishing marks: *Talking hat*

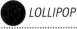

CHARACTERISTICS: Quiet and a little bit creepy. Is easily encouraged into mischievous behaviour.

ROLE: To try and stay out of trouble, which is not easy with her hat telling her to be naughty and Wing, her guardian angel and mentor, trying to teach her to do the right thing.

ORIGIN: Lives in a quiet town called Baka Town that isn't all it seems.

BACKGROUND: She is a young girl with an unhealthy fascination with the occult. She has a magic hat called Kuro Mizard who encourages her to use her magical powers for playing pranks. Luckily she has a guardian angel to teach her right from wrong. She and her friends discover that there is something sinister going on in Baka Town.

POWERS: Can do magic, but does not always use it for good.

ASSOCIATES:
Mentor: Wing is her guardian angel, whose job is to keep Lollipop out of trouble. See page 54.

Trickster: Kuro Mizard is both her pet and her hat, and loves getting Lollipop into mischief. He also tries to protect her from the trouble he causes.

THE KIDS ARE ALL RIGHT

Although the showbiz maxim of "never working with children and animals" may hold true, in the worlds of comics and animation you are completely in charge and they will do exactly what you want them to do, when you want them to do it! One of the great aspects of using children as the lead characters – apart from their natural curiosity – is their vivid imaginations. This can be a useful storytelling device, letting their inventions blend with reality to create fantastic adventures, but with a useful escape route if you need it.

How you present your child characters depends on your own drawing style, the nature of the story, and whether you see children as little angels or something insidiously evil, such as those in *South Park*. Your intended audience will also dictate the style and content, with younger audiences preferring their characters more obviously heroic.

OVER TO YOU

As research is a big part of the creative process, check out how pre-teens are presented in cartoons and what styles are used. Some examples are *Rugrats, Powerpuff Girls, South Park, Angela Anaconda, Recess, Jimmy Neutron, Cramp Twins* – and lots of anime titles too.

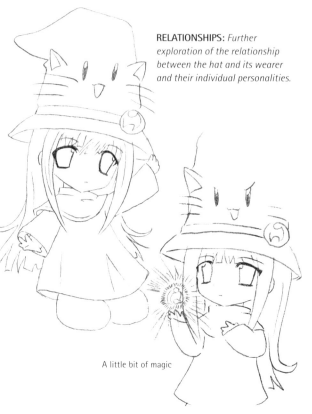

RELATIONSHIPS: *Further exploration of the relationship between the hat and its wearer and their individual personalities.*

A little bit of magic

ANIME STYLE: *Large eyes are one of the distinguishing features of anime characters. The other is the use of large areas of flat colour, called cel shading, derived from the technique of painting onto clear acetate film (cel) used in traditional animation.*

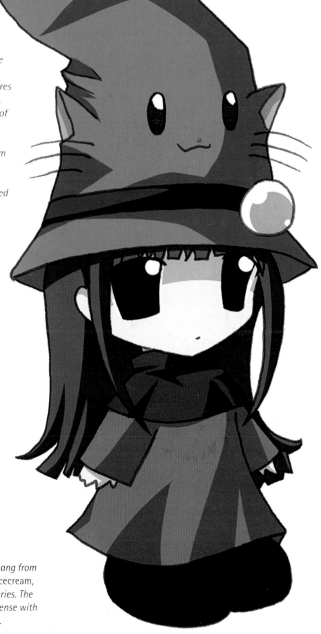

The whole gang from Telephone Icecream, an anime series. The title is nonsense with no meaning.

Artist: Al Davison

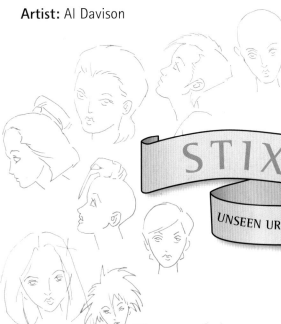

One of the main reasons for using archetypes in stories is to help overcome stereotypes, and none is more prone to this tendency than the Hero. The typical approach is to use muscular men in costumes, though there is now a tendency toward everyman Heroes with foibles, and an ever-increasing number of antiheroes.

STIXX

UNSEEN URBAN WARRIOR WITH STICKS OF POWER

The pencil drawings were scanned into Photoshop, where the contrast was adjusted to give the lines more strength and colours were tested to establish an overall look.

BAD HAIR DAY: *In developing the Stixx character a lot of attention was given to her appearance, especially her hair. A sheet of sketches was produced, experimenting with a diverse range of hairstyles.*

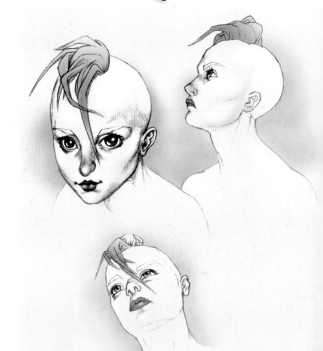

THE CHOSEN ONE: *The one chosen, for its street-smart look that would blend in with other street people, was drawn up in more detail and from different angles to get a clearer idea of her appearance. Working like this helps to familiarize you with the construction of the head and face features.*

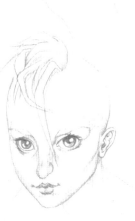

● STIXX

Age: *24*

Height: *1.6 m. (5 ft. 4 in.)*

Hair colour: *Anything bright (natural blonde)*

Eye colour: *Green*

Distinguishing marks: *Hairstyle, wheelchair*

CHARACTERISTICS: Born with a disability that affects her legs, Stixx can only walk short distances with the aid of sticks and spends most of her time in a wheelchair. Has a very individual dress sense. Is tenacious and compassionate in equal measure.

ROLE: As the Hero she has to overcome obstacles. These range from negotiating steps to dealing with discrimination and verbal abuse.

● **ORIGIN:** Abandoned as a child by her parents (who could not face up to her disability) she grew up in different institutions and foster homes in the underprivileged, inner-city areas.

BACKGROUND: Works as a private investigator who specializes in finding missing children. She is trained in martial arts, with expertise in Escrima (Filipino stick fighting) which she learned from her mentor Jill Curtiss.

● **POWERS:** Her disability and street-smart looks, coupled with people's prejudices and inner-city indifference, render her invisible to the public around her so she is able to carry out her investigations unnoticed.

● **ASSOCIATES:**
Herald: "Spud", an ageing punk who runs a record shop, keeps her ear to the ground for news about missing or runaway kids. Quotes lyrics of old punk records as *Zeitgeist* philosophy.

Mentor: Jill Curtiss, an Escrima expert, runs a centre for street kids. She took Stixx in when she was young and homeless and taught her Escrima and Kali.

The Hero's journey is all about overcoming obstacles, both internal and external, and this particular Hero, being wheelchair-bound, has to face both of these almost every hour of the day. Although Marvel comics have a selection of "disabled" heroes – Professor Xavier, DareDevil and Dr. Don Blake (Mighty Thor) – they are all compensated by having superpowers.

MAKE THE ORDINARY EXTRAORDINARY

Stixx is a relatively normal person – apart from her martial arts skills – and much of her power lies in the anonymity of being female and disabled. By creating characters outside of the usual stereotypes, stories can be developed in new, uncharted directions that are more credible than the usual superhero fare. Focus on one aspect of the character that can take them beyond the average, but without going beyond the realms of possibility – whatever they are.

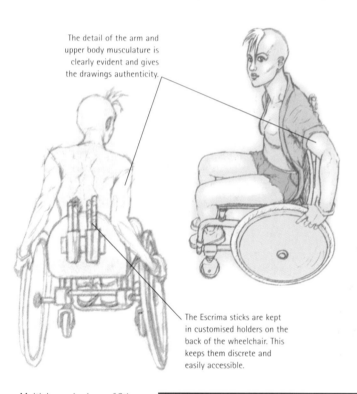

The detail of the arm and upper body musculature is clearly evident and gives the drawings authenticity.

The Escrima sticks are kept in customised holders on the back of the wheelchair. This keeps them discrete and easily accessible.

▶ OVER TO YOU

Create a heroic character from a minority group and give them a single power or facility that makes them exceptional. Try taking an average "normal" person and putting them in a situation where they are a minority figure. How will you make them heroic?

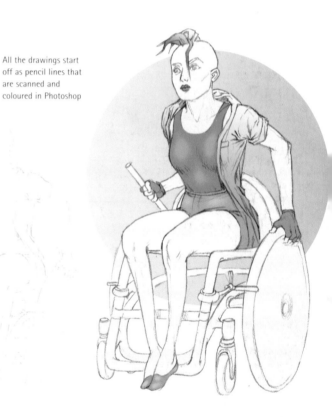

All the drawings start off as pencil lines that are scanned and coloured in Photoshop

Multiple-angle views of Stixx in her wheelchair were made to establish both the mechanics of her conveyance and her interaction with it. Some initial clothing ideas were also tried.

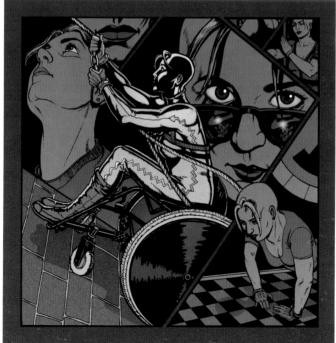

DRAWING ON EXPERIENCE: *Artist Al Davison, himself disabled, photographed a model in his own wheelchair for reference images to make the sketches shown here. He is also a black belt in karate, which gives him a good understanding of the dynamics of martial arts. He has a lot of personal experiences relating to the issues covered in the story. The finished character studies were created as pencil drawings.*

ALL ABOUT PRESENTATION: *A presentation panel in the finished style showing Stixx in action. Panels such as this are very useful when trying to sell a concept as they showcase both the artist's ability and style as well as give a good idea about the character without going into story details.*

Artist: Simon Valderrama

ARTHUR

THE BURDEN OF A HERO

THE BOY KING: *Arthur was still a boy when he drew the sword from the stone, sealing his fate as the new king of England. A simpler drawing style was used for this period of the story to convey a sense of innocence and youth.*

Taking an existing story or legend and creating your own interpretation of it is a common and acceptable practice. Disney Studios established their reputation (and their fortunes) on very loose adaptations of classic tales; indeed, practically the whole Hollywood film industry seems to rely on rehashing old stories. So why not you?

There have been many interpretations, both literary and visual, of the tale/myth of Arthur over the centuries since he may (or may not) have existed. The Arthurian legend has been illustrated by some of the world's greatest draughtsmen – Beardsley, Crane, Doré and Rackham – not to mention Disney. The tale is so filled with archetypal characters that adaptations, from light romantic musicals to dark gothic movies, all work.

ROUGH: *This refers to the first drawing on the right, not to the character's sense of well-being. This pencil sketch was the basis of the final coloured image (shown far right). Strong, accurate pencils (2nd right) are vital for a powerful finished artwork. If you are getting someone else to do the inking and colouring it is even more important your outline work is clearly defined and free from tonal work.*

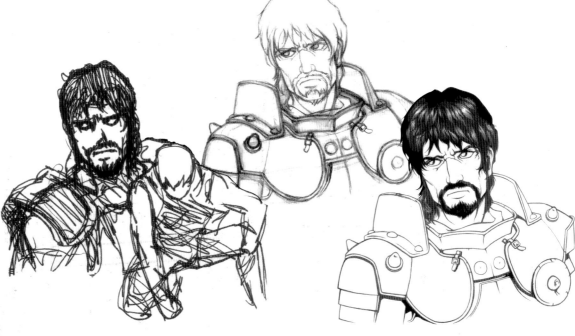

ARTHUR

Age: *27*

Height: *1.7 m. (5 ft. 9 in.)*

Hair colour: *Black*

Eye colour: *Brown*

Distinguishing marks: *Crown and enchanted sword*

CHARACTERISTICS: Noble, wise, and fearless leader who became disillusioned with his knights.

ROLE: Once and future king who brought peace to England.

ORIGIN: The son of King Uther Pendragon and Igraine, his wife. Merlin gave him to Sir Ector, a knight (who already had a son, Kay), who became his guardian.

BACKGROUND: As squire to the newly knighted Sir Kay Arthur drew the sword, Excalibur, from a stone, thus making him king of England. His task was to unite all the dissenting kings, which he achieved through the egalitarianism of the Round Table, and to chase the Saxons from the land. Once peace was achieved, Arthur's authority started to decline, so he sent his knights on a quest for the Holy Grail.

POWERS: Able to wield the mystical sword Excalibur.

ASSOCIATES:
Shapeshifter: Arthur's wife, Guinevere, betrays him by having an affair with Lancelot, which brings about the downfall of Camelot.

Threshold Guardian: Lancelot's friendship with Arthur and his betrayal of that trust by stealing Guinevere helped prevent Arthur from fulfilling his mission.

THE RELUCTANT HERO

Simon Valderrama's version concentrates on the burden of being a Hero. Sometimes this is shown as the Hero's reluctance, which usually comes at an early stage of the journey when the Hero is filled with doubts about his worthiness or ability to participate in the adventure (a subtle manifestation of the Threshold Guardian). In this version, Arthur has already fulfilled his destiny but is overwhelmed by his sense of the responsibility of his role – a sort of Hero's mid-life crisis. This approach humanizes the Hero and places him in a context we can all understand. We can relate to his internal battles a lot more easily than we can to combat on the field, yet the fight is no less heroic.

▶ OVER TO YOU

Create your own interpretation of the story of Arthur – or another legend with which you are familiar – and look for a different way to tell it. This can be from the point of view of one of his associates, or even a first-person account.

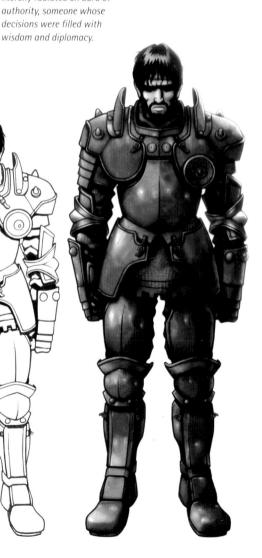

THE ENLIGHTENED KING: *With the magical force of Merlin behind him, Arthur literally radiated an aura of authority, someone whose decisions were filled with wisdom and diplomacy.*

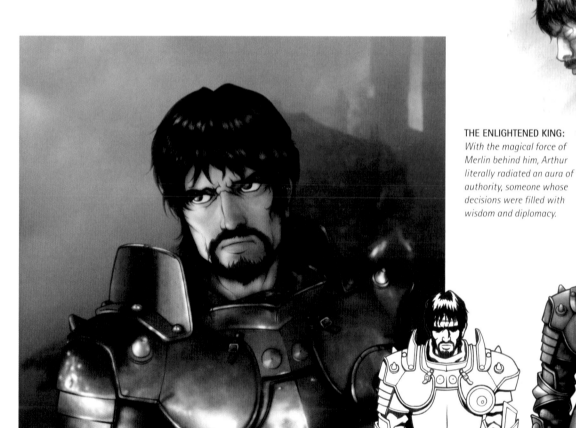

A SHINING EXAMPLE: *The range and methods of colour usage in comics/graphics novels has changed considerably in recent years, thanks to innovative artists, digital tools, and improved printing technology. The pencil drawing left was brought to life through digital painting. Simon Valderrama, a professional 3D SFX animator, used his experience of creating photorealistic texture maps to produce the metal for the armour. This, coupled with his knowledge of lighting, resulted in the powerfully realistic image.*

ONCE A KNIGHT: *Thanks to the enduring quality of medieval craftsmanship there are still plenty of examples of armour that can be used as reference material. This does not mean that imagination and modern design sensibilities cannot be included in the representations. Worse liberties have been taken with history in the name of storytelling.*

Artist: Andrew West

ORAN

TORTURED SOUL, BROKEN SAINT

Finding a commercial outlet for your stories and characters is not easy. The comic publishing world is fiercely competitive; feature-length animated movies are both prohibitively expensive and time-consuming to produce, while animated shorts are relegated to niche festival slots – if you are lucky. Then there is the Internet...

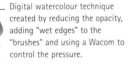

Digital watercolour technique created by reducing the opacity, adding "wet edges" to the "brushes" and using a Wacom to control the pressure.

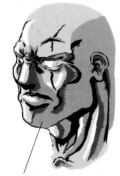

PIXEL PAINTING: *Early watercolour sketches of Oran, exploring both his appearance and use of different colouring techniques. Experiments like this are never a waste of time because they help you to hone your skills and to arrive at a solution through a process of elimination.*

Solid colour was used for this image, with Opacity at 100% and a "hard edge" on the brush. Using "Painter" software will give you even more options.

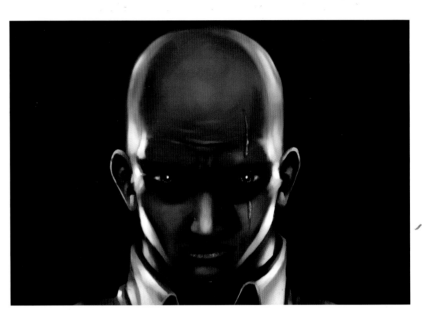

THE MARK OF A MAN: *The scar through his eye was conceived as a way to illustrate his violent past, and can also symbolically represent a certain "blindness" in his actions and beliefs.*

SKETCHY IDEAS: *A series of pencil sketch studies of Oran's head used to help the artist familiarize himself with the character. Making drawings from as many angles as possible will help add dimensionality as well as being useful reference material when working on the final project.*

 ORAN

Age: *33*

Height: *1.8 m. (5 ft. 10 in.)*

Hair colour: *Black, but head is kept shaved*

Eye colour: *Brown*

Distinguishing marks: *Scar through left eye, amulet on chain around neck*

CHARACTERISTICS: A warrior and loner who lives by a strict code of values. He will go to any lengths to act for "the greater good", even if it means sacrificing himself.

ROLE: He is seeking redemption in the eyes of his God, but may also be a pawn in the greatest trick ever played on mankind.

● **ORIGIN:** Raised in the hostile sands and cobbled streets of Iraq. A freedom fighter haunted by those who were slain in the name of politics and conflicts of faith.

● **BACKGROUND:** Oran seeks sanctuary in the age-old texts of his beliefs, but the ancient words cannot quell the dread triggered in him by the first mysterious broadcasts from the BIOCOM satellite network. While acting as a freedom fighter he was taken prisoner by a NATO patrol and shipped in chains to the USA as a terrorist.

POWERS: His faith in his spiritual heritage gives him near-superhuman strength.

● **ASSOCIATES:**
Mentor: Kamimura is the wise old man of the Broken Saints quartet, who was banished from his Shinto temple and went to the West in search of an answer.

Herald: Raimi's world is a virtual one of computers in which he discovers an all-important message.

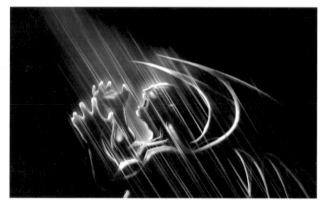

BETTER THE DEVIL YOU KNOW? *A conceptual image created to explore Oran's wrestling with his inner demons. Though it wasn't used in the story, pictures like this are useful for establishing character and visual styles.*

PRESS RELEASE: *This picture was done as part of a press kit to try and encapsulate Oran in a single image, showing him as a trapped and tortured soul.*

Broken Saints (of which Oran is one of the four protagonists) was devised as a 24-part Web-based graphic novel about a quest for Truth. A profound and gripping story by Brooke Burgess was presented as a hybrid of traditional art mixed with movement and sound. The story was illustrated by Andrew West, with animation and effects created in Flash by Ian Kirby.

WORKING IN A TEAM

Creating a story with four distinct Heroes gives plenty of scope for complex character development, with other archetypes manifesting through the principals. Oran is essentially an antihero, so the Shadow archetype – a strong aspect of his personality – is displayed as he wrestles with his own tortured mind. The diversity of the characters also meant a distinct range of drawing styles could be utilized to represent each one, while maintaining an overall unity of design.

While creating your own characters from scratch is the aim of the majority of artist-storytellers, collaborating with other writers is part of being a professional. Designing and developing the look of other people's characters is a discipline that requires flexibility, patience and humility. Most writers have a clear idea of how their characters look or, more usually, what they don't look like. If the writer has approached you, the chances are he or she is already familiar with your style and likes what you do, which will make your job that much easier. Mutual respect is essential to producing the best possible work.

▶ OVER TO YOU

If you know a writer, approach them with the idea of turning their story into a graphic novel, or collaborating on a new project together. If not, find a story you like and draw characters based on what has been written. The Web is a great source of unpublished stories in every imaginable genre.

Another angst-ridden character sketch.

RUGGED INDIVIDUAL: *The shaved head was chosen to convey ruggedness and maturity, as well as an unwillingness to fall prey to vanity, which is also supported by his utilitarian clothing. His physique was drawn to convey strength and domination.*

ME AND MY SHADOW: *Oran is often shown with heavy shadow to symbolize the dark side of his nature. The pose demonstrates his anger and aggression, yet he is still a Hero.*

Artist: Ami Plasse

Not all your projects are going to be single stories with a clear three-act narrative. Anyone with even a moderate amount of ambition would like to have their character syndicated as a series, whether it be comics or a network cartoon. These formats are essentially character-driven, and though themes and story arcs can be carried throughout a series, strong characters with which the audience can engage will ensure its success.

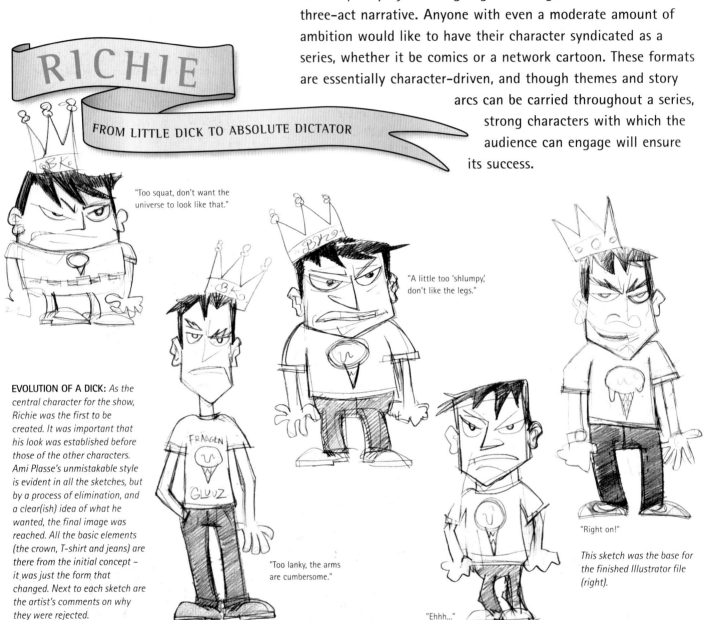

RICHIE

FROM LITTLE DICK TO ABSOLUTE DICTATOR

"Too squat, don't want the universe to look like that."

"A little too 'shlumpy', don't like the legs."

EVOLUTION OF A DICK: *As the central character for the show, Richie was the first to be created. It was important that his look was established before those of the other characters. Ami Plasse's unmistakable style is evident in all the sketches, but by a process of elimination, and a clear(ish) idea of what he wanted, the final image was reached. All the basic elements (the crown, T-shirt and jeans) are there from the initial concept – it was just the form that changed. Next to each sketch are the artist's comments on why they were rejected.*

"Too lanky, the arms are cumbersome."

"Ehhh..."

"Right on!"

This sketch was the base for the finished Illustrator file (right).

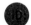 *RICHIE SHIMSHUN*

Age: *30*

Height: *1.7 m. (5 ft. 6 in.)*

Hair colour: *Black*

Eye colour: *Green*

Distinguishing marks: *Crown (courtesy of a certain hamburger franchise)*

CHARACTERISTICS: Obnoxious, self-centred and pretty much devoid of any redeeming qualities.

ROLE: Absolute Dictator of Planet Earth, who is advised and assisted by a small group of aliens and humans.

ORIGIN: An ice-cream scooper from the east side of the Big City who hadn't grown out of childish pranks like spray-painting cats, or mixing insects into chocolate shakes.

BACKGROUND: Through a series of clerical errors by some lazy alien officials Richie was appointed Absolute Dictator. They were really looking for someone who was wise, compassionate, and incorruptible to stop the Earth's uncontrollable conflict, waste and ecological abuse polluting the surrounding systems.

POWERS: Through advanced technology, the aliens installed him with

nearly absolute power (but a remarkably small budget) in order to ensure his reign could not be challenged by anyone on Earth. He is forced to rule the world justly and benevolently, despite every instinct he has to the contrary.

ASSOCIATES:
Mentor: Koooolbert is a 350-year-old, three-eyed Octlak who was sent to Earth to act as one of Richie's

primary advisers. Like most of his race, he is an ultra-mellow, good-natured, fun-loving creature. His main job is to make Richie "be nice".

Trickster: Roscoe, and his mate Karl, work for Richie. They do odd jobs around the office and supply a steady flow of "street-corner wisdom", most of which is useless babble that sometimes produces useful insights. See page 48.

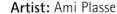

Despite the lack of a formal mythological story structure, using archetypes as the basis for your characters will give them more clearly defined roles on which you can expand. You are also going to need a good number of characters for this type of project to work. Although Richie is the protagonist/Hero of the show, the archetypal roles of the supporting cast will carry and develop his personality.

EMPIRE BUILDING

How you create and develop the personae of the ensemble will ensure the project's ongoing success, but creating original visuals is what is going to make the initial impact on the audience and, more importantly, the commissioning editors. Designing a cast in a style that will work over the full range of characters will take a lot of experimentation. Start with sketches of one character. When you have reached a format with which you are satisfied, start on simple sketches of the others. If you are happy with the way they work you can then flesh them out and concentrate on other aspects of the overall design, such as scenery and identity.

OVER TO YOU

Devise a cast of characters to inhabit the world of an ongoing series. Use a character profile sheet (see page 12) for each one, keeping plenty of notes on interrelationships and possible story arcs. File all the sketches together with each profile sheet. Maintaining some sort of order and system will actually make it easier for your imagination to wander.

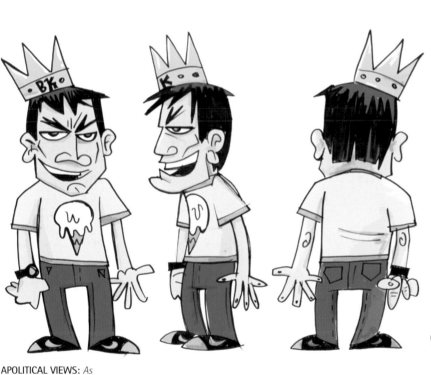

APOLITICAL VIEWS: *As Absolute Dictator Richie has lots of views, but these are just three of them.*

THE LOGOS: *Image is very important, so a dynamic logo is essential not only to start the show but also to liven up the presentation folder you leave with potential investors.*

RESOLUTION DEPENDENT: *The final illustration of Richie was made using Adobe Illustrator. The sketch was scanned and used as a template for the vector version. Apart from the advantages of resolution-free images with small files, vector files are needed for making animations using Macromedia Flash or Toon Boom Studio, both excellent programs for creating stylized cartoons such as this.*

Artist: Emma Vieceli, Sweatdrop Studio

ELLA

RELUCTANT HERO

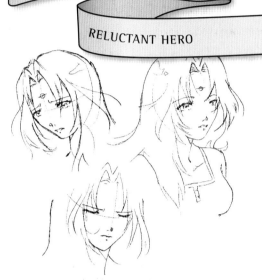

Quick sketches help establish familiarity with the form and explore emotions. The basic construction guidelines for the face are still visible. Make as many of these sketches as you can, particularly for complex characters.

One of the important parts of telling a story is the "point of view", in other words through whose eyes the narrative unfolds. There are three basic choices: first, second or third person. First person is the "I did such and such" method that works well in books, but not so well in visual media such as movies and comics. The second person is very tricky and really needs to be written in the present tense. It was popular with early text-based computer adventure games ("You are moving through a dark forest and a five-foot dwarf, brandishing an axe, jumps out in front of you"). The final method is the third person, which is most commonly used. This is the "god's-eye view", because you know what is going on in everyone's thoughts and what they are going to do next. This omnipresent view draws us into stories, especially visual ones, as we become a passive part of the experience.

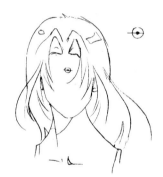

SHOW ME A SIGN: *The use of symbols and symbolism is an essential part of the Dragon Heirs story. The top picture shows Ella's worker spirit mark, her sign of the ordinary world. The left one shows the mark of the spirit binder, passed to her by Neissus, which indicates the transformation Heroes have to go through.*

UNDER CONSTRUCTION: *When drawing new characters, creating a simple underlying structure of ellipses will help you quickly build a physique that can literally be fleshed out. Once you feel confident working with the form and its proportions you can draw without the aid of those shapes. The completed drawing (far right) with the construction lines removed can be made by tracing the pencil image with ink using a light box, inking directly onto the pencil lines and carefully erasing after, or by scanning and digitally "inking".*

⬤ ELLA

Age: *23*

Height: *1.7 m. (5 ft. 3 in.)*

Hair colour: *Blonde*

Eye colour: *Blue*

Distinguishing marks: *The worker spirit sign (and later the spirit binder sign)*

CHARACTERISTICS: Ella is a bright and headstrong young girl, filled with curiosity for the world of the mage spirits. She often had the feeling she should be part of something bigger but felt trapped in her existence as a farmer.

ROLE: It is her destiny to become the "key bearer", the spirit world's second chance. She is to travel with Neissus and find the Dragon Heirs, who are under the threat of an evil force.

● **ORIGIN:** Alphrede village, the daughter of two well-respected farming worker spirits.

BACKGROUND: Ella lives in a world where people are ruled by their spirit signs. After the death of her parents she lived under the care and protection of her brother Kyra. She did not know she was a part of the Dragon Heir prophecy until Neissus arrived at the village to collect her, talking of her destiny.

● **POWERS:** She was born with limited mage abilities, mainly focused around potion making. She can use herbs and spices to create both poisons and healing potions.

● **ASSOCIATES:**
Herald: Neissus is a spirit binder who brings news of the prophecy to Ella. He also acts as her Mentor to teach her about being the key bearer. See page 70.

Shadow: Verance is the black part of the dragon spirit who is determined to stop the Dragon Heirs from fulfilling the prophecy of the transcendence of the dragon spirits.

GOD'S-EYE VIEW

Even though you are supposed to be recounting the story from a distant and detached vantage point (from which you can see everything that is going on) you still need to pick one character as your main focus. Convention dictates that the protagonist is usually the Hero (and vice versa), and hopefully someone with whom the reader can empathize. If you can hook your readers at an emotional level, you have a much greater chance of keeping their interest. For example, the character of Ella is as new to the world of Dragon Heirs as the reader, so we are making discoveries at the same time she does.

Another useful aspect of the god-like third-person point of view is not just what we can see/show but also what we choose not to show. It is up to you, as writer/artist, to divulge as much, or as little, information as best serves the story. The most successful suspense and horror films work on what you can't see, not on the grotesque images to which most people have become immune. This point of view will also affect the positioning, angles, and perspectives you choose to represent the scene, just as the movie director has to select the right camera angle. Keep all these options in mind as you develop your characters and stories.

▶ OVER TO YOU

Next time you read a graphic novel/comic, or watch a film, ask yourself why a particular angle was chosen for a scene, and think how you would have framed it. Look at the "point of view" from which the story is told. Take another character from the story and retell the story from their perspective.

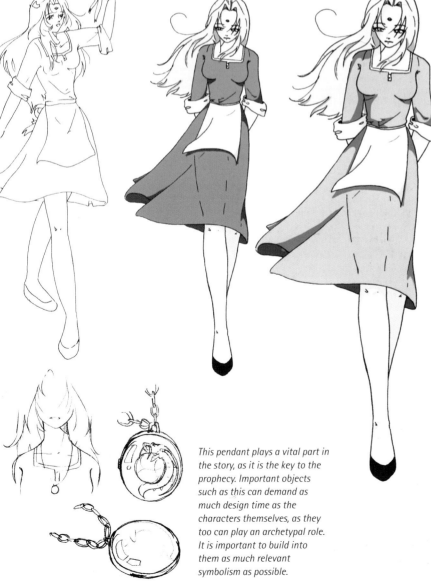

This pendant plays a vital part in the story, as it is the key to the prophecy. Important objects such as this can demand as much design time as the characters themselves, as they too can play an archetypal role. It is important to build into them as much relevant symbolism as possible.

PRETTY IN PINK: *The early version of Ella was dressed in pink but it was decided the colour was not appropriate. Once the change of clothing colour was decided it was very easy to change as the colouring was done on layers in Photoshop. It was simply a matter of substituting one colour for the other without affecting any other part of the image.*

A crucial scene from the Dragon Heirs story, where Ella has to bear the responsibilities about to be passed to her by Neissus.

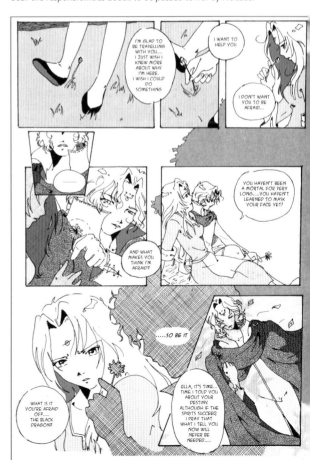

Artist: Thor Goodall

OLD MAN

TAKE A LOOK AT MY LIFE

Building a story around a solitary character using the mythical story structure appears, on the surface, to be an insurmountable challenge, but in fact the contrary is true. As stated earlier, all the archetypes are present in the individual's psyche, so getting them to manifest in a single character is just a matter of showing the relevant traits at the right stage of the story.

2D MODEL SHEET TO 3D MODEL: *This model sheet shows the character in all his disproportionate glory. Exaggeration, both under- and over-, is a standard method used by cartoonists and animators to add personality to their creations. In the case of the old man it is used to add pathos rather than humour, despite his comical appearance. The turnaround was especially useful when the character was converted to 3D.*

Milk bottle glasses enlarge the eyes to exaggerated proportions.

The character's sedentary lifestyle meant no need for muscle detail, except the overdeveloped stomach.

LOW PROFILE: *An early version of the old man. Although the features are still grossly disproportionate, they are significantly less exaggerated than the final drawings, but closer to the completed 3D version.*

FINISHED: *The finished version of the old man, with the all-important cup of tea.*

ID: *OLD MAN*

Age: *81*

Height: *1.6 m. (5 ft. 4 in.)*

Hair colour: *Bald*

Eye colour: *Blue*

Distinguishing marks: *Thick, round glasses, oxygen cylinder*

CHARACTERISTICS: Slightly senile loner who talks to the furniture.

ROLE: Lives every day as if it were his last – which it may well be.

ORIGIN: Born in 1925 in Hull, northern England, where he kept going back between trips.

BACKGROUND: Fought in World War II. Joined merchant navy as a boiler-room engineer after the war. Married several times (contemporaneously) during his travels, but never settled down or had children (that he knew of). Outlived all (both) of his friends, his wives, and the rest of the planet's population, but doesn't know how.

POWERS: None. Takes all his willpower to make it through the day. Makes a good strong cup of tea.

ASSOCIATES: None – there's no one left.

Finding inspiration for these one-man shows should be easy, as the world around us is full of characters who lead reclusive lives, through choice or not, many of whom have different personalities living in their heads. A variety of different approaches can be used when portraying these characters – humour, pathos, drama – depending on the story you are telling and the message you want to convey.

ISSUES AND TISSUES

Artist and animator Thor Goodall wanted to explore some of the themes that old age and loneliness present. By creating an exaggerated caricature he ensured that the comic possibilities would prevent the story from becoming too maudlin. With the character's diminished faculties, every activity, whether it be making a cup of tea or dressing himself (a task he obviously abandoned), becomes one of heroic proportions. Every indecision becomes a Threshold Guardian, and every decision represents the role of the Mentor.

After a long development period it was decided eventually to create the finished animation using 3D software, which helped speed up production and cut costs.

OVER TO YOU

Devise a story based around a solitary character. This can be anything from a hermit, to a vagrant, to a writer. Make the tale follow the mythical format without support from any external characters.

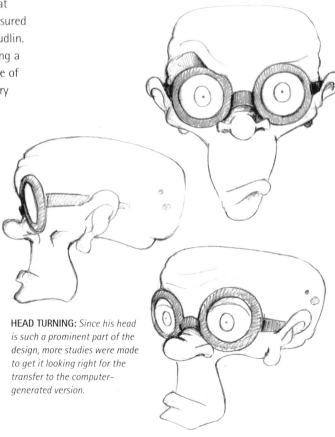

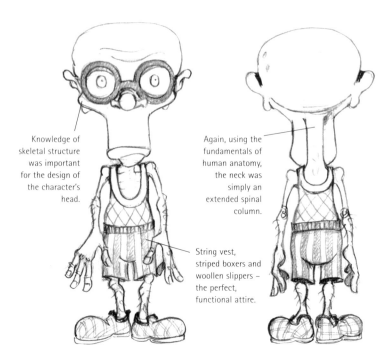

Knowledge of skeletal structure was important for the design of the character's head.

Again, using the fundamentals of human anatomy, the neck was simply an extended spinal column.

String vest, striped boxers and woollen slippers – the perfect, functional attire.

HEAD TURNING: *Since his head is such a prominent part of the design, more studies were made to get it looking right for the transfer to the computer-generated version.*

ANIMATED OLD MAN: *How he eventually appeared in the animated short* Have a Nice Day, *a film about coming to grips with living alone.*

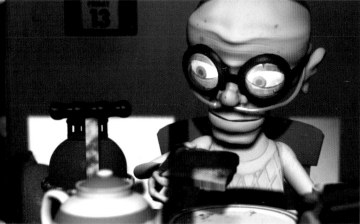

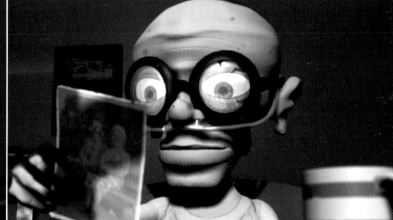

MENTORS

TELEMACHUS AND MENTOR
Telemachus was the only son of Ulysses and Penelope. After the fall of Troy he went in quest of his father, attended by Athena, in the guise of Mentor, who gave him wise counsel.

After the Hero, the most familiar archetype is the Mentor—the wise teacher, there to help the Hero learn and advance along the path The term is widely used in modern educational and social welfare circles for those who give advice and security to the less fortunate. The name itself comes from the ancient Greek myth, the *Odyssey*, when the goddess Athena, in the guise of the wise old man Mentor, appears before the Hero, Telemachus, to impart the necessary knowledge to help him on his journey.

Typically a Mentor is a wise old man or woman. Historically these were the shamans, gurus or magicians, like Merlin in the Arthurian legends. In recent years, popular cinema and writing have produced a good share of memorable Mentors: Obi-Wan Kenobi in *Star Wars*, Gandalf in The *Lord of the Rings*, Professor Xavier in *X-Men*, Dumbledore in *Harry Potter*, Morpheus and the Oracle in *The Matrix*. The list goes on and on.

MERLIN
The magician who, according to legend, helped Arthur realize his destiny to become king of England. The extent of his influence does depend on which version of the story you read, but there is no doubting his role.

Your Hero should be on a journey to self-discovery or self-knowledge, so at some time he is going to need some guidance along the right path. Because of this, a Mentor can sometimes be represented as a function performed by another character rather than as a single personality. In this way you can avoid the trap of creating stereotypical characters, though it may simplify your storytelling to have the Mentor as one figure. The important thing is to have a person or persons who can give the Hero good counsel when he reaches an obstacle.

Sometimes the Mentor can be internalized as ethics or a code of conduct. These are usually lessons learned earlier in life from a living Mentor, such as a relative, a schoolteacher or a shaman – something that would be determined by the cultural context of the story. The internal Mentor would manifest as the Hero knowing exactly how to act in a crucial situation.

▶ OVER TO YOU

▶ Read up on the lives of history's great teachers, such as Martin Luther King, Mahatma Gandhi and the founders of the major religions.

▶ Make a list of fictional (books, movies, comics) Mentors. List their defining attributes, both physical and behavioural, and see which ones are most common. This will help you decide what to incorporate and what to avoid in your own character designs. This is also a useful exercise to do with Heroes.

DR MARTIN LUTHER KING
Some Mentors are able to inspire whole communities and nations into acts of heroism that go beyond the individual's quest.

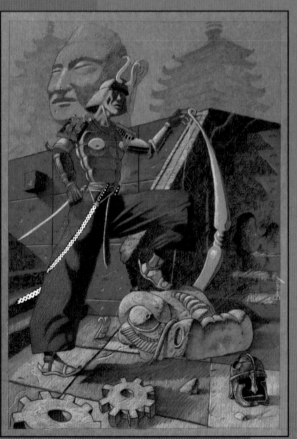

ARMAS
Jesus Barony
Mentors are teachers and masters. If the Hero is a warrior then he needs to learn the proper skills from a master before venturing on his path.

The Mentor will often give the Hero a vital gift for his journey; whether this is a light sabre or a red pill, it has to help the Hero attain his goal. Though benevolence is one of the Mentor's great qualities, traditionally this gift has to be earned by the Hero.

Because the Mentor is vital in the Hero's story, he can appear at any point in the narrative, though usually near the beginning (in what would be called the "first act"), but principally he is there to impart knowledge and guidance whenever needed.

Endowing your Mentor with humour will make him seem more human, and help to ease the tension caused by the seriousness of his position. A Mentor's experience and wisdom should give him eyes to see the folly of the world and the ability to laugh at it.

However you decide to portray the Mentor in your story make him, or her, interesting and worthy of the title (even if you have delve into "the dark side")... and try to steer clear of long white beards and big sticks.

RED OR BLUE?
The Mentor can give the Hero a gift to help him on his way, but can test the Hero at the same time to make sure he is worthy of the task.

Artist: Ziya Dikbas

The original concept behind Professor Oziris was for a character with highly developed psychic and extrasensory abilities. Although he is the protagonist of the story, his role is that of Mentor to a specially selected group of apprentice warriors.

PROFESSOR OZIRIS

MIND OVER MATTER

HAIR LINES: *Early pencil sketch, to establish head shape and colouring scheme. Ideas for a logo are also shown.*

VISION OF A VISIONARY

The physical look of Oziris was partly based on eccentric, early 20th-century European scholars, such as dietician Professor Arnold Ehret and electrical genius Nikola Tesla, both of whom were very "wiry" and absorbed in experiments with higher consciousness and energies. They also both dressed formally. Even though

FAMILIAR RINGS: *The hand detail shows some of his rings of power and the cane he uses to channel cosmic energy.*

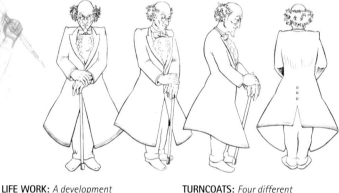

LIFE WORK: *A development sketch showing Oziris in action with his stick. Working from reference shots or life is advisable with these types of images incorporating moving cloth.*

TURNCOATS: *Four different views of the same pose give an exact example of how the character looks.*

PROFESSOR OZIRIS

Age: *Millennia*

Height: *1.7 m. (5 ft. 7 in.)*

Hair colour: *Red*

Eye colour: *Pale blue/gray*

Distinguishing marks: *Pince-nez glasses, cane, small, pointy chin with goatee*

CHARACTERISTICS: Wiry stature with a shock of red hair. Considered both eccentric and enigmatic.

ROLE: To secretly impart his ancient mystical knowledge to a hand-picked group of students.

ORIGIN: Sole living survivor of Atlantis. His name is a corruption of Osiris, the Egyptian god of death and the underworld, sometimes also known as the Lord of Divine Law.

BACKGROUND: He founded the University of Higher Consciousness to pass on some of his knowledge to seekers of Truth. He selects the most adept students to partake in specialist training in the deeper mystical arts to fight against an evil force that will arise during the paradigm shift that was prophesied by the Atlantans before their destruction.

POWERS: Seer. Master of the metaphysical realms. Mastery of telekinesis. His rings bear pieces from the five crystals of knowledge that sunk with Atlantis.

ASSOCIATES:
Shadow: Alex Ronald is a ruthless mercenary whose interest in the truth is limited to the cause of the highest bidder. He thrives on the battlefield and his only fear is peace.

Hero: Merlin Quick is the most adept of Oziris's students. Already a master of armed combat, he remains detached from the violence around him and under his Mentor's guidance he has experienced new realms of spiritual peace – but can still outshoot any other human or machine.

Oziris was thousands of years old his appearance had to have a modern classical feel that would both transcend and integrate with contemporary society.

Apart from his mystical powers he also had to have other means of protecting himself from the evil forces that were gathering for the final showdown. As a Mentor, a staff or cane was chosen, but one that could harness and channel cosmic energy. Being set in modern times, an automatic pistol was deemed suitable as well.

The story development involved a lot of research into ancient and mystical powers, from the siddhas of India to the shamans of the Americas, and how their knowledge was passed on to students. Research and historical references are vital when creating a character like Oziris (more for the accuracy of the metaphysics than his dress sense).

▶ OVER TO YOU

Learning nondigital techniques, such as painting with gouache, are an important part of developing your skills and learning your craft. When practising try photocopying your inked drawing onto thick paper and paint on that, rather than on the inked original.

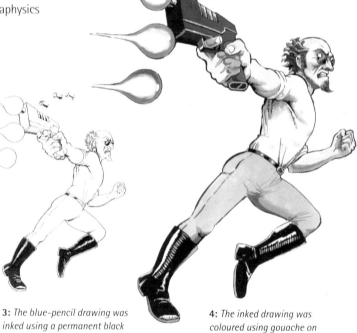

1: *An initial sketch, for the running gunfight pose, using a nonrepro blue pencil. Different arm and foot positions are visible, as are the artist's notes to himself.*

2: *A cleaned-up pencil drawing with more definition, ready to be inked.*

3: *The blue-pencil drawing was inked using a permanent black marker pen. Further detail was added, with the boots being filled in and highlights added.*

4: *The inked drawing was coloured using gouache on Bristol board.*

ATTENTION DISORDER: *With his attention on many different realms, Oziris sometimes has trouble coping with the mundane and will resort to using his telekinetic powers to help him find the everyday objects he misplaces. Pencil sketch (top) and more final version (right).*

GREY MATTER: *A panel from the story, showing Professor Oziris teaching the adepts how to raise their consciousness beyond the sensory realm. The tint and white effects were added to the ink drawing in Photoshop.*

Artist: Anthony Adinolfi

KAYEM

ONCE A KNIGHT

Creating original characters takes planning; inventing an imaginary country requires even more work; but devising a whole new planet involves copious amounts of imagination and organization. This usually includes devising a whole raft of new "'ologies" – physiology, biology, geology, ecology, sociology, psychology and mythology. Building your own alien world requires an understanding of how all these aspects interrelate to make your creation believable. Referencing our own world is a good place to start and, with its amazing diversity of weird and wonderful creatures, it has plenty to inspire.

A DOG'S LIFE: *Just as humans are supposed to have evolved from apes, so Bandarins have evolved from canines. They have retained their fur, as their planet is much cooler than ours.*

LINE AND TONE: *When you are satisfied with your preliminary drawings make up a model sheet showing at least a front and side view. This will help with further drawings.*

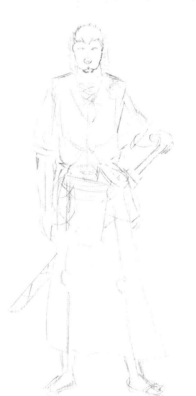

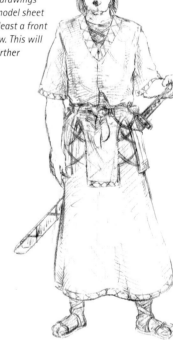

QUICK DRAW: *If you have a clear idea of how the character is going to look, or an idea "pops" into your head, quick sketches like these act as visual notes.*

GUIDELINES: *Once the initial sketch is down on paper, start working on more detailed drawings to develop clothing and other attributes that make the character unique.*

ID: *ARANIK KAYEM*

Age: *29 Bandarin years*

Height: *1.7 m. (5 ft. 8 in.)*

Hair colour: *Light brown (mottled)*

Eye colour: *Blue*

Distinguishing marks: *Carries a Banstone sword*

CHARACTERISTICS: Prodigious exponent of Kida'rin disciplines, but filled with self-doubt.

ROLE: Provides counsel to his friend Sothi Henson, and protection should it be needed.

ORIGIN: The planet Bandar. He was a guardian of the Kida'rin Order, an intense physical and spiritual discipline, and youngest to be knighted.

● **BACKGROUND:** The rigours of the Kida'rin life became too demanding on his body and soul as he was unable to synthesize the new powers, so he left the order. Having tasted the unity with nature that came from enlightenment, Kayem became filled with self-doubt, fearing he had lost everything he had learned. The powers begin to manifest during his travels, and he learns he has lost nothing.

● **POWERS:** Unity of spirit with nature. A martial arts master who carries a Banstone sword, serving as both a traditional sword and energy channel.

ASSOCIATES:
Hero: Sothi Henson is a soft-spoken Bandarin traveller, interstellar pilot and navigator with an important destiny. He has the freedom to journey beyond the scope of

Bandarin space and is fuelled by a strong desire for discovery and enlightenment.

Shapeshifter: Serrazelgobaa (Serra) has an intimidating stature and bold manner that hide a more complex, sensitive nature. Her guarded manner makes her seem cold at first, but when her trust is gained she is a loyal friend. See page 82.

DON'T PANIC, IT'S ORGANIC

Most alien environments are usually based on familiar organic forms because they are easier to represent on the page or screen (actually, invisible ones are even easier but don't make very interesting drawings!). Just as everyone seems to speak in the audience's mother tongue, keeping everything in recognizable forms makes the storytelling that much easier. Changing the names and properties of elements, while maintaining their essential nature, gives plenty of scope for archetypal characters and mythological story structure to flourish.

All these points were taken into consideration in the creation of Bandar, the world inhabited by Aranik Kayem and the other characters in this animation-in-development.

▶ OVER TO YOU

Devise your own alien/fantasy world. Approach the task scientifically, questioning all your creative decisions. You may not use much of the information you write down but you must be able to answer any potential questions, even in your own mind. Just remember that your readers will often be more critical than you. How many times have you seen a film and questioned its logic? If you create a desert planet, where do the inhabitants and creatures get sustenance? Do they need any? If not, why not?

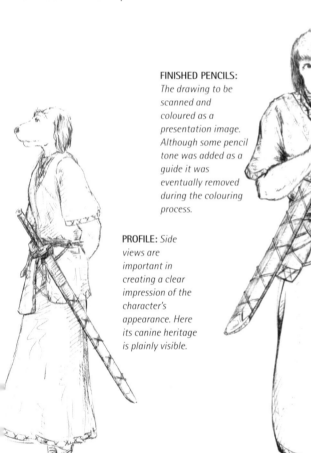

FINISHED PENCILS: *The drawing to be scanned and coloured as a presentation image. Although some pencil tone was added as a guide it was eventually removed during the colouring process.*

PROFILE: *Side views are important in creating a clear impression of the character's appearance. Here its canine heritage is plainly visible.*

BANSTONE SWORD—KIDA'RIN WEAPON OF CHOICE: *"Banstone" is a rare element, indigenous only to the planet Bandar. A guardian's sword is "forged" from the material by Kida'rin monks in a month-long spiritual ceremony, and bonded to its guardian carrier. In its natural form Banstone has unique energy-channelling properties, which are enhanced by the ritual. The Banstone sword is practically unbreakable by any known physical means. The grip is wrapped in a thin cloth weave, though stone is left exposed to create a better contact with the guardian's hand to allow a cross-channelling of energy between the sword and its bearer.*

RUSTIC PALETTE: *A very muted colour palette was chosen for Kayem because Bandarin clothes are very rustic. Presentation images such as this are very useful if you are trying to sell your ideas to raise completion (or even start-up) funds.*

Artist: Ami Plasse

KARL & ROSCOE

MORE WISECRACKING THAN WISE

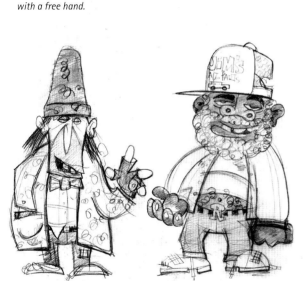

Quick sketches are essential building blocks in character development. More akin to doodles, you can do something similar while talking on the phone, watching television, or carrying out some other activity that doesn't fully engage your mind and leaves you with a free hand.

While this book concentrates on representing each archetype with a single character, there is nothing to stop you using two or more to fulfil the task. In certain cases the archetypal role can be more easily expressed as an event or by an inanimate object. It is this flexibility that makes using the mythical structure so useful. Although there is an understandable tendency to make the Mentor someone who is obviously filled with sage-like wisdom and respectability, using two halfwits (such as the ones on this page) can add an interesting dimension to the role and fulfil the Trickster function at the same time.

ROUGH STUFF: *Using an overall style already created during the development of the main character (see page 36) pencil sketches were made of the two tawdry sages that could be scanned and used as a template for redrawing in Adobe Illustrator.*

"KARL" and "ROSCOE"

Age: *"Old enough to know better" "and too old to care"*

Height: *"Got high from too many beers and can't stand up"*

Hair colour: *"Roscoe's the silver fox" "and Karl's looks black"*

Eye colour: *"Mostly red" "heh heh"*

Distinguishing marks: *"Roscoe's rather fine beard and" "Karl's very original hat"*

CHARACTERISTICS: Unkempt loafers with a penchant for dominoes, dried meat products and low-cost, malt-based, alcoholic beverages.

ROLE: They do odd jobs around the office and supply a steady flow of "street-corner wisdom" to Richie and the rest of the staff, but most of it is useless babble.

ORIGIN: They've been in front of the store for as long as anyone can remember.

BACKGROUND: They spent their days playing dominoes, listening to a scratchy, 30-year-old transistor radio and bickering in a constant flow of barely coherent rants. Richie, the newly appointed Absolute Dictator, hires them as caretakers, to complete the staff of his headquarters.

POWERS: "Karl smells powerful bad..."

ASSOCIATES:
Hero: Due to a clerical error Richie has just been wrongly appointed as Absolute Dictator of earth by a group of aliens. See page 36.

Shadow: Tech Guy fixes all the tech stuff, and likes listening to loud goth, punk and garage on tinny computer speakers. He is difficult with anyone he doesn't like – such as Karl.

ARE TWO HEADS BETTER THAN ONE?

The pairing up of characters is a well-tried-and-tested method of adding dynamism to a role. When we think of duos – other than singing ones – the great comedic pairings (Abbot and Costello, Laurel and Hardy, Tweedledum and Tweedledee) usually spring to mind. There are also a fair number of Heroes who have their ever-present sidekicks (Batman and Robin, Don Quixote and Sancho Panza), but it is rare for a Mentor to appear as a double act. One of the more interesting, and probably most difficult, aspects of creating coupled characters is developing believable dialogue, especially with witty repartee, bickering, or even the finishing of each other's sentences, that still manages to put across the requisite words of wisdom. A mixture of a fertile imagination and observation (including watching well-written movies or TV shows) should do the trick.

▶ OVER TO YOU

Create your own imaginary double act. They don't have to be funny or particularly wise, but they should be able to work as a single entity rather than two separate personalities.

MAGIC MARKERS: *Magic markers used to be the favoured tool of advertising visualizers and layout artists. Although they have become victims of digital tools, in the hands of an artist they can quickly produce an instantly recognizable style of illustration. Here we see Karl and Roscoe in action – if you can call it that.*

REALITY CHECK: *While judging someone by their appearance is not usually advisable, one would be right to doubt whether these two scruffy characters are capable of stringing two words together, let alone of delivering forth words of wisdom, yet somehow they do. It is possible that their grasp on reality is so tenuous that their skewed view of the world gives them insights missed by other more grounded people. Both characters were drawn and coloured in Adobe Illustrator, making them ideal for using in Flash animations or for printing at any size.*

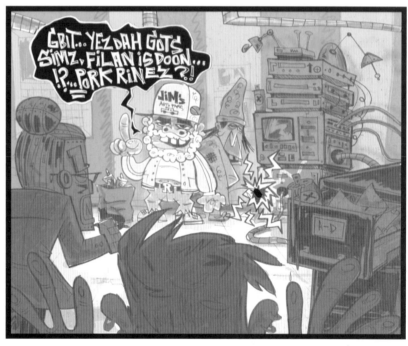

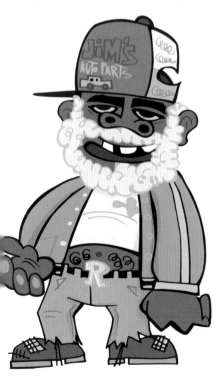

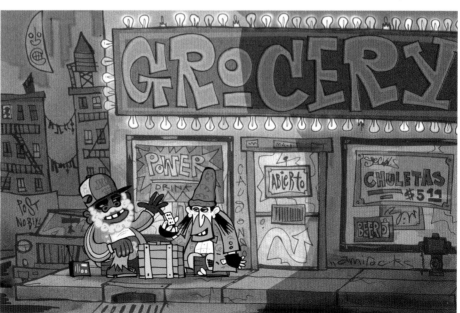

IN SITU: *A good way to establish the personality of a character is to place it in its natural environment. This picture tells us everything we need to know about the roots of the soon-to-be-employed janitors and unsuspecting Mentors.*

Artist: Jade Denton

KROLL

STICKS AND STONES

The Mentor's role is to offer counsel and wisdom to the Hero as he embarks on his adventure. Although the Mentor holds a prominent place in the life of the Hero, it is only during moments of crises that they appear. So what do they do for the rest of the time? Naturally, as the writer/creator, you have devised a whole back-story for them. However, as Mentors are often mystical beings it can be very hard to pin them down to anything specific, but they do have a life apart from that of advising your Hero. Most of them lead heroic lives of their own.

BODY-BUILDING: *Kroll is closer to being a Hero than a Mentor, and this is demonstrated in his physique. To portray this type of body accurately you would need to refer to body-building magazines, or visit your local gym. Through movies and other media we are quite familiar with extreme physiques so it is very important that they are drawn accurately: take your time as any anatomical irregularities will be obvious to your readers. Artistic license can be used to cover up a multitude of "errors".*

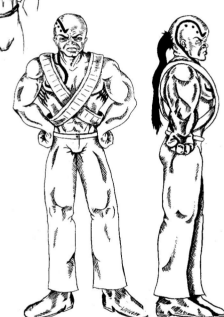

The character sheet is the best place to establish proportions and finalize the anatomical details you have been developing during the preliminary sketch stage.

 KROLL

Age: *42*

Height: *1.9 m. (6 ft. 4 in.)*

Hair colour: *not applicable*

Eye colour: *Brown*

Distinguishing marks: *Stylized dragon tattoo on head, neck and chest*

CHARACTERISTICS: Kroll is a tough fighter and mystic, a level-headed leader.

ROLE: Leader and Mentor to a small group of resistance rebels. Through his own actions and example he shows the younger fighters the way of a true warrior.

ORIGIN: Kroll's story is set on a small tropical island with a heritage of magic and mysticism.

BACKGROUND: Tribal warrior and healer, his land and people were taken over by mystic overlords. He then swore to return his princess to the throne and protect her with his life.

POWERS: Physical strength for hand-to-hand combat and a keen eye for deadly accuracy with knives. Uses mystical herbs, powders and stones to create explosions, and for healing.

ASSOCIATES:
Shadow: Black Ice joined his tribe after her family was killed. He taught her how to fight and survive, and also educated her in the local political systems. See page 98.

Shapeshifter: Byhalia is a shaman sorceress who visited Kroll in his dreams and taught him about the powers of mystical plants and stones. See page 90.

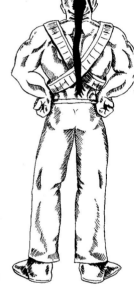

TOP MARKS *Apart from the physique, your characters are going to have idiosyncratic marks and accoutrements that set them apart as individuals. These can be simple, such as hairstyles and weapons, or more sophisticated, like costumes. A major character should have something to make it recognizable.*

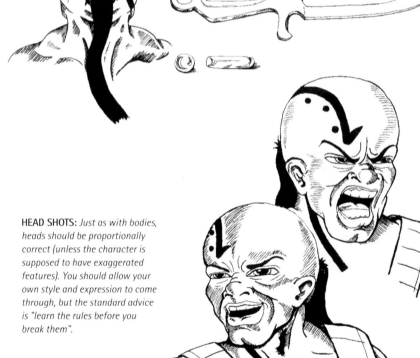

HEAD SHOTS: *Just as with bodies, heads should be proportionally correct (unless the character is supposed to have exaggerated features). You should allow your own style and expression to come through, but the standard advice is "learn the rules before you break them".*

OVER TO YOU

Devise a protagonist Mentor character. Look at all the different possible types – teachers, martial arts masters, shaman – or go against type and use a housewife or disabled child. Wisdom is not dictated by form. Once you have created the character, look for a satisfactory way to tell the story.

Even if your comic is going to be produced in black and white you will still need to work on some colour images for covers. Establish a palette for the character and even a colouring style. You don't have to rigidly adhere to it but it will serve as a useful guide. An annotated colour version of the character sheet is a good idea.

MENTOR AS WARRIOR

Teachers, sages, gurus and all-round masters of the esoteric: Mentors make fascinating protagonists, even though their story won't strictly follow the mythical story structure because they should have already made the life-altering journey that qualifies them as Mentors. But, as was shown on page 48, they don't always make that journey. If you want to use a Mentor character as your protagonist you should adapt your stories so that he or she is challenged in their tasks. If they spend the whole story just dispensing words of wisdom you will soon lose your readers. If you make them a leader/warrior type, like Kroll, then there will be battles to fight and the chance for them to test their knowledge. Alternatively you can create stories about the people the Mentor encounters or who seek their wisdom. There is no doubt that Mentor archetypes make for great stories; it's just a matter of choosing the right approach.

Artist: Simon Valderrama

SWORDMASTER

A CUT ABOVE

Apart from comics and animation, one other area needing strong archetypal characters is computer games, and RPG (role-playing games) in particular. These are essentially interactive stories, usually involving a quest. Early versions were made up of drawings to set the scene, and text to play the game. As computer technology advanced so did the games, developing into the 3D marvels we see today. Yet despite the technological advances, a captivating story with intriguing characters and gameplay is still a core requirement.

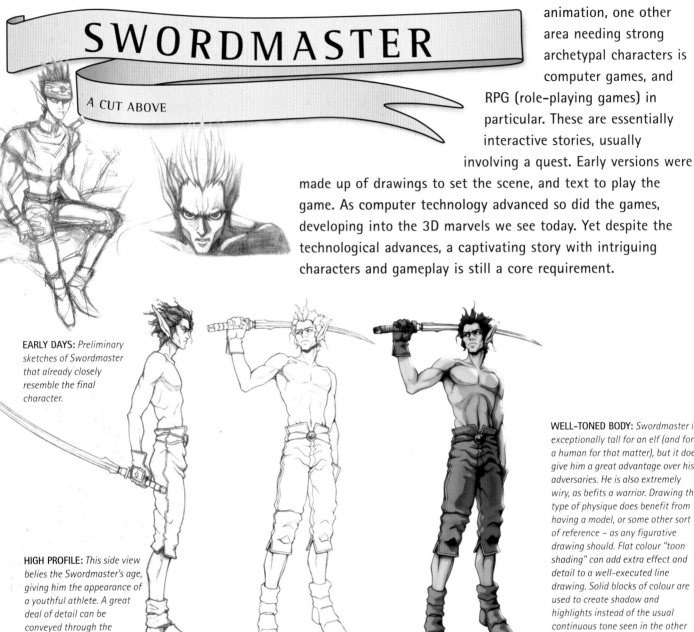

EARLY DAYS: *Preliminary sketches of Swordmaster that already closely resemble the final character.*

HIGH PROFILE: *This side view belies the Swordmaster's age, giving him the appearance of a youthful athlete. A great deal of detail can be conveyed through the economic use of line.*

WELL-TONED BODY: *Swordmaster is exceptionally tall for an elf (and for a human for that matter), but it does give him a great advantage over his adversaries. He is also extremely wiry, as befits a warrior. Drawing this type of physique does benefit from having a model, or some other sort of reference – as any figurative drawing should. Flat colour "toon shading" can add extra effect and detail to a well-executed line drawing. Solid blocks of colour are used to create shadow and highlights instead of the usual continuous tone seen in the other pictures on this page.*

 SWORDMASTER

Age: *210 years*

Height: *2 m. (6 ft. 6 in.)*

Hair colour: *Dark grey*

Eye colour: *Dark grey*

Distinguishing marks: *Elongated proportions— ears and limbs; sword*

CHARACTERISTICS: Reclusive; intense and fanatical but with a good heart; great sense of honour.

ROLE: To teach Liel the way of a warrior, including martial arts.

ORIGIN: Unknown.

● **BACKGROUND:** Outcast from the pacifist elfin society, Swordmaster lives in the forest on the edge of the village. He is the only one who still maintains the martial arts and honour system of the ancient elfin warriors.

POWERS: Extremely fast, appears to defy gravity with his movements: unmatched skill with a sword.

● **ASSOCIATES: Hero:** Liel, the daughter of an elf and a human, feels like a misfit in elf society and becomes the Swordmaster's disciple after a series of extraordinary events.

● **Herald:** Syin is the mother of Gon, Liel's friend, who introduces her to the Swordmaster. Syin leaves food and clothes for the Swordmaster, as he is too proud to accept them as a gift.

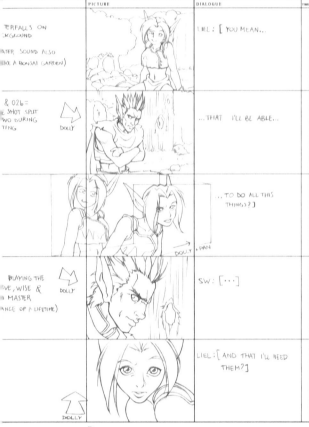

STORYBOARD: *This storyboard shows some of the dialogue from the initial encounter with Liel and the Swordmaster. It also shows animator's notes, sound directions, and "camera" directions. Detailed storyboards are vital for animated films as the luxury of retakes or experimenting with camera angles is practically impossible.*

OVER TO YOU

Once you have written a character profile (using the guidelines given on page 12) start making sketches that will best portray the character's personality and idiosyncrasies. Make drawings in several poses that you consider typical. Now show them to someone and see if they can describe the character's personality correctly.

NOW THE HEAD LINES:
Clearly defined line work is the secret to producing a top-quality coloured image, and this is why the inker's job is so important. He or she has to understand which areas are to be coloured and keep them free from ink or tone.

CLOSE TO HAND: *A detail of the Swordmaster's gloved hands and weapon. The forest depths are captured in strong contrasts between the dark tones of the shadows and the luminosity of the highlights and reflections. The artist's experience with 3D texture-mapping and shading is visible in the sword's blade.*

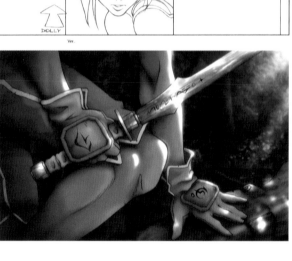

RAISING THE TONE:
Because Photoshop is simply a tool – albeit a very sophisticated one – the results are dictated by the user's abilities. Producing naturalistic tones without sacrificing the structure of the line takes lots of practice, and a graphics tablet. At least working digitally gives you plenty of chances to correct your errors without sacrificing the original line work.

GENOCIDE

Genocide is an in-development anime RPG about elves, centred on the adventures of Liel, a young, feisty, half-elf girl. A series of animations were created to introduce the characters and their background, and to advance the story during the game. A great deal of information about the characters has to be relayed in these short interludes, so a complete understanding of their roles is vital. One way to achieve this is through the writer's method of "showing, not telling", where information is imparted through the characters' actions and reactions rather than through long, explanatory dialogue. Though much of this task is down to the writer, the character's physical appearance can also provide a lot of clues to its personality and history. This is the domain of the artist, who has to work symbiotically with the writer to produce the desired effect.

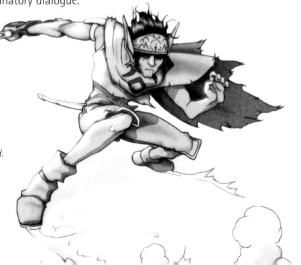

BACKSLIDING: *The Swordmaster demonstrating his skills and speed. His lithe physique makes him extremely agile and capable of performing almost impossible feats, such as this.*

Artist: Wing Yun Man

WING

LITTLE ANGEL, BIG HEART, BIGGER RESPONSIBILITY

Angels are useful entities to work with. As divine beings they seem to have a direct connection to the source of all things archetypal, from Hero angel (X-Men's Archangel) and those singing Heralds we have to hark to every Christmas, to the troublesome fallen ones that cause so much chaos in the world (or at least get blamed for it). Then there are the ever-popular guardian angels that protect and guide the Heroes. The generally accepted role of an angel is that of a messenger (*angelos* is Greek for messenger), and because they are bringing those messages from the divine, they make ideal Mentors.

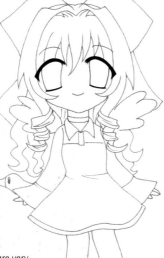

KEEP IT SIMPLE SKETCHES: *The simplicity of the chibi-style drawing gives plenty of freedom for making quick sketches in all sorts of poses.*

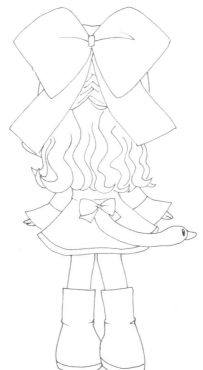

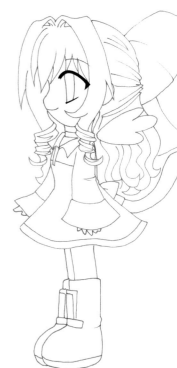

MODEL CHILD: *Chibi characters are very simple in design and usually have an oversized head and huge eyes, with other facial features (nose, mouth) kept to a minimum. Characters are drawn using similar proportions to those of small children (approximately four heads in height).*

● **WING**

Age: *14*

Height: *1.4 m. (4 ft. 7 in.)*

Hair colour: *Black*

Eye colour: *Aqua*

Distinguishing marks: *Little wings, swan's head bow on her dress*

CHARACTERISTICS: Kind-hearted and patient.

ROLE: Acts as the conscience for Lollipop and has to teach her right from wrong.

ORIGIN: She was sent to Baka Town to watch over Lollipop but can't remember from where.

● **BACKGROUND:** Wing has to teach Lollipop right from wrong and how to use her powers for good. If she is successful at this she will become human again. Unfortunately she has to contend with Kuro Mizard's bad influence on Lollipop, which is sometimes more than she can cope with.

● **POWERS:** Good and kindness.

● **ASSOCIATES**

Hero: Lollipop is Wing's charge whom she has to protect from Kuro Mizard's bad influence and teach right from wrong. See page 28.

Trickster: Kuro Mizard is Lollipop's pet and hat, and loves getting her into mischief. He also tries to protect her from the trouble he causes.

WINGS ACROSS THE WORLD

Historically angels are not limited to one religion or culture. They appear in many forms and many equally different roles, so adapting one as an anime character is well within the bounds of acceptability (not that you are likely to get a visit from the angel's union if it wasn't!). The general consensus is that angels are ethereal beings without form, so they can appear in a shape with which the viewer is most culturally comfortable, or the one that will have the most impact. Keep this in mind as you design your angel character, and try to avoid making them too complicated. Remember that angels seem to be assigned specific functions (angel of mercy, angel of wisdom, angel of death, and so on). The character Wing has to guide her charge, Lollipop, and teach her right from wrong, which in itself appears to be more than enough for her to cope with. For a more complex angel, see page 100.

For a more complex angel, see page 100.

▶ OVER TO YOU

If angels are to be part of your story do some research into the subject, even if just from an anthropological or historical viewpoint. You should be able to find a wealth of material that will help you to develop all types of interesting characters.

FILLING IN THE GAPS: *Getting the most expression from as few lines as possible is part of the art of working in this format. Our minds fill in the missing details when we see a picture reduced to its most recognizable basic elements.*

THE EYES HAVE IT: *Apart from humour, chibi anime are known for their extremes of emotion. The eyes are critical in demonstrating this, as is the mouth, which can be no more than a single line.*
Extracting the subtle nuances of expression from that line can take a lot of practice.

CUTE APPLIES: *Then it's back to the cuteness that appeals so much to young girls.*

SUPER DEFORMED: *With its oversized head and eyes, and lack of a nose, this style is sometimes – for obvious reasons – called "Super-Deformed" (SD). When portraying emotions these features are further exaggerated.*

CHIBI STYLE: *Wing and the other characters from the series (see pages 28 and 96) are drawn in the anime style known as "chibi" (Japanese for small or child) because the characters are very childlike in appearance. Cuteness and humour are an essential part of the genre. The cel-shading technique, using large areas of flat colour, emphasizes the simplicity of the style.*

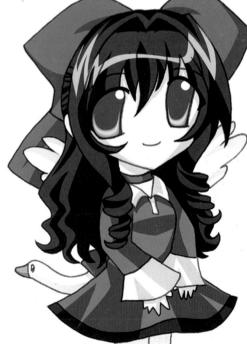

THRESHOLD
GUARDIANS

Threshold Guardians are obstacles – whether corporeal or internal – that the Hero must overcome during his journey. The corporeal Guardians can, literally, be gatekeepers, soldiers of the enemy put in the path of the Hero to test his resolve, even if they are not aware of that function. How many times in films have you seen "flunkies" posted at the doors of clubs where the "bad guys" are doing "business"? To vanquish them the Hero has to resort to either cunning or brute force.

Whereas muscle may be easy to defeat, internal obstacles are harder for the Hero to overcome. These internal Guardians are also the ones that will help him grow the most. A Hero has to be fallible; he has to have weaknesses or he would never embark on "the journey". What set the original Marvel superheroes apart were their defects and idiosyncrasies. The reader could identify with them because of their humanity. Spider-Man had to battle Peter Parker's neuroses just as much as he had to fight Dr. Octopus et al. These subtle Guardians are the hardest to portray visually, requiring a combination of facial expressions and internal dialogue to convey the Hero's fears and doubts.

When creating characters to represent Threshold Guardians don't always go for the obvious solution of muscle-bound thugs, but try other options. Make them underhanded and ruthless, cunning and vicious, or even beautiful femmes fatales. One enduring image from Greek mythology, for example, is that of Odysseus, tied to the mast of his ship, being tortured by the sirens' voices.

OSIRIS
The tamarisk tree enclosed a coffer containing the body of Osiris, the Egyptian god of the underworld, who had been put there by his vengeful brother Seth in order to usurp Osiris's position.

CYCLOPS
Not the one from *X-Men* but the original one of Greek mythology, from the epic poem, *The Odyssey*. The Hero, Odysseus, and his men were imprisoned by Polyphemus, the Cyclops, and only escaped when Odysseus made him drunk, and put out the giant's eye with a burning stake.

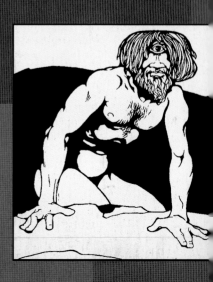

Devise different ways of portraying obstacles on the Hero's path. Will human/animate ones work better than inanimate/natural phenomena? Which will benefit the story best and help the Hero to grow?

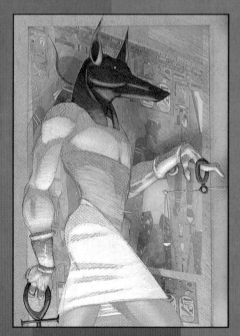

ANUBIS
Jesus Barony
As the assistant to Osiris, it was Anubis' duty to attend funeral preparations to weigh the heart on the scale of justice, and judge whether a person's deeds on earth were good or bad, thereby deciding their fate.

Apart from confrontation, the Hero can use another tactic to overcome the Guardian, and that is by making him (or her, or it) an ally. Undercover police use this technique: by befriending a gang member they are able to get to the leader. Using this method the Hero will temporarily become a Threshold Guardian in order to overcome – but not destroy – the obstacle.

For the purpose of storytelling you can also make Threshold Guardians out of animals, natural phenomena (such as rivers and trees), or inanimate objects (such as cliffs or boulders) – anything that challenges the Hero's path.

When devising this role for your story, look for creative solutions that avoid the obvious. Try using opposites. If you think a big bruiser is what you need, will a slim, attractive woman do the same job? Rather than physical strength can the Guardian be endowed with psychic powers? Maybe the Guardian can win his first encounter with the Hero. All these storytelling devices will influence your design decisions.

There may be occasions when you have created a character but don't know what to do with it – you just know it looks good. Why not give it the personality traits of the Threshold Guardian to make the life of your Hero just that little bit more unpleasant?

Whatever form you decide to create for this archetype, remember that the Hero must not just be tested by the Threshold Guardian; he must also learn something from the experience.

OBSTACLES ON THE WAY
Natural phenomena such as boulders and rivers can serve as challenges to the Hero's resolve. Any sort of physical or mental obstacle can represent the Threshold Guardian.

LANCELOT
Simon Valderrama
It was the betrayal of Lancelot's affair with Guinevere that brought about Arthur's downfall.

Artist: Ruben de Vela

GEVORA

THE DEVIL IS IN THE DETAILS

Sometimes a character can be developed out of a single concept. In the case of Gevora, it started with an idea for a piece of magical armour. From there the history of the armour, and how the character came to own it, was envisaged. Out of this his personality and role were generated, along with his physical characteristics and the other attributes that would make him into a useful and believable character in the story, in this case a Threshold Guardian.

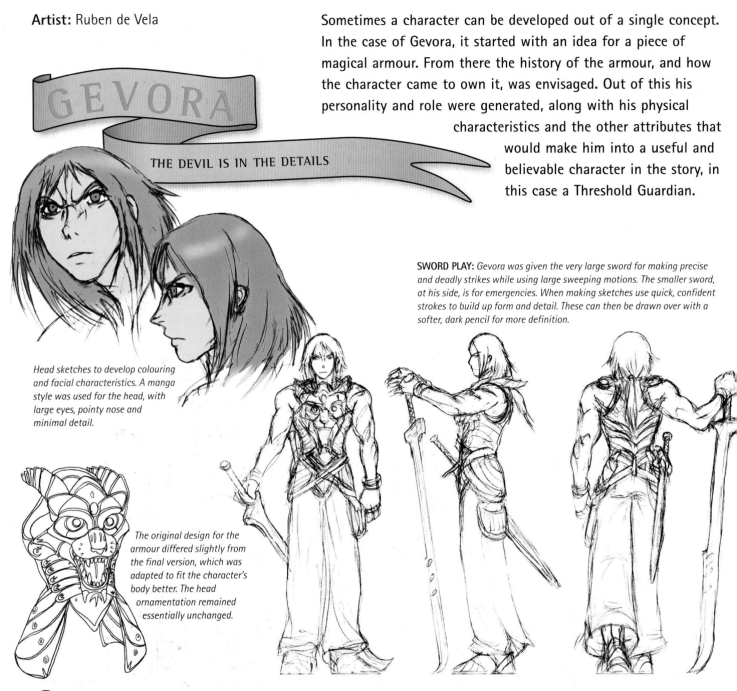

Head sketches to develop colouring and facial characteristics. A manga style was used for the head, with large eyes, pointy nose and minimal detail.

SWORD PLAY: *Gevora was given the very large sword for making precise and deadly strikes while using large sweeping motions. The smaller sword, at his side, is for emergencies. When making sketches use quick, confident strokes to build up form and detail. These can then be drawn over with a softer, dark pencil for more definition.*

The original design for the armour differed slightly from the final version, which was adapted to fit the character's body better. The head ornamentation remained essentially unchanged.

 GEVORA

Age: *17*

Height: *1.8 m. (6 ft.)*

Hair colour: *Copper*

Eye colour: *Green*

Distinguishing marks: *Lion tattoo on back; claw-mark scars on left arm*

CHARACTERISTICS: Ferocious and fearless warrior; arrogant, volatile and wild.

ROLE: Defends the overlord from being attacked by the story's Hero.

ORIGIN: Ancient Far East Asian country.

● **BACKGROUND:** Swordsman and junior officer in the army of an evil overlord. He was badly wounded when ambushed by a demon. On defeating the demon its energy was transferred into Gevora's armour, which took on the appearance of the demon.

● **POWERS:** His ruthless fighting abilities stem from the demon's powers embedded in the armour, making him almost invincible. This power is very volatile and he is not always able to control it. It makes him arrogant, and also susceptible to weakness and loss of focus.

● **ASSOCIATES:**
Herald: Gevora's fiancee, Areljascha, was captured Gevora's master, to serve as his concubine, who was unaware that the warrior would stop at nothing to rescue her.

Shadow: Although the demon was defeated by Gevora its subtle form still manifests behind the armour and controls Gevora.

Although it is usual to build your story around the Hero/protagonist, working "backwards" from another character, such as this one, can produce interesting and often surprising results. Because fiction writing is often a nonlinear process it is possible to work in this way, but make sure you keep your work well organized on index cards, or with a dedicated story-outlining software.

BUILDING THE CHARACTER

The design for Gevora started with the drawing of the armour. If you commence with a core idea you can build the character around it. If you have a clear idea of how it will look make lots of pencil sketches and even a model sheet to show the character from different positions, to get a complete all-round view. You can change this later, but it will give you a solid starting point. The more sketching you do the more confident your line work will become, and clarity of ideas will also bolster your drawing confidence.

OVER TO YOU

Create an object as a starting point for a character. Decide on an archetype (preferably not a Hero) and its role, and develop a character. Build up a story around this character without making it the protagonist or Hero.

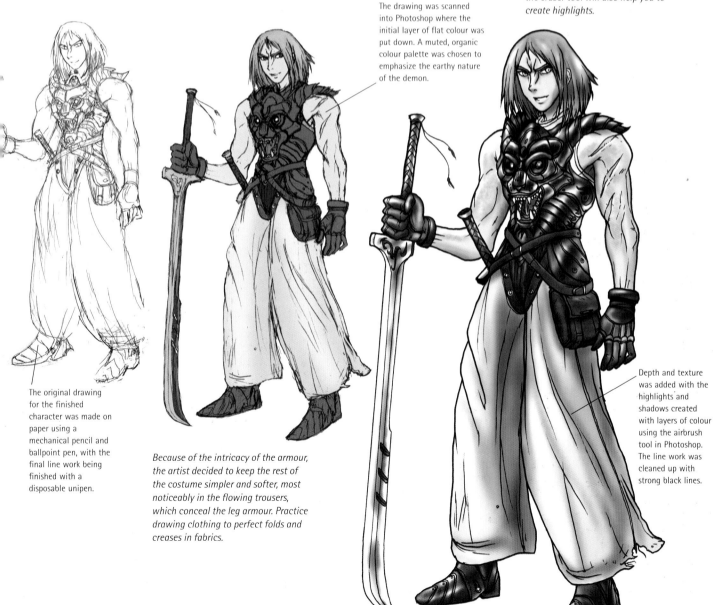

The completed character in full demonic combat regalia. To speed up the colouring process, create a palette of colours (called Swatches in Photoshop) that you will be using for the whole character. Using the eraser tool will also help you to create highlights.

The drawing was scanned into Photoshop where the initial layer of flat colour was put down. A muted, organic colour palette was chosen to emphasize the earthy nature of the demon.

The original drawing for the finished character was made on paper using a mechanical pencil and ballpoint pen, with the final line work being finished with a disposable unipen.

Because of the intricacy of the armour, the artist decided to keep the rest of the costume simpler and softer, most noticeably in the flowing trousers, which conceal the leg armour. Practice drawing clothing to perfect folds and creases in fabrics.

Depth and texture was added with the highlights and shadows created with layers of colour using the airbrush tool in Photoshop. The line work was cleaned up with strong black lines.

FANSIGAR

A DEMON WORKER

Artist: Duane Redhead

The popularity of the television series *Buffy, The Vampire Slayer* and its spin-off *Angel* have brought to life the worlds and alternative dimensions of demons for millions of people. The shows' creator and writers developed their own mythologies, not just for vampires but also for urbanized demons. Just as *Men in Black* created a world where aliens coexisted with humans, *Buffy/Angel* did the same for demons. Although Joss Whedon, the shows' creator, may not have been the first to introduce the concept, he was responsible for popularizing it.

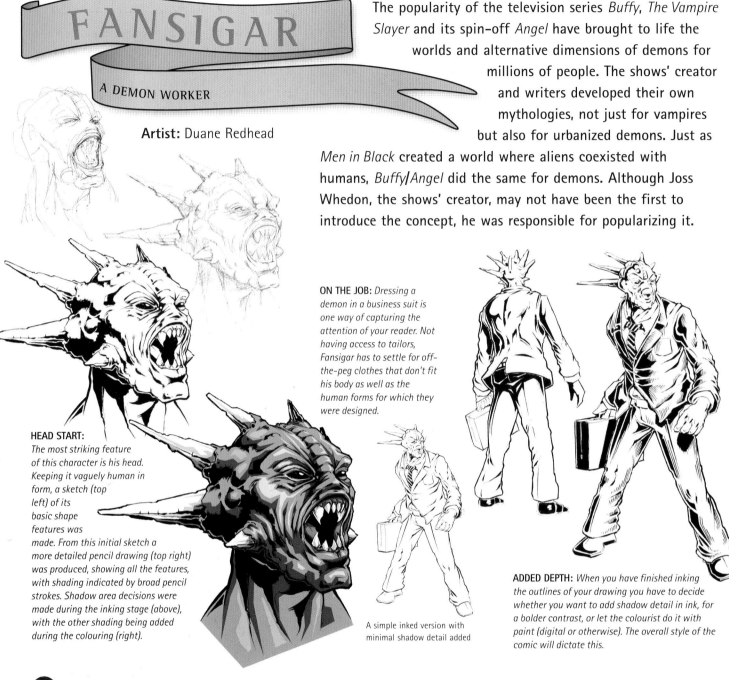

ON THE JOB: *Dressing a demon in a business suit is one way of capturing the attention of your reader. Not having access to tailors, Fansigar has to settle for off-the-peg clothes that don't fit his body as well as the human forms for which they were designed.*

HEAD START:
The most striking feature of this character is his head. Keeping it vaguely human in form, a sketch (top left) of its basic shape features was made. From this initial sketch a more detailed pencil drawing (top right) was produced, showing all the features, with shading indicated by broad pencil strokes. Shadow area decisions were made during the inking stage (above), with the other shading being added during the colouring (right).

A simple inked version with minimal shadow detail added

ADDED DEPTH: *When you have finished inking the outlines of your drawing you have to decide whether you want to add shadow detail in ink, for a bolder contrast, or let the colourist do it with paint (digital or otherwise). The overall style of the comic will dictate this.*

 FANSIGAR

Age: *723 (human) years*

Height: *1.9 m. (6 ft. 4 in.)*

Hair colour: *Cream-coloured horns*

Eye colour: *Black*

Distinguishing marks: *Eight horns and a mouth full of fangs*

CHARACTERISTICS: Fearless and obedient. Loyal (to the highest bidder), but only serves one master at a time. Different moral code to humans allows him to perform acts others wouldn't consider.

ROLE: Currently employed as a courier and general bodyguard for a firm of underworld accountants.

ORIGIN: Stentor, a demon dimension.

BACKGROUND: Stentorians are pan-dimensional travellers, who enter the human world looking for work. They usually only work for criminals, lawyers and occultists though they have been known to work in nightclubs. They take their payment in salt, a highly prized commodity in their world.

POWERS: Physical strength; armour-like skin is impenetrable to human weapons as it has to withstand moving between dimensions; voice capable of reaching a debilitating volume and pitch.

ASSOCIATES:
Herald: Raksas liaises between the Stentorians and their human clients. He is multi-lingual and a ruthless negotiator who always gets what he wants.

Trickster: Squabbo was born with soft skin so is unable to travel into the human world, but insists on wearing human clothes. His lack of understanding of humans makes him the brunt of jokes.

COMIN' AT YA: *Action poses can say a lot about your character. One such as this will probably require photographic references for the pose, or can be created using a program such as Poser or Daz Studio. Of course – depending on your ability to visualize – you can draw it from memory, though getting the proper perspective can be a challenge*

OVER TO YOU

▶ If you want to develop characters/stories based around demons, watching episodes of *Buffy/Angel* is a great place to start.

▶ When creating your own demons (on paper) try to juxtapose opposing ideas, or just go for extremes.

A more detailed sketch to establish perspective

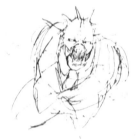

A quick sketch to establish viewpoint

A sketch concentrating on the folds and movement of the cloth

Cleaned-up pencil sketch ready for inking

SPAWNING IDEAS

One of the side effects of that level of media success is the confidence it gives to other artists and writers to create their own characters, and not simply to license or adapt existing stories. It has also opened the way for the creation of demons that are not only not evil but also carry on an existence often as mundane as that of many humans, including having to wear a suit and tie. While anybody who wears a suit and tie may seem (to some!) either alien or demonic, the story possibilities to be derived from inventing demons that lead quotidian lives, or blending them into other genres, are endless. What crime lord wouldn't like to have an unstoppable demon as their bodyguard?

Creatures – such as the one shown here – can also be used for exploring issues such as prejudice and racism (specism?), where ferocious appearances belie the peace-loving vegetarians beneath. It's also worth investigating parallel dimensions, or simply the possibility that there are diverse beings living in our world of whom we are unaware.

Apart from all the story possibilities, you can let your imagination run wild in devising their appearance. Demons with human traits – physical and mental – seem more believable than aliens with similar attributes, especially when you look at the diversity of creatures on our own planet.

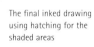

The final inked drawing using hatching for the shaded areas

Artist: Ziya Dikbas

Though the role of a Threshold Guardian is to hinder the Hero in getting close to their goal, it is usually a minor part in the whole story and is sometimes played by another character, or even portrayed as a flaw in the Hero himself. Taking the idea of an archetype literally can produce larger-than-life characters with a story of their own.

T-GANNA

QUIET VOICE, BIG STICK

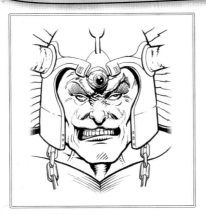

This close-up is of T-Ganna's face when he is about to expel the demon, disguised as Nathan.

MIXING THE MYTHOLOGY

T-Ganna was developed to be part of a traditional-style mythological tale, involving the exploits of imaginary divine personalities. Inspiration was taken from the great traditions of Norse and Hindu religious mythology, Arthurian and samurai legends, with a bit of sci-fi thrown in to give it a modern flavour. For example, the name T-Ganna comes from that given to the Hindu god Shiva's attendants and soldiers. Their leader Ganesha, the elephant-headed boy god, was created to protect the goddess. With this in mind, the character was created with the head-to-height ratio of a child, but with heroic width. The helmet shows Norse influences, while the armour resembles that of a samurai.

EARLY COSTUME: *Shown right, this early version of the character was modified to produce the final form. Many changes are purely intuitive, while others are carefully rationalized to make the character work better. Whichever way you do it the decision is yours and, as evidenced in many comics, there is nothing to stop you changing aspects at a later date.*

FIRST IDEA: *A preliminary sketch working on the physique and armour of the character, using blue pencil.*

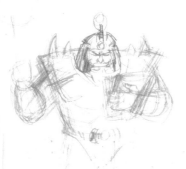

 T-Ganna

Age: *Immortal*

Height: *2.3 m. (7 ft. 7 in.)*

Hair colour: *Bald*

Eye colour: *Dark brown*

Distinguishing marks: *Size, horned helmet, the Staff of Light*

CHARACTERISTICS: Imbued with wisdom, sensitivity, and discrimination. Possesses an overwhelming dedication to duty.

ROLE: To protect the Golden City and its creator, Atha-Veera, by preventing evil entities from entering the city.

ORIGIN: Integral part of the divine being, he was created as part-machine and part-organic body; a sort of cosmic Robocop.

BACKGROUND: The reason for his existence is to protect the Golden City from evil forces.

POWERS: Armed with The Book of Sight and The Staff of Light he is able to see through any disguise into the heart of all beings. His armor, besides offering

protection, is equipped with sensors that let him feel the negative energies of malevolent beings from great distances. His armour also has power-assisted joints for greater strength and speed.

ASSOCIATES:
Mentor: Atha-Veera not only created the Golden City from her heart, but also T-Ganna to protect it. She is the source of all his power.

Shadow: Nathan is a vehicle for a demon intent on destroying the Golden City. The demon was hoping the innocence of a child would make it easy for him to gain entry but had not counted on T-Ganna's powers.

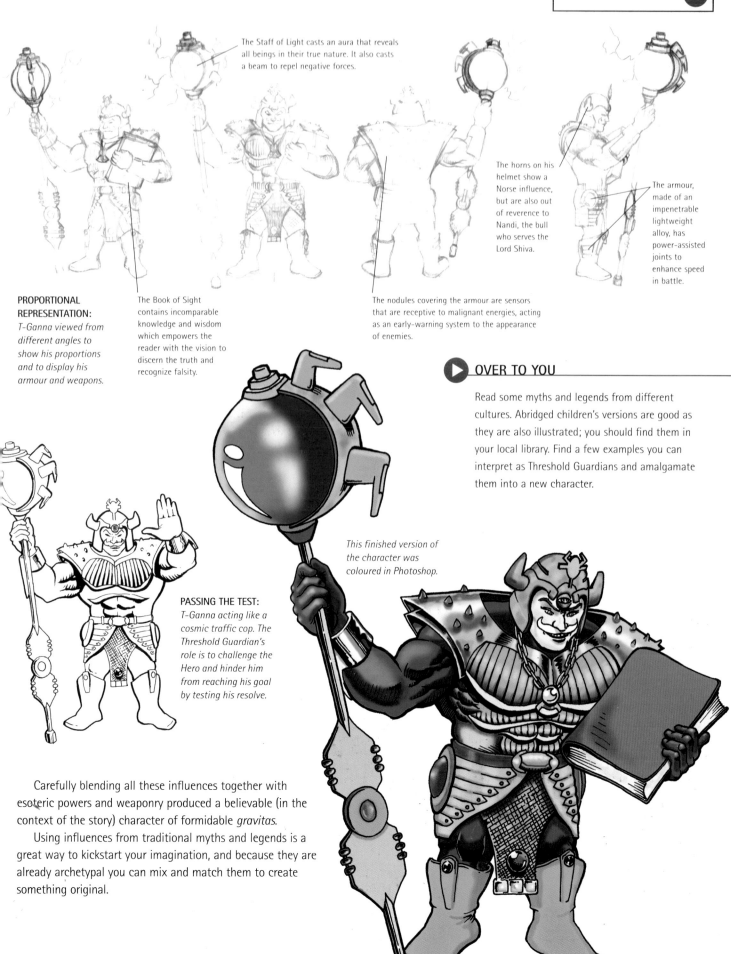

The Staff of Light casts an aura that reveals all beings in their true nature. It also casts a beam to repel negative forces.

The horns on his helmet show a Norse influence, but are also out of reverence to Nandi, the bull who serves the Lord Shiva.

The armour, made of an impenetrable lightweight alloy, has power-assisted joints to enhance speed in battle.

PROPORTIONAL REPRESENTATION:
T-Ganna viewed from different angles to show his proportions and to display his armour and weapons.

The Book of Sight contains incomparable knowledge and wisdom which empowers the reader with the vision to discern the truth and recognize falsity.

The nodules covering the armour are sensors that are receptive to malignant energies, acting as an early-warning system to the appearance of enemies.

▶ OVER TO YOU

Read some myths and legends from different cultures. Abridged children's versions are good as they are also illustrated; you should find them in your local library. Find a few examples you can interpret as Threshold Guardians and amalgamate them into a new character.

PASSING THE TEST:
T-Ganna acting like a cosmic traffic cop. The Threshold Guardian's role is to challenge the Hero and hinder him from reaching his goal by testing his resolve.

This finished version of the character was coloured in Photoshop.

Carefully blending all these influences together with esoteric powers and weaponry produced a believable (in the context of the story) character of formidable *gravitas*.

Using influences from traditional myths and legends is a great way to kickstart your imagination, and because they are already archetypal you can mix and match them to create something original.

Artist: Shaun "Swampy" O'Reilly

CELESTE

WARRIOR PRINCESS

If fantasy and/or science fiction are your preferred genres, then there's a good chance that at some time you are going to want to create a gratuitously sexy warrior princess, if for no other reason than to satisfy the yearning to do so. Although – physically – they are (very) three-dimensional, it is easy to fall into the trap of making the character one-dimensional. A lot of this is to do with gender bias. A female artist will have quite a different interpretation to a male artist; the latter's ideas will be influenced by his age and experience. The ideal is to create the characteristics first and then build a body around them (but as the appearances are market-driven you will probably end up with a stereotypical look anyway).

LIFE: *Whenever possible, make sketches from life. Get your friends to pose for you. This will teach you to work quickly, as they probably won't be able to sit still for as long as a professional model.*

SHOULDER PADS: *The shoulder pads attach to the neck armour and are decorated with reliefs of vampire skulls.*

COLLAR: *This neck and shoulder armour was designed to protect the neck.*

BODICE: *Custom-fitted metal bodice to protect her vital assets (no Kevlar vest this!).*

ARM ARMOUR: *Doubles as a weapon with the addition of a claw-fingered gauntlet.*

 CELESTE

Age: *27*

Height: *1.8 m. (5 ft. 10 in.)*

Hair colour: *Black*

Eye colour: *Yellow*

Distinguishing marks: *Very ornate armour*

CHARACTERISTICS: Fearless warrior with vengeance in mind.

ROLE: To destroy the Blood Saviours and protect the Warriors of Christ.

ORIGIN: Celeste was born in 1034, to the second cousin of the king of Finland, and raised in the family castle.

BACKGROUND: In 1045 her family was killed by invading Russians. She went to live with her uncle, Hubert of the North, leader of the Warriors of Christ, an order of vampire hunters. He trained Celeste as a warrior. During an attack by the Blood Saviours, a rival group of religious warriors, Celeste was bitten by the vampire Riccoan, who turned her into a vampire, before she killed him. Celeste escaped and organized an army of vampires to mete out revenge on the Blood Saviours.

POWERS: Strength and immortality of a vampire.

ASSOCIATES:
Threshold Guardians: Blood Saviours are kitted out for fighting vampires. These formidable warriors are the fanatical front-line of their order.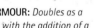

Shadow: The Crimson Mask is one of the oldest blue-blood European vampires. Time and the demonic powers channelled through his body have twisted it into a hideous and inhuman shape. It is said that the mere sight of his face can kill a man.

MORE ARMOUR THAN AMOUR

Having surrendered to the temptation to create a fighting fantasy female, you will have to design a suit of armour that accentuates the bodacious body you have produced for her. Unfortunately this will inevitably end up as a totally impractical means of protection in battle. But when it comes to women's clothes, practicality is often sacrificed at the expense of appearance.

Just because you are dealing with fantasy realms, it doesn't mean you can't blend in some reality. You can't design armour that would obviously restrict the character's ability to move or fight; however, you can invent reasons as to why a centrefold lookalike is able to wear over 100lb of metal costume yet still move as if she's wearing a body stocking.

SWORD: *The all-important weapon of choice for removing the heads of enemy vampires, again featuring the skull motif.*

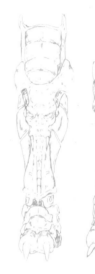

▶ OVER TO YOU

Make your characters as sexy as you want, but remember you do have a responsibility to them (and to your readers) to make them believable.

BOOTS: *The metal boots were presented to Celeste by two grateful artisans who created their own individual designs that still featured the vampire skulls.*

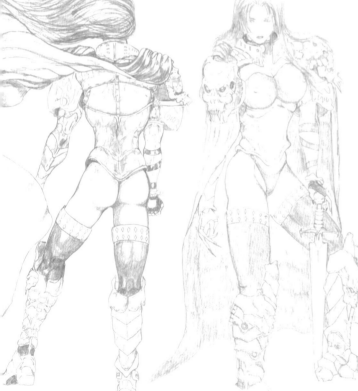

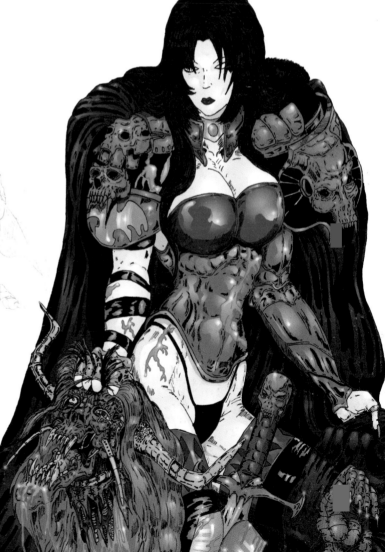

PENCIL SHADE: *Despite the advances in digital tools, a pencil is still the best tool for drawing. The tactile and organic nature of the medium is far more expressive than any computer alternative. When producing drawings for comics, pencil shading should be avoided on images that need inking. Simple cross-hatching will work better than "colouring in".*

REALITY CHECK: *Fantasy realms should conform to practical realities as much as possible, such as the very sensitive area left unprotected by armour in the picture above left. Historical and geographical elements should also be considered – even for the undead. For example, how does a vampire survive in the land of the midnight sun? Is a tanga bikini practical during the dark months in the Arctic Circle?*

Artist: Jon Sukarangsan

DROPSHIP EARL

ILLEGAL ALIEN

Working with aliens is an interesting exercise as there is a general tendency to endow them with human traits, be they physical, mental or emotional. This practice, known as anthropomorphism, is also applied to animals in cartoons and to real-life domestic pets. With animals there are agreed and observed patterns of behaviour that can be incorporated into the character to retain some of their "animalness". Aliens are another matter: not only is their existence debatable, but also very few people can claim to have seen, let alone studied, them (excluding Area 51 of course). These human attributes are vital for the purpose of storytelling, and ascribing archetypal roles to aliens makes the task a little bit easier.

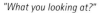

"What you looking at?"

ON THE MOVE: *Earl on the move. Making a variety of sketches of such alien creatures in motion will help you when it comes to working on finished productions.*

LEAP OF FAITH: *An early design sketch showing Earl preparing to make one of the powerful leaps for which his race is famous.*

AN OFFICER AND A ... *A sketch of Earl before he became an outlaw, wearing a commander's ceremonial uniform and carrying a sceptre of his office. Drawings like these help establish a character's history even if they are not used in the final project.*

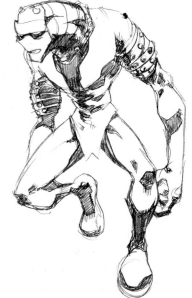

ID: *DROPSHIP EARL*

Height: *2.5 m. (8 ft. 4 in.)*

Hair colour: *n/a*

Eye colour: *Green*

Distinguishing marks: *Speckled rainbow pattern on back of neck*

CHARACTERISTICS: Ruthless and cunning, a wandering pirate known for wrecking entire space fleets with the aid of his motley intergalactic gang.

ROLE: Earl leads a band of 100 outlaws. Motivated by greed and self-interest, he is not averse to mercenary activities against the Federation.

ORIGIN: Earl is from the planet Deskarta, a harsh world of constant war and violence. He served as Lt. Admiral in the Deskarta Royal Armada during the six-year civil war, where he developed his thirst for combat and bloodshed.

BACKGROUND: Served as an officer in the Universal Federation Police but was stripped of his rank for using extreme violence against a large group of nonviolent protesters – he landed his battleship on top of them, thus earning the name "Dropship". After his demotion he left the service to pursue a career as an intergalactic pirate.

POWERS: Earl is a master in the art of Jussaka, the use of curved blades. Deskartans, with their large hands, exhibit enormous grappling strength and their powerful legs give them the ability to jump distances of up to 25.5 m. (80 ft.).

ASSOCIATES:
Hero: Jamie Ladd works for the Universal Federation. Her sister was one of the protestors killed by Earl's ship and she is determined to bring him in.

Trickster: Parker is a test-tube parrot that lives on Earl's ship. It is always causing trouble by repeating things it shouldn't and usually in the wrong ears.

Natural armour plates protect the soft neck which can be withdrawn for protection.

HEAD AND SHOULDERS: *A study of the character's head and neck, working on details for the final image.*

GRIPPING STUFF: *It takes a lot of practice to get unusually proportioned anatomy looking believable and functional. You can even try drawing a skeletal model for reference.*

Studded bands for decoration

Huge hands are used for wielding Jussaka swords, punching and grappling objects and enemies.

Powerful leg muscles allow Deskartans to jump great distances, assisted by strong arms.

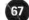 **OVER TO YOU**

Check out the natural history or biology section of your local library or museum for ideas. The insect and deep-sea worlds contain some particularly weird and wonderful creatures that could be used as the basis for an alien.

SIDE VIEW: *A detailed profile drawing of the final creature.*

ARMED TO THE TEETH: *Completed design with Jussaka blade. The enormous hands and powerful legs are clearly evident. The armour and long neck bear a resemblance to a tortoise.*

FORM AND FUNCTION

One of the principles of good design is that form and function have to work together. When designing aliens you don't suffer all the constraints facing industrial designers, but there are still many things to consider. Matching the physique to the personality will depend on what exactly your creation does. Opposites are a tried and tested route, with scary monsters being soft and kind-hearted (think *Monsters Inc.*) or cuddly ones being decidedly evil (*Gremlins*). Decades of sci-fi films and comics have explored myriad possibilities, but there is still plenty of scope for original ideas. Nature can provide a wealth of inspiration. Our planet supports many bizarre creatures, some of which are almost outside the bounds of imagination, with an existing biology to boot. Whatever you create, make sure its physical functions are logical.

HERALDS

The Herald plays an important role in mythical structure because he is the one who literally makes the announcement known as the "Call to adventure". The Herald can take many forms and be incorporated into other archetypes, and vice versa. He inspires the Hero not only to start his journey, but also to continue it.

As with the Threshold Guardian, the Herald can be an event, rather than a person. If you make your Herald human or animal you will have to create the type of character that can fulfil the role of messenger and motivator, and also companion.

Historically, Heralds were the protocol officers to knights and royalty. They kept track of lineage and coats of arms, but also acted as messengers between combating parties, usually relaying the challenges. In Greek mythology Hermes (Mercury in Roman mythology) is the best-known Herald, and has become symbolic of messengers. For the Hindus, Hanumana (the monkey god) epitomizes the Herald. Hanumana was both Rama's messenger and his faithful servant, and also had a great sense of humour typical of the Trickster archetype (see page 106). Though the Herald's central role is to give the message that drives the Hero into the initial action, he can play an integral part in keeping the Hero sufficiently motivated to carry on with his quest. During the development of your story, you can make your Herald one of the pivotal or main characters. A love/ romantic interest is always a good place to start – Superman's Lois Lane and Spider-Man's Mary Jane were often motivating forces for these superheroes.

HERMES, PANDORA AND EPIMETHEUS
In Greek mythology, Hermes was a messenger from the gods, as well as a guide to travellers, a protector of boundaries, a helper of heralds and speakers, and a bringer of good or unexpected luck.

COATS OF ARMS
Heralds were the ones that traditionally bore the flags and coats of arms for knights and the aristocracy, to announce their arrival. This is the derivation of the term heraldry, the design of coats of arms.

HANUMANA
The Hindu monkey god was the messenger of Lord Rama. He also announced, to the demon Ravana, Rama's arrival to save his captive wife. Hanumana is also known as a trickster.

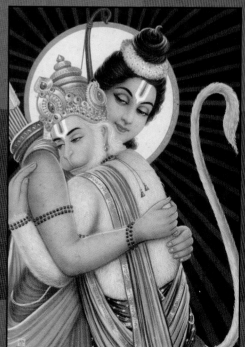

▶ Make a list of events that could trigger your Hero into action.

▶ Consider different ways a message could be delivered. Think about alternative messengers and their relationship with the Hero.

Other partner roles can also serve the Hero to keep him motivated. Frodo's Sam in The *Lord of the Rings* is a prime example (although some may argue that Sam was the Hero). The partner can often act as a grounding force to temper the Hero, as Sancho Panza did in *Don Quixote*, acting as an emissary between the real world and the Hero's quest.

When creating your Herald bear all these options in mind. The initial "Call to Adventure" may even be delivered by another character, such as the Mentor, but it is still up to the Herald to maintain the Hero's motivation. The "Call" may also originate with the Herald but be delivered through another medium such as letter or computer, like Trinity's message to Neo in *The Matrix*. Trinity is another fine example of a motivating force for the Hero.

Making your Herald an attractive female is a soft option, so look at other ways to keep your story and characters more interesting and original. For example, try making the Herald an event – such as a murder or kidnapping – that drives the Hero on his path, the memory of the event being the motivating force. The defining event will be somewhat dictated by the setting and genre of your story, and does not have to be violent. Love is a great motivator.

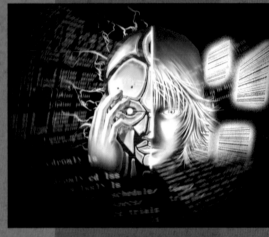

RAIMI
Andrew West
In the story of the Broken Saints it is Raimi, the computer nerd, who discovers the all-important message that sends the story's four heroes on their quest.

SANCHO PANZA
Don Quixote's companion is promised the governorship of a conquered isle for helping in the quest. Panza's role is to try and maintain the reality of Quixote's imagined heroic quest.

MAKING ANNOUNCEMENTS
The herald's announcements can be in any form, depending on the place and context of your story, with the written by far the most common.

Artist: Emma Vieceli, Sweatdrop Studio

When you create your own mythological tales the roles of archetypal characters are easily and clearly defined, even without any knowledge of the theory behind the structure. Neissus's part in the manga story of Dragon Heir was important to the story's development, making him the perfect Herald to set the Hero on her journey.

NEISSUS

BINDER OF THE DRAGON SPIRITS

THREE FACES OF NEISSUS: *Three different aspects of Neissus: (left to right) cloaked and hooded when travelling among people; in usual travelling mode; and in his true form as the spirit binder, as revealed to the dragon spirits.*

DRESS REHEARSAL: *An early experiment where a headband was used to hide the spirit sign on his forehead when in public. This was eventually changed to a hooded cloak.*

S FOR SYMBOLISM: *Detail of the embroidered S, representing Spiratu, on Neissus's clothing.*

CLASSIC LOOK: *His features are not only influenced by classical mythology, but also by those of elves. The femininity of his looks was used to express the anima.*

The sign of the Spirit Binder

EXPRESSIVE LINES: *Exploring moods and emotions through facial expressions is an important aspect of working in the manga style. Experimenting with economy of line work will help maintain authenticity.*

 NEISSUS

Age: *Unknown*

Height: *1.7 m. (5 ft. 9 in.)*

Hair colour: *Blonde*

Eye colour: *Blue*

Distinguishing marks: *Sign of the "spirit binder" on forehead*

CHARACTERISTICS: He is a spirit in a mortal shell, graceful and somewhat unreal. It is said that "he does not simply walk this world, he wears it".

ROLE: To take into himself the four different, fully matured dragon spirits from their mortal vessels and transport the unified dragon's soul back to Spiratu's Hall of the Beasts.

ORIGIN: A spirit binder, from the spirit world of Spiratu, incarnated into human form.

BACKGROUND: His mission to reunite the four separated parts of the dragon spirit at the Ritual of Transcendence is doomed to failure so he has to take Ella, a mortal who bears the "worker spirit", as the key bearer, to help return the dragon spirit to its rightful place.

POWERS: To collect and conjoin disparate spirits and transport them in his body.

ASSOCIATES:
Hero: Ella, the key bearer, who has to complete his mission should he fail. See page 38.

Herald: Nute is a mage spirit who lives with her tribe in the barren lands. She joins the four spirit heirs and helps them on their quest.

USING SYMBOLISM

Another aspect of stories using mythological structure is the use of symbols. The characters themselves are symbolic representations of the archetypes. Items within a story are often given symbolism. In "real world" stories these can become slightly obscure, or subject to different interpretations, just as dreams are. In fantasy myths the symbols can be given clear meanings that are easily explained within the context of the story. These can be simple motifs, like the embroidered "S" on Niessus's clothes which represents Spiratu, the spirit world from which he comes, or the mark on his forehead that designates his role. Other symbols can be subtler, with story events reflecting and giving meaning to events in life, such as the unification of the individual spirit with a greater one. These are all themes explored in the Dragon Heir story.

NEW ROMANTIC: *Being a messenger from the spirit world, Neissus was designed to have an unreal, mystical presence. His look was influenced by classical Greek and Roman mythology, with a dash of Renaissance.*

THIN BLUE LINE: *The initial blue line drawing showing some of the underlying construction used to build the figure.*

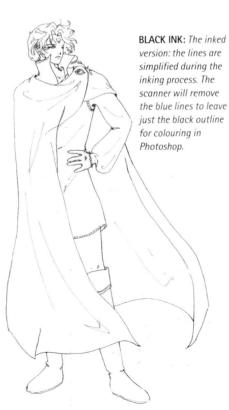

BLACK INK: *The inked version: the lines are simplified during the inking process. The scanner will remove the blue lines to leave just the black outline for colouring in Photoshop.*

▶ OVER TO YOU

Look at symbols and find ways to incorporate them into your stories. Include physical ones such as amulets or weapons, and subtle ones such as morals. Try disguising them in backgrounds and scenery. You can even make them obscure to keep your readers guessing as to their meaning.

LONG LEGS: *Just as large eyes are a recognizable feature of manga characters, so are long legs – and Neissus is no exception.*

COLOUR COVERAGE: *The Dragon Heir manga is printed in black and white, but this coloured version uses the flat cel-shading colours favoured by anime artists. Muted and pastel colours were chosen to convey a sense of peace.*

Artist: Nic Brennan

When developing background stories for your characters you have to do the same for their environment, especially if it is fictional. Setting your tale in an existing place requires some research to ensure accuracy, but with invented countries you have to supply not only history, but also geography, sociology, religion, economics and every other subject you should have studied at school.

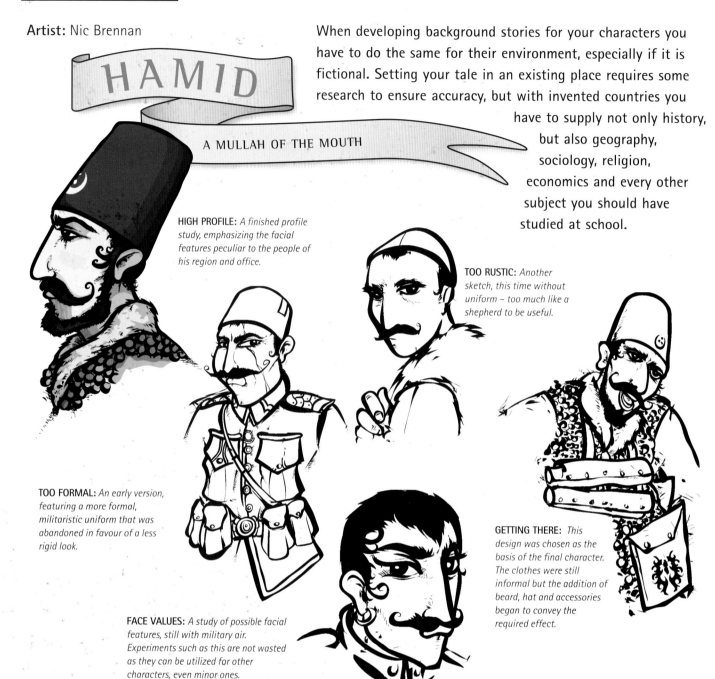

HAMID

A MULLAH OF THE MOUTH

HIGH PROFILE: *A finished profile study, emphasizing the facial features peculiar to the people of his region and office.*

TOO RUSTIC: *Another sketch, this time without uniform – too much like a shepherd to be useful.*

TOO FORMAL: *An early version, featuring a more formal, militaristic uniform that was abandoned in favour of a less rigid look.*

GETTING THERE: *This design was chosen as the basis of the final character. The clothes were still informal but the addition of beard, hat and accessories began to convey the required effect.*

FACE VALUES: *A study of possible facial features, still with military air. Experiments such as this are not wasted as they can be utilized for other characters, even minor ones.*

HAMID KABIR

Age: *34*

Height: *1.7 m. (5 ft. 9 in.)*

Hair colour: *Black*

Eye colour: *Brown*

Distinguishing marks: *Lantern fixed to back, scrolls and books of holy texts*

CHARACTERISTICS:
Fearless messenger of the faith. Inspirational orator.

ROLE: To carry messages and orders from the Sultan and spread the word of God. To inspire the people.

ORIGIN: Lives in Karkistan, a nation spanning from Eastern Europe in the north to the Middle East in the south, during the early part of the twentieth century.

BACKGROUND: As a member of the Holy Order, he was picked to become a messenger because he feared only God. Originally these messengers served as runners carrying state missives, but later they were used to spread the Faith to common people and inspire the troops of the Holy War. They came to be known as the Mullahs of the Mouth, the Agas of Word, and the Heralds of the Faith.

POWERS: Unflinching faith in God. All members of the order were holy warriors that lead the troops to glory, inspired by words of fire from the Holy Book and the courage that came from the faith that God was standing beside them.

ASSOCIATES:
Hero: Alga, a freedom fighter from one of Karkistan's southernmost territories, who is inspired by Hamid's words.

Trickster: Adham is a street urchin who makes trouble for the mullahs by stealing their scrolls and through other sorts of mischief. Grows up to be the Hero of the story.

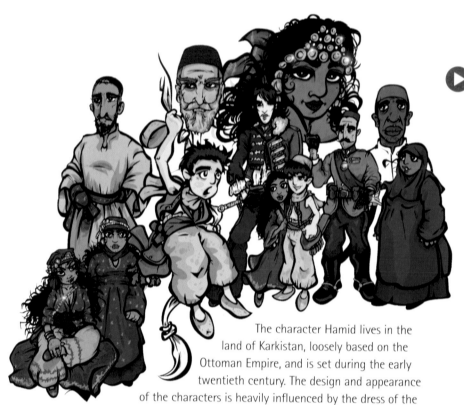

The character Hamid lives in the land of Karkistan, loosely based on the Ottoman Empire, and is set during the early twentieth century. The design and appearance of the characters is heavily influenced by the dress of the time, but the history is completely invented.

IT'S IN THE CARDS

To keep all the background stories and other information consistent, sheets similar to the character profile (see page 12) are useful for cross-checking details. Writing details on index cards and pinning them to a board is another option, using coloured strings to show how the characters are related or connected. There are dedicated writing and mind-mapping software programs that can help with this as well. The more complex your story, the more important it is to spend the time creating a strong back-story. There is an old proverb that says, "When doing a day's wood-chopping, spend the first seven hours sharpening the axe". In other words, the more preparation you do, the easier your work will be.

In developing Hamid, Nic Brennan not only created a back-story for the character but also for the order he belonged to, complete with legends and eyewitness accounts. It is this sort of attention to detail that will help raise your work beyond the ordinary. Just keep in mind J. R. R. Tolkien's epic invented legends and mythology.

LOCAL STYLE: *To help develop the atmosphere of the era, a drawing of the character was made in the contemporary artistic style. Details like this are important in establishing a sense of place. Creating symbols and other unique features is also useful.*

▶ OVER TO YOU

Choose a country and period of history that holds a fascination for you, and create your own country based upon it. Develop a character who acts as an emissary for that country, and start building a story around him/her.

CAST OF CHARACTERS: *Working up pictures is great practice for presenting your characters and also for establishing the overall look of the project. Colour palettes, wardrobe, and drawing styles all have to be considered before the work on the final project goes ahead.*

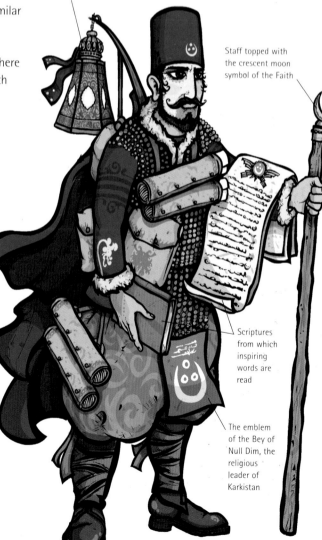

HERALD OF THE FAITH: *Hamid in full regalia, bearing all the accoutrements of his order.*

Lantern used for reading scriptures in the dark and for guiding soldiers

Staff topped with the crescent moon symbol of the Faith

Scriptures from which inspiring words are read

The emblem of the Bey of Null Dim, the religious leader of Karkistan

PIPER

WHO PAYS, CALLS THE TUNE

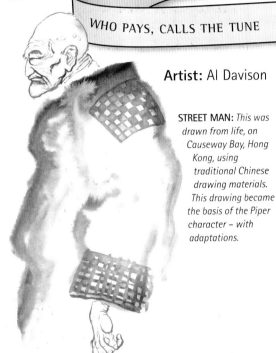

Artist: Al Davison

STREET MAN: *This was drawn from life, on Causeway Bay, Hong Kong, using traditional Chinese drawing materials. This drawing became the basis of the Piper character – with adaptations.*

Inspiration for characters and stories can come from anywhere, providing you keep your eyes and mind open. Travelling is a great way to expand the mind, as even the mundane becomes new and exciting. In a foreign country a homeless person can stimulate ideas, while at home they would be ignored or avoided. Whilst in Hong Kong, artist Al Davison saw a homeless old man scavenging for food. He started sketching him. After some time the old man stopped his search and started practising Tai-Chi-Chuan in the street. Fascinated, Al continued sketching. Later he saw the old man chopping firewood with his bare hands. This led Al to devise the character Piper.

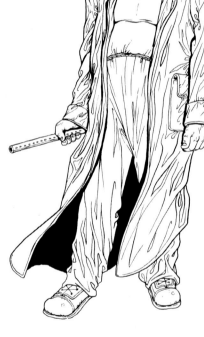

LIFE LINES: *A good knowledge of anatomy (to portray accurate bone and muscle structure) is required to create such a lived-in face. One would have difficulty finding a life model from which to draw (though some of the faces seen on commuter transport come close). Apart from gaining experience through life drawing, a book on constructive anatomy for artists is invaluable and there are many excellent ones available from Dover Books.*

IN THE MOOD: *Colour can change the impact and emotional response of a drawing. Compare your reactions to the original line version and this coloured one. When working on your own drawings take this into consideration.*

PIPER

Age: *Not certain*

Height: *1.9 m. (6 ft. 4 in.)*

Hair colour: *Ash blonde*

Eye colour: *Green*

Distinguishing marks: *Always wears long padded coat and carries a flute; scary eyes*

CHARACTERISTICS: Compassionate, fearless, altruistic and a deadly killer.

ROLE: To rescue children from a life of crime and teach them how to fight it. Also acts as a Mentor.

ORIGIN: Born in Hong Kong, he was adopted by the crime family that killed his parents, without ever discovering how they died.

● **BACKGROUND:** His adoptive family trained him to be a hit man. He had his own code of honour that would not allow him to kill the parents of children. He was tricked into breaking his code and for revenge he kidnaps the children of the gangsters and trains them to fight against organized crime.

● **POWERS:** Master of aikido and karate. Expert hypnotist who can mesmerize people with his flute.

● **ASSOCIATES:**
Hero: Kazuo is the son of a gang leader, who was raised and trained by Piper and is dedicated to the battle against the crime family.

Herald: Flack is a young Jamaican woman who was the daughter of a drug baron. Piper had her trained as a computer hacker to help in his cause.

ADOPTION AND ADAPTATION

Adopting the characteristics he found most striking – the anonymity of homelessness and martial arts – and combining them with the fundamentals of a traditional tale (*The Pied Piper*) inspired a new story about a homeless hitman.

Travelling to the other side of the world is not cheap, but visiting a neighbouring state may offer enough cultural diversity to get the creative juices flowing. Observation is the important thing, and something to record what you see – a camera or sketchpad.

▶ OVER TO YOU

Keep a sketchbook/scrapbook of interesting looking people you see and write notes alongside your drawings. When you have a good selection, take one of your favourite childhood stories, preferably a traditional classic, and insert one of your sketched people into it.

ON THE BEAT: *Your story is all about action. In animation this is easy to achieve at varying levels; in comics it has to be alluded to using still images. Poses at peak moments of an action work best, such as the one shown here. The arm holding the bamboo flute is at its apex, just before it starts its downward swing. The addition of lines along the edge of the flute also infers movement. Perspective has to be taken into consideration, as does movement in the folds of the cloth.*

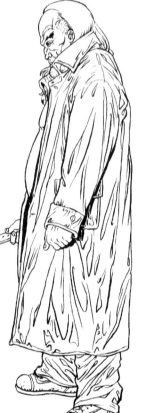

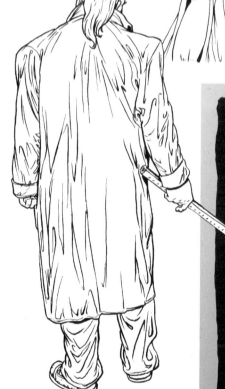

WALK AROUND: *Three views of Piper – front, side and rear – that capture his appearance. As well as hands, some of the most difficult things to draw convincingly are folds and creases in clothes, material and, worst of all, skin. Piper's dishevelled look relies on these creases that have to be created with pen strokes. Observation and lots of practice are the best ways to improve.*

MONOTONE: *Because of the amount of detail in the inked drawing, large areas of flat colour using an almost monochromatic palette could be used to great effect. To take this pin-up image beyond looking like a simple screenprint, highlights such as the sweat stain, red nose and blackened eyes were added to bring it to life. Experiment with your use of colour (easier if you use digital paint).*

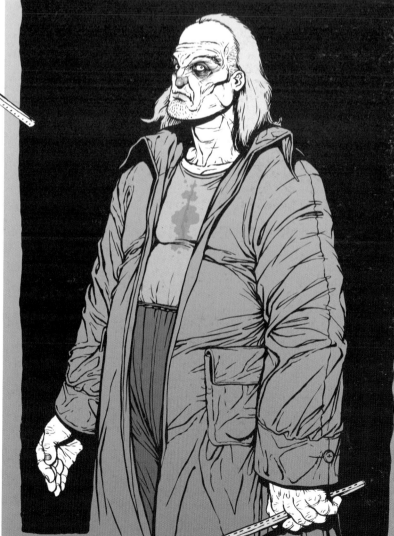

Artist: Thor Goodall

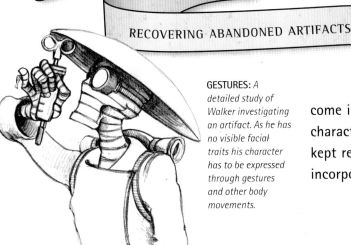

RECOVERING ABANDONED ARTIFACTS

Post-apocalypse stories are very popular with sci-fi and comics writers because they provide a clean slate on which to work. Freed from the constraints of existing cultural heritages and mythologies, the writer can create new ones, allowing the development of strong archetypal characters. Much of the creative process associated with devising these characters is little more than doodling, but out of these musings come ideas and personalities that can be fleshed out. This character was a refugee from previously abandoned stories, who kept recurring in the artist's sketches, so he built a new story to incorporate him.

GESTURES: *A detailed study of Walker investigating an artifact. As he has no visible facial traits his character has to be expressed through gestures and other body movements.*

TURNING JAPANESE: *These early pencil sketches show the essence of the finished character, but he looks more like a Japanese samurai than an archeologist.*

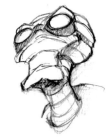

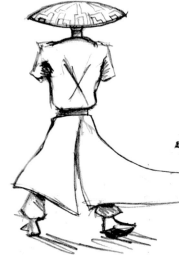

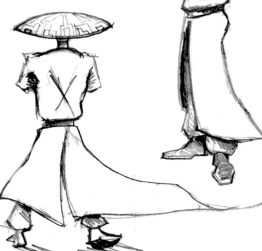

IT'S A WRAP: *Sketches and studies exploring Walker's appearance. The bandages protect his skin from the intense sunlight of the almost ozone-free atmosphere, and are the artist's homage to the Egyptologists and the mummies they discovered. The dark goggles are used to protect his eyes from the sun and sand.*

● WALKER

Age: *27*

Height: *1.8 m. (5 ft. 10 in.)*

Hair colour: *Blonde*

Eye colour: *Pale blue*

Distinguishing marks: *Bandages, aviator goggles, large samurai-style hat*

CHARACTERISTICS: Loner. Very observant and inquisitive. Insatiable thirst for knowledge and water. Not entirely fearless.

ROLE: Searches the desert looking for clues of previous civilizations to take back to his fractured community, who aren't always interested in his discoveries.

ORIGIN: Born some time in the future when most of the planet has been reduced to desert.

● **BACKGROUND:** Lives in a strange, arid land, through which he wanders, looking for artifacts from which residual DNA might be extracted. He calls himself an "arkecologist", a name his parents teased him with as a child, before they disappeared during a sandstorm. He once discovered a long cavern buried beneath the sands showing a symbol of a red circle with a line through it, on which was written, in ancient script, London

● Underground. He now uses it as a lab for experimenting with the DNA he finds.

POWERS: Able to walk for great distances in the desert heat and sand. Very acute eyesight allowing him to find objects. Has created mutant hybrids from DNA.

ASSOCIATES:
Trickster: Robot is his sidekick/butler who carries all the heavy equipment

● and is given to making snide comments about his master to no one in particular.

Shadow: The Captain is from the government's special force whose job it is to stop anyone digging up the past and questioning their version of history. Mostly he wants to stop Walker's DNA experiments.

REWORKING OLD IDEAS

You will often find that inspired ideas or truly archetypal characters will reappear as you work. It may be worth taking the time to explore the possibilities they present. Considerations such as a character's archetypal role are not important at the early stages; this will develop naturally as the story unfolds. Here Walker is presented as a Herald, with his discoveries marking the beginning of an adventure. Whether he is working for the story's Hero, or whether he is the Hero and the discovery itself represents the Herald, is all part of the development process.

▶ OVER TO YOU

Go through your files (you do keep your old scribbles, right?) and find a character you have abandoned but still find interesting. Try putting it in a new setting, or changing its role slightly. Appearance and personality aren't always connected, which is one of the reasons for working with archetypes.

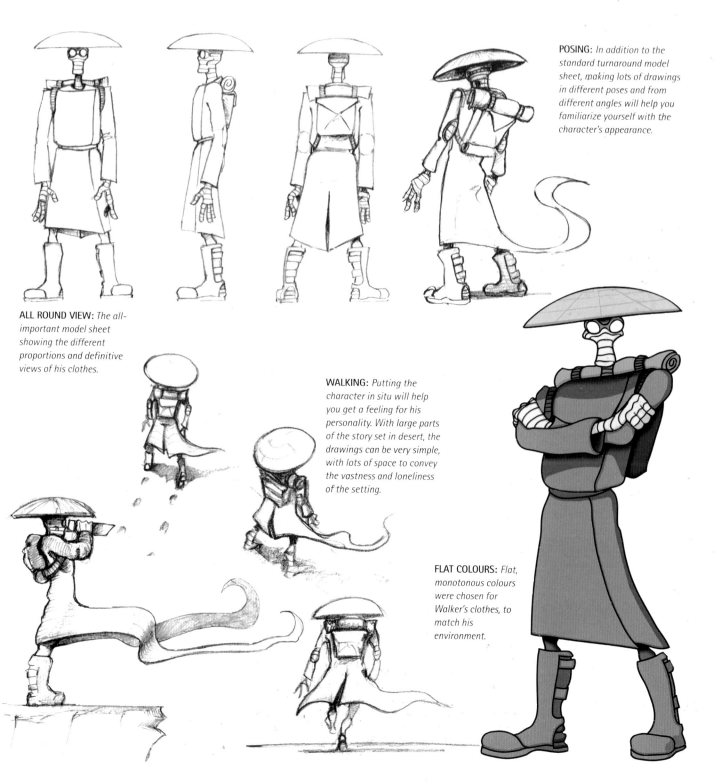

POSING: *In addition to the standard turnaround model sheet, making lots of drawings in different poses and from different angles will help you familiarize yourself with the character's appearance.*

ALL ROUND VIEW: *The all-important model sheet showing the different proportions and definitive views of his clothes.*

WALKING: *Putting the character in situ will help you get a feeling for his personality. With large parts of the story set in desert, the drawings can be very simple, with lots of space to convey the vastness and loneliness of the setting.*

FLAT COLOURS: *Flat, monotonous colours were chosen for Walker's clothes, to match his environment.*

Artist: Alistair Cade (CFCA)

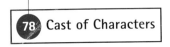

BLACKWING

THE AVENGING ANGEL

For animators, collaboration and teamwork are vital for the completion of a project. The sheer volume of work involved in producing the thousands of drawings that go into even a short film requires a group with clearly defined roles, from lead animators to in-betweeners, clean-up artists, inkers and painters. Though the advent of digital workflow has reduced the amount of labour, it has also removed many of the previous specializations, with one person now carrying out many of the tasks on a single computer. Comics, likewise, often divide the work between two or three specialists. Well-established characters and titles often have different artists working on different stories, and others creating covers.

SKETCHBOOK: Building your character through constant sketching is definitely your best approach. Practise drawing different poses and parts of the body will also improve your skills. Choose the parts of the body you find most difficult (which for most people are hands and torso) and draw them using photos, life models, or from memory. Practice really does make perfect.

SMELLS LIKE TEAM SPIRIT

There are many practical reasons for this division of labour in comic production, primarily the speed at which the pages can be created. While most artists are capable of producing the story and the images through every stage, from pencil to the finished coloured pages, a publisher will often delegate the jobs to those artists strongest in a particular discipline. This ensures the best quality work is produced within the deadlines. Another advantage of this teamwork is that you are interacting with other people. Ideally there should be a sense of mutual respect for each other's talents, with no animosity or lofty ideas about the importance of one role over another. With so much work being done digitally these days, and the ubiquity of broadband, it is now possible to collaborate with artists in other parts of the country or even the world (though this does remove the social aspect of working in a larger studio).

ID: *BLACKWING (Marc Robbins)*

Age: *27*

Height: *1.9 m. (6 ft. 1 in.)*

Hair colour: *Black*

Eye colour: *Black*

Distinguishing marks: *Black wings on his back, fire in his eyes*

CHARACTERISTICS: Devoutly religious, but with a lust for vengeance.

ROLE: To mete out revenge on those who killed his father, and on those responsible for his mutation.

ORIGIN: Australia.

● **BACKGROUND:** Wrongly imprisoned for the murder of his father, Marc Robbins found solace in the Bible while in prison. As a reward for good behaviour he was given a day-release job as a cleaner at a nearby genetic research and development facility. Under the auspices of project leader Dr. Rudolf Darkolff, Marc is smuggled out of prison and becomes the subject of unethical human/animal DNA transmutation experiments, which spiral out of control.

● **POWERS:** Flight, incredible strength, destructive vision.

ASSOCIATES:
Shadow: Dr. Rudolph Darkolff abducted Marc Robbins and made him the subject of an unethical human/animal DNA transmutation experiment that transformed him into Blackwing.

● **Shapeshifter:** Razorback was another test subject in the same institution that created Blackwing. He was involved in earlier, less refined, experiments that produce more bestial results. Razorback also survived the cataclysmic destruction of the laboratories, but his future is likely to be less noble than Blackwing's.

FIGHTING WORDS: *Another interpretation of Blackwing, with pencils and inks by Paul Abstruse, and colours by Katarina Knebl. These types of artwork will often take an overview of the character and mix it with symbolism to create images that establish the persona rather than relate the story.*

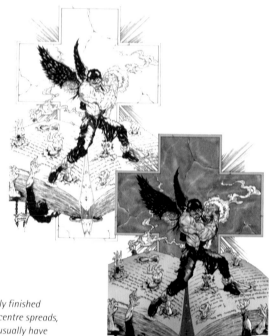

PIN-UP: *Pin-up pictures are highly finished images that are used for covers, centre spreads, or advertising/posters. They will usually have more detail than normal comic pages, as well as the use of graduated colour instead of flat colour or the more commonly used black and white. Different artists will do their own interpretations and versions of a character. This is sometimes known as fan-art, and is where most working artists start. This image was drawn by Alistair, inked by Khosnaran Khurelbaatar, and coloured by Chad Layer.*

▶ OVER TO YOU

▶ Get together with your comic-creating friends and talk about the possibility of collaborating on a title. Discuss each other's strengths and weaknesses before deciding who will do what, and make sure everyone is happy with their role.

▶ Watch Kevin Smith's film *Chasing Amy*, which has some humorous scenes portraying the tensions that can develop between a penciller and an inker working together on the same title.

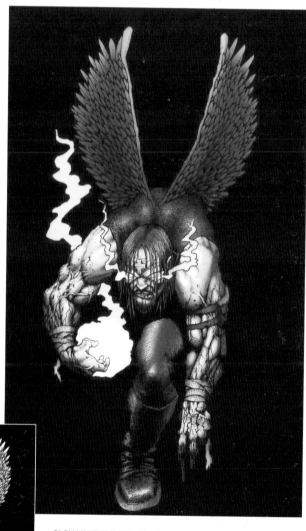

GLOW IN THE DARK: *The darker nature of the character is fully portrayed with the use of heavy shadows, vengeance burning in his eyes and hand. This pin-up, pencilled and inked by Khosnaran Khurelbaatar, with colours by Chad Layer, shows the advantages of working in a team.*

SHAPESHIFTERS

Shapeshifters are interesting characters to create because of their ability to change form. You can experiment with a variety of looks while concentrating on a single personality. Of course, a Shapeshifter is a more complicated character than someone who can simply alter their physical appearance. At the most basic level are those like Mystique from the *X-Men* stories, who can transform into a perfect replica of another person or mutant, but the function of the true Shapeshifter is more complex.

At a subtle level the Shapeshifter represents what Carl Jung called the "anima" and "animus", that is the female part of the male unconscious and the male part of the female unconscious, respectively. These are the parts of the psyche that help us to understand (or not) the perceived complexity of the opposite gender. An understanding of this concept is a useful tool in storytelling for creating conflict between characters, especially those in relationships.

This conflict can be developed by distrust through misunderstanding of motives. It can also be used to create confusion in the Hero through facing his emotions if he becomes infatuated by beauty. (It should be re-emphasized here that none of these roles are gender-specific.) Ultimately the role of the Shapeshifter is to confuse the Hero and also act as a catalyst for change.

With this in mind there is great scope for devising a variety of characters, and by its very nature the Shapeshifter can appear in the form of any of the archetypes, including the Hero. In fact most of comicdom's superheroes are Shapeshifters in that they have two identities, one as the costumed do-gooder and the other their worldly

ANIMA AND ANIMUS
The male and female aspects of the unconscious mind make for a balanced personality, when in harmony, but look out if they are in conflict.

DEMON'S WIFE
Al Davison
As the wife of Tengu (page 84), she learns to change her personality to that of a femme fatale, in order to act as an assassin. This ability later proves to be her husband's downfall.

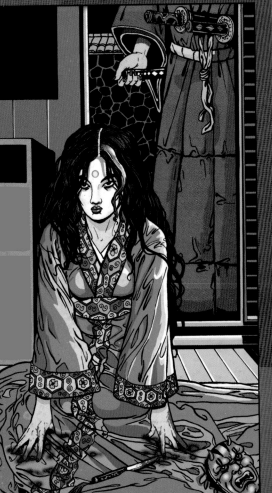

▶ **OVER TO YOU**

▶ If you want to create superhero stories, come up with some viable alternatives for the Hero's everyday worldly persona.

▶ Consider different psychological ways of portraying Shapeshifters. Look at how you could visually represent these changes in a single character.

RAZORBACK
Jesus Barony
Scientific experiments that go wrong are often used for creating shapeshifter characters that undergo physical and psychological transformations, as popularized by the Incredible Hulk.

alter ego, which can be anything from a reporter to a wealthy industrialist. Coming up with a believable alias can be harder than creating the superhero in the first place. The duality of these Heroes adds the interesting conflicts that transcend the battle against the supervillains. The villains, too, often face the same dichotomy, but it can be even more pronounced as their alter egos must have a patina of respectability to mask their evil intentions.

Not all comics deal with the superhero genre, luckily, so the Shapeshifter can be used to create other interesting and complex characters, such as femmes fatales. Though they have already been suggested as Threshold Guardians, their hidden agendas nominate them as Shapeshifters. Also that motley gang of creatures – vampires, werewolves and demons – that has haunted both the pages of Victorian literature and the streets of Sunnydale are Shapeshifters.

Whether you decide to make your Shapeshifter transmute physically or psychologically, try to make the two different aspects as diverse as possible and remember they invariably work best with male–female relationships. Just keep in mind that the Shapeshifter's main purpose is to create doubts in the mind of the Hero.

PHYSICAL CHANGE
Legend has it that heretics returned from the grave as vampires that could transform into bloodsucking bats. The ability to change into animal forms is well known among shamans, even if their intentions are not as gruesome as vampires.

LOTHARIO
The Lothario is the male equivalent of a femme-fatale, shown here with his personality being exposed through his physique.

Artist: Anthony Adinolfi

SERRA

MIXING THE ROUGH WITH THE SMOOTH

One of the storyteller's roles is to impart knowledge, principally of a moral nature, although other information can be given too. Historical stories, for instance, tell us about past events in a more palatable format, providing the author has done enough comprehensive research. Practically all novels contain some facts that can broaden our world knowledge, whether or not they touch on moral issues. One of the traps many writers fall into is that of proselytizing, forcing their views on the reader in a less-than-subtle manner, which often leads to two-dimensional characters that lack any depth of personality.

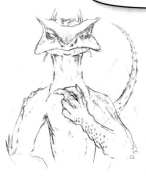

IDEAS: *Sketching ideas for characters as they come to mind is the best way to capture your ideas. Put in as much detail as you can, even if the proportions aren't accurate. Fine-tuning comes later.*

COLOUR AND TEXTURE: *Creating colour and texture palette references for all characters is the next vital step. This will be dictated by the intended use – either for print (comics) or animation. Printed images can have a lot more detail than those created for animation. The high number of images required for animation means that you have to keep things simple.*

DRAWING: *Once the basic ideas are down on paper, the details have to be worked on. Drawings should be made from as many angles as possible, with a minimum of front and profile views.*

ESTABLISHING SCALE: *When creating alien creatures it is important to establish a sense of scale. The most effective method is to place them next to one of the principal characters. Simple sketches will be sufficient to act as a reminder.*

SERRAZELGOBAA

Age: *39 by the Klylkeen calendar*

Height: *2.1 m. (7 ft. 1 in.); 3.4 m. (11 ft. 3 in.) from top to tail*

Hair colour: *Mottled green/brown skin*

Eye colour: *Yellow*

Distinguishing marks: *Wears a lavender-coloured cloth wrap*

CHARACTERISTICS: Serrazelgobaa's intimidating stature and bold manner hides a more complex, sensitive nature. Thought of as a stern warrior, her sense of artistic and scholarly endeavour and her capacity for compassion and loyalty are often overlooked.

ROLE: Serves as a crew member and adviser to the Bandarins: Sothi Henson, Aranik Kayem, and others. Also acts as a convenient source of intimidation when needed!

ORIGIN: The planet Klylkee.

BACKGROUND: Serra worked her way up through the ranks of the military to become a well-regarded tactical officer aboard a Klylkeen light frigate.

Inspired by the courage and determination of the crew, she took on a special assignment as adviser to the Bandarin, Sothi Henson. She also had the task of keeping a close watch over a pirate captive since she couldn't trust the Bandarins' ability to keep him from escaping.

POWERS: Incredible strength and resilience.

ASSOCIATES:
Hero: Sothi Henson, a soft-spoken Bandarin traveller, interstellar pilot and navigator has the freedom to journey beyond Bandarin space and is fueled by a strong desire for discovery and enlightenment.

Mentor: Aranik Kayem, former Kida'rin guardian. Fellow traveller aboard the Bandarin vessel Stormcrow. See page 46.

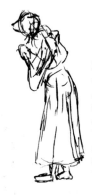

THE MORAL OF THE STORY

Another advantage of using archetypal characters is that they have a certain built-in moral code. This does not mean that they are obliged to be good; the moral code of Shadows and Shapeshifters, for instance, definitely tends toward baser activities. The moral lessons come in through interactions between the characters. In the case of Serrazelgobaa (Serra), the lesson is about prejudice, about judging a person, or creature, by their appearance. The character was designed to look ferocious yet be very cultured and sensitive in order to emphasize this point. As you build your characters and their personalities, allow these traits and the ensuing lessons to develop naturally.

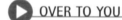 OVER TO YOU

Create a character that allows you to investigate a social or moral issue. Try not to make the issue too obvious, giving the reader the chance to ponder over it.

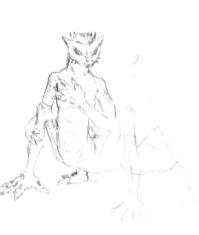

EVOLUTION OF A SPECIES: *Starting with a basic outline structure and adding detail is usually the best way to work, especially with complex physiques.*

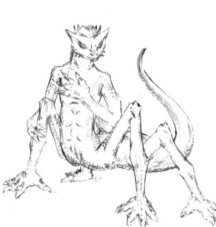

DRAWING THE LINE: *The finished line work ready to be scanned and coloured in Photoshop.*

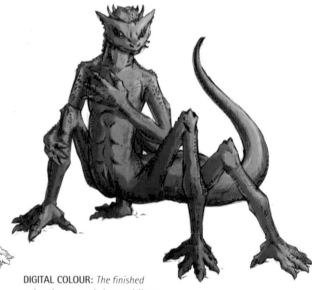

DIGITAL COLOUR: *The finished colour image made in a multilayer Photoshop file using a Wacom tablet and stylus.*

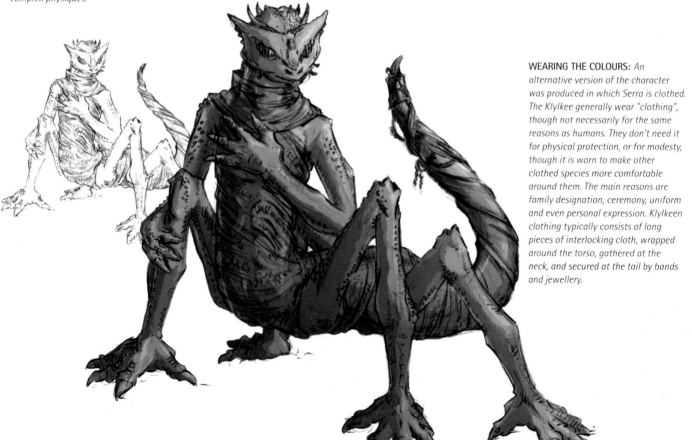

WEARING THE COLOURS: *An alternative version of the character was produced in which Serra is clothed. The Klylkee generally wear "clothing", though not necessarily for the same reasons as humans. They don't need it for physical protection, or for modesty, though it is worn to make other clothed species more comfortable around them. The main reasons are family designation, ceremony, uniform and even personal expression. Klylkeen clothing typically consists of long pieces of interlocking cloth, wrapped around the torso, gathered at the neck, and secured at the tail by bands and jewellery.*

Artist: Al Davison

When using the mythological format for storytelling, one person can be utilized to represent several archetypal roles. This not only adds greater complexity to the character but also enables economy of narrative.

TENGU

DOMINATING DEMON WITH A DOUBLE LIFE

A completed portrait of Tengu in all his pointy demon glory.

Tengu is the name of a traditional Japanese demon whose usual role is that of a Trickster. The Tengu developed for the story *The Demon's Wife* is multifaceted, representing not only the Shapeshifter, but also the Shadow, and even a Threshold Guardian. Creating such a pivotal character requires a full understanding of its various roles to make the design work dynamically.

EAST MEETS WEST: *In keeping with the character's lifespan a mixture of traditional art and contemporary digital techniques was used in its design and creation. This non-repro blue drawing was made in Photoshop, printed onto board, and inked using a traditional Japanese brush. The black-line image was scanned and coloured in Photoshop to produce the finished picture shown above .*

FACE TO FACE: *Different views and expressions of Tengu in demon and human form. Making quick pencil sketches like these will help you explore the character's looks and personality. This is particularly useful when working with two such distinct forms of the same character.*

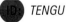 *TENGU*

Age: *Indeterminate*

Height: *1.7 m. (5 ft. 8 in.) human; 1.9 m. (6 ft. 3 in.) demon*

Hair colour: *Black*

Eye colour: *Green or red*

Skin: *Red in demon form*

Distinguishing marks: *pointy features*

CHARACTERISTICS: Ruthless megalomaniac. His exaggerated demon features are exhibited in his human form, but in a reduced way.

ROLE: His plan is for world domination by using his captive wife as a means of integrating into society. Only by defeating him can his wife, the story's Hero, complete her journey.

ORIGIN: Comes from a demon dimension that has a different timescale to the human world.

BACKGROUND: His interests in the human world led to his banishment from the demon realm. To live among humans he had to assume the form and identity of someone who could help further his ambitions.

POWERS: Able to change form and personality. He can dominate people and control their minds to carry out his will.

ASSOCIATES:
Hero: Oni – tricked into being his wife – who wins her freedom and gets revenge.

Herald: Katsuya Fuji, a young samurai, is killed by Tengu, who takes his form and marries his bride-to-be. In the present he is reincarnated as Kazou Harada, a Tokyo police detective, not aware of his connection to Tengu's Wife.

Originally conceived as the story's main villain, Tengu's proximity to the Hero meant he served many purposes on her journey. The story starts in early sixteenth-century Japan, when Tengu ambushes a young samurai who is on the way to be married. The demon takes human form, challenges the samurai, and defeats him by using magic. He assumes the form of the dead samurai and marries the bride-to-be.

The demon's plan is to gain power within the human world. Through the use of magic he forces his new wife to be his accomplice, and uses the samurai's family connections to help advance his plan. The story spans five centuries, coming to a climax in the late twenty-first century.

Although Tengu represents many of the darkest aspects of the psyche that would make him a Shadow, his devious personality, as well as his ability to change form, label him as a Shapeshifter.

DRESSED TO KILL

A series of pencil sketches were made, referencing traditional Japanese prints of Tengu, with particular attention given to the characteristic long nose. The artist carried out research into the various modes of dress prevalent throughout Japanese history to ensure authenticity. He also studied contemporary trends when trying to envisage the fashion of the future.

OVER TO YOU

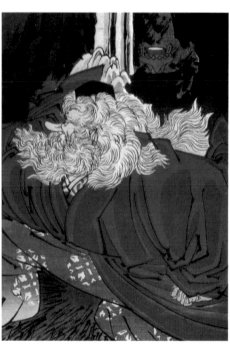

Tengu was taken from Japanese mythology in the same way as other characters, such as the Mighty Thor, have been adapted from different cultures. The Japanese print shown above, *Yoshitune and the King of the Tengu* by Yoshitoshi, shows details that helped inspire the character. The long, pointy nose is clearly visible. Find another traditional mythical person and adapt them into a modern context. Collect all the necessary visual reference material you need and keep it in a scrapbook or other filing system.

ROUGH WITH THE SMOOTH: *Early pencil studies of both forms of Tengu. Sketches such as this help to establish the physical differences and similarities of the two versions.*

A SMOOTH BLEND: *Experiment with different colour schemes and techniques when creating your model sheets. For these images the artist experimented with Photoshop's blending tool. More vibrant colour was used for the demon compared to the monochromatic palette used for the human guise.*

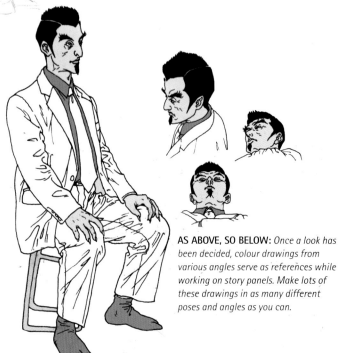

AS ABOVE, SO BELOW: *Once a look has been decided, colour drawings from various angles serve as references while working on story panels. Make lots of these drawings in as many different poses and angles as you can.*

Artist: Richard T. White Jr.

GARGOYLE

SPREADING HIS WINGS

Monsters, mutants, freaks and beasts have always been part of storytelling, whether just for entertainment or as part of a cautionary tale. For a lot of people these creatures are real and not the product of someone's fertile imagination. Thankfully we are just dealing with the imaginary stuff. What is interesting is how these fictitious entities have become an established part of our legends and myths. Vampires and werewolves – two obvious Shapeshifters – appear in everything from children's cartoons, through teen drama and comedy, to adult horror (and "adult films" too, apparently), so why not utilize this rich resource as a basis for new characters?

WING BACK: *The skin that makes up the wings is stretched out of Gargoyle's back and over the jointed bones that have broken out of his back. When they are not in use the bones retract into his body and the skin shrinks back to its normal shape, rendering the wings invisible.*

SKIN-TIGHT: *Details of the front and back of the wings showing how they are made up of simple jointed bones with skin stretched over them.*

LEAD CHARACTER: *Pencil drawings are a good way to hone your skills, especially figure drawing. The important thing to remember is if you intend to use the pencil drawing for a finished comic panel then you must not add shading; the inker and the colourist do this. This drawing was to try at a more realistic look for the character.*

GARGOYLE

Age: *11*

Height: *1.5 m. (4 ft. 11 in.)*

Hair colour: *Ginger/red*

Eye colour: *Grey*

Distinguishing marks: *Bones appearing through his skin, wings*

CHARACTERISTICS: Shy and withdrawn, but a versatile and talented circus performer.

ROLE: A young boy having to cope with two sets of body changes as he enters puberty.

ORIGIN: Not known. His name was Joshua and he was found, at two years old, abandoned at the door of a circus keeper's trailer door.

BACKGROUND: Adopted by the Keeper, the young, strange-looking child quickly learnt circus skills. At eleven his body began to change, with his bones and skin strengthening. One day, the circus elephants stampeded, and Joshua was trampled. As one of the elephants landed on his chest Joshua pushed it into the air, unfolded a set of wings and flew to the top of the tent. He was renamed Gargoyle and became the circus's main attraction.

POWERS: Incredible strength and the ability to fly.

ASSOCIATES:
Shadow: The keeper took Joshua into the circus as an abandoned child, but would often physically abuse him. Now he is afraid of retribution because of the boy's new found strength.

Herald: Cat Yo is an American-Asian high-wire gymnast who performs with Joshua and always tried to protect him before his transformation. There is definitely romance in the air.

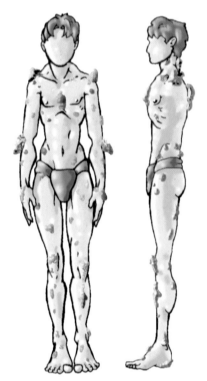

FLESH AND BONES: *The turnaround shows the character's emaciated body with protruding bones. The body was coloured in Photoshop and the bones added on a separate layer that could be switched on and off. A 3D texture effect was used to add depth to the skeletal protrusions.*

BONE HEAD: *Using the same technique for creating the colour image as was used for the full body version, bones were initially added on a separate layer then blended in with main picture. The experiment was not completely successful and the hyperreal style was reverted to the line version.*

BUILD YOUR OWN MONSTER

If you want to use "horror" creatures for your character, try to be a little bit original. Avoid vampires, as they have been done to death (literally) in *Buffy*, *Angel* and *Blade*. Having characters that transform in a Jekyll-and-Hyde way helps to add extra drama to your story as well as fulfilling the Shapeshifter role. Such transmogrifying characters shouldn't be precluded from being the Heroes of a story. Cunning or bipolar characters (whose transformations are more internal, as their real role is one of deception) can quite easily take on the Shapeshifter role.

When using mutated characters, try to ensure that there is a certain amount of logic, not only to their looks but also to their appearance in the story. You don't have to give a long explanation (it's better if you don't), but you must make sure the reader can suspend disbelief. It doesn't have to be logical or believable in our world, but it does have to be in the world you have created.

▶ **OVER TO YOU**

Find a mythical, legendary, or literary supernatural creature and adapt it into a new character. There are several "encyclopedias" and dictionaries specializing in the subject that can be used for reference.

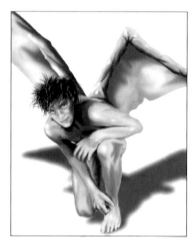

NO BONES: *To create this colour version of the character, colour photos of a model were used and repainted in Photoshop, changing features so the original model is not recognizable. This version shows Gargoyle before the bones were added. The artist did lots of experiments but was never completely satisfied with the results, preferring to retain the simpler version.*

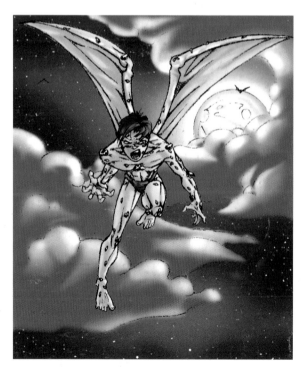

NIGHT FLIGHT: *Lots of people dream about having the ability to fly, but for Joshua it became a painful reality that helped save his life. Studying winged creatures will help you create wings that should function (but if in doubt just remember that bees manage to fly).*

Artist: Duane Redhead

CRYING WOLF

Since Lon Chaney Jr. donned furry make-up for the 1941 film *The Wolf Man*, werewolves have become a fixed part of the horror genre of popular culture. Even though the origins of the man-wolf (wer being old English for man) can be traced back to ancient Greek mythology, it is visual media that has brought werewolves to the masses. Werewolves have been incorporated into all genres – comedy (the Abbot and Costello and Teen Wolf movies), comedy horror (*American Werewolf in London*, *The Howling*) through to teen angst (*Ginger Snaps*) and martial arts (*Brotherhood of the Wolf*, *Underworld*). So there is plenty of scope for you to create your own lycanthropic world.

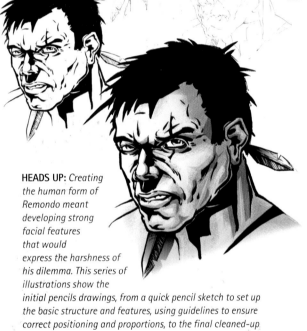

HEADS UP: *Creating the human form of Remondo meant developing strong facial features that would express the harshness of his dilemma. This series of illustrations show the initial pencils drawings, from a quick pencil sketch to set up the basic structure and features, using guidelines to ensure correct positioning and proportions, to the final cleaned-up pencils. For the final image, the pencil drawing was inked before colour was added to give depth to the features.*

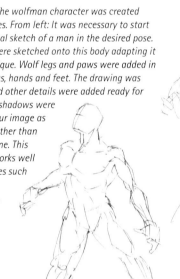

BECOMING A WOLF: *The wolfman character was created with a series of sketches. From left: It was necessary to start with a rough anatomical sketch of a man in the desired pose. The wolfish features were sketched onto this body adapting it for the enhanced physique. Wolf legs and paws were added in place of the human legs, hands and feet. The drawing was cleaned up, and fur and other details were added ready for inking. Highlights and shadows were added to the final colour image as areas of solid colour rather than areas of continuous tone. This method of colouring works well with vector programmes such as Adobe Illustrator or Macromedia Freehand.*

ID: *REMONDO SILVA*

Age: *33*

Height: *1.7 m. (5 ft. 9 in.)*

Hair colour: *Black*

Eye colour: *Dark brown*

Distinguishing marks: *Tattoos on his arms and torso; blue fur in his wolf form*

CHARACTERISTICS: Self-disciplined. A loner with a curiosity for the unknown.

ROLE: To reconcile the conflict between his human and wolf personalities.

ORIGIN: Born in Hermosillo, Mexico.

BACKGROUND: In his early twenties he met a shaman who wanted to teach him about medicinal plants, but he was drawn into the mysteries of the world,

● where he encountered a wolf spirit that possessed his body. Under the guidance of the shaman he learned to control the beast and is now searching for a way to overcome the transformation.

POWERS: Incredible strength and stamina in wolf form. Some shamanic magic when human.

● **ASSOCIATES:**
Shadow: Isegrin is a sorcerer trapped between the worlds of man and wolf. He controls wolf spirits and uses them to capture anybody who stumbles unprepared into the alternative reality of his world. He wants to create a pack of lycanthropes to keep him company.

● **Mentor:** Genaro is a shaman who started to teach Remondo about healing plants but now has to guide him in the battle with the wolf spirits.

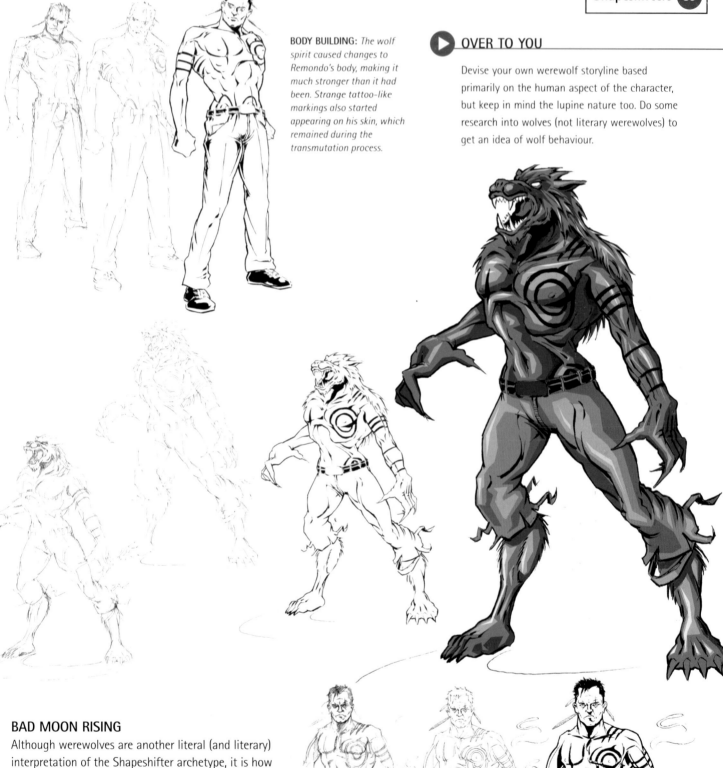

BODY BUILDING: *The wolf spirit caused changes to Remondo's body, making it much stronger than it had been. Strange tattoo-like markings also started appearing on his skin, which remained during the transmutation process.*

OVER TO YOU

Devise your own werewolf storyline based primarily on the human aspect of the character, but keep in mind the lupine nature too. Do some research into wolves (not literary werewolves) to get an idea of wolf behaviour.

BAD MOON RISING

Although werewolves are another literal (and literary) interpretation of the Shapeshifter archetype, it is how you utilize them within the context of your story that is important. Traditionally the transmutation takes place on the full moon and is beyond the control of the person afflicted. In the case of this character, the human form is the Hero of the story who is struggling to maintain mastery over the bestial nature of the creature, even though the physical change itself is involuntary. As the story unfolds we find out how successful he is in quelling the feral part of his being before it destroys him.

BATTLE STANCE: *With the help of his mentor, Remondo was able to summon power to help him control the beast during the change of body shape. This didn't lessen the physical agony, but it did stop the beast running wild.*

Artist: Jade Denton

BYHALIA

FLY LIKE AN EAGLE

Anyone who has read the Harry Potter books will be familiar with the term "animagus" and the concept of a human (or rather a wizard) being able to transform into an animal at will. While Harry Potter is a work of fiction (yes, kids, it is), shamans of the American Indians have always possessed this knowledge and the ability to use animal forms. At what level of reality this occurs, if at all, is not going to be discussed here, but it does create useful possibilities for characters and stories. There is also a good source of research material, describing which animals are commonly used, in both anthropological studies and first-hand accounts.

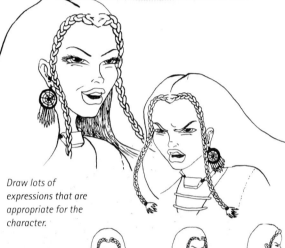

Draw lots of expressions that are appropriate for the character.

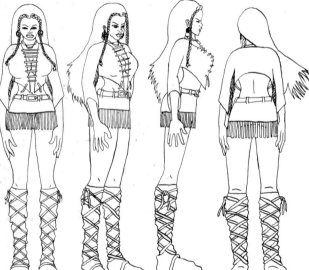

With a physique verging on the fantasy female mould, the turnaround shows her assets in all their glory.

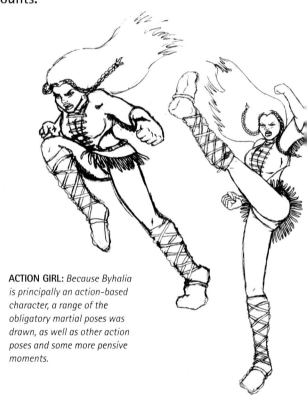

ACTION GIRL: *Because Byhalia is principally an action-based character, a range of the obligatory martial poses was drawn, as well as other action poses and some more pensive moments.*

● BYHALIA

Age: *Unknown*

Height: *1.8 m. (5 ft. 10 in.)*

Hair colour: *Brown*

Eye colour: *Brown*

Distinguishing marks: *Stylized eagle marks on both hands, which appear in all the forms she takes*

CHARACTERISTICS: Kind-hearted; has a general distrust of mankind from witnessing too many senseless wars and the destruction of great cultures; a ruthless warrior against oppression.

ROLE: Helps the downtrodden overcome adversity.

ORIGIN: Born in the Sonora area on the US/Mexican border.

● BACKGROUND: Disowned by her family, who feared the marks on her hands, she was apprenticed to a shaman and made great advances in the knowledge of the unknowable, enabling her to avert death. She learned how to use animal forms to move around unnoticed. Her concern for humanity trapped her on the earthly plane, preventing her from achieving the freedom needed to join the other shamans.

● POWERS: She has the ability to change into any form she has seen and can move about in her dreams and the dreams of others.

ASSOCIATES:
Mentor: Kroll is a mystic warrior Byhalia met in one of her dream states. She taught him how to use plants for healing. See page 50.

● Shadow: Black Ice is waging a one-person war against the US government's covert agencies. Byhalia sometimes helps, but doesn't always agree with her lack of interest in helping the oppressed. See page 98.

(Note: Being a Shapeshifter, Byhalia's relationship with these two is tenuous and hard to define.)

EXPAND YOUR MIND

If you are taking the cultural or mystical heritage of any ethnic group as the basis for your story or character, it is advisable to do some proper research. No matter how fantastic the ideas may seem, it will give more credence to your fiction – and is a mark of respect – to represent that culture as accurately as possible. You also get the added bonus of expanding your mind by learning something new.

The more information you have, and the better your understanding of the culture, the more you will avoid stereotyping when you come to drawing your characters. Many potential readers may have done some reading on the subject, and there is nothing more disheartening for a writer or artist than to have poorly researched inaccuracies pointed out to them.

Let your imagination run wild – remember that there is a whole world of unfathomable wonders out there for you to explore.

▶ OVER TO YOU

Look into other ethnic cultures as a source for mystical characters. Find out about the rituals and powers they are supposed to achieve, and the best ways to incorporate them into believable characters.

When drawing humans, working from reference material is always useful; with animals, especially wild ones, it is obligatory. There is no shortage of wildlife photographs but be careful how you use them, as you could enter the murky world of copyright. Collect as many different pictures as you can and practise until you are familiar with the animal's anatomy. After that you can adapt the anatomy to fit the style of your comic.

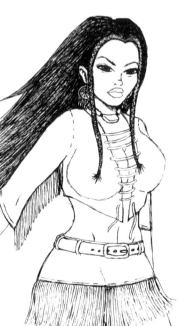

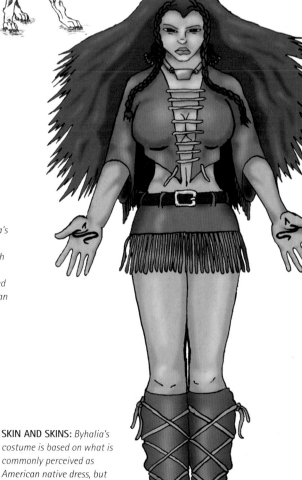

MARK OF THE BEAST: *The sign on Byhalia's hand that marked her destiny. Hands are notoriously difficult to draw and are worth practising in as many different poses as possible. Like faces, they are often featured in story panels, especially if they contain an important element like this.*

SKIN AND SKINS: *Byhalia's costume is based on what is commonly perceived as American native dress, but adapted to appeal to a teenage (male) audience.*

COSTUME JEWELLERY: *Every element of the character's appearance should be drawn in detail to increase familiarity with recreating it regularly.*

SHADOWS

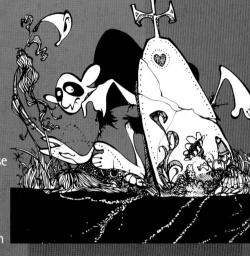

The bad guy; the villain; the dark side; the antagonist – these are all common names associated with this archetype. And what is a story without this character? The Shadow is the force that continually challenges the Hero, with the sole aim of preventing him from achieving his goal. The Shadow is also the one that can effect the greatest growth in the Hero, by making him face and overcome his fears and weaknesses. This is what makes the Shadow a pivotal character in the story – and often the most memorable.

UNDERGROUND
Cartoon Saloon
A deranged, graveyard cannibal is used to represent the darkest side of humanity, even though it is presented in a cartoon style.

Darth Vader is probably the best known of all Shadow characters in recent years and epitomizes the struggle both inwardly and outwardly. In the original *Star Wars* trilogy this culminated in his battle with the Hero, Luke Skywalker, and in the prequel trilogy in Anakin's (losing) battle with his own demons and the temptations of power offered by the Emperor (another Shadow).

When creating superhero characters you have to develop supervillains capable of destroying the Hero. They have to be superior, or at least equal in power, to the Hero, because without the challenge of adversity the Hero would not be able to grow.

RAVANA
The demon lord of Lanka, kidnapped Lord Rama's wife to make her his own. With Ravana's destruction Rama was able to return from exile and regain his rightful place as king.

Developing supervillains can be even more fun than devising superheroes, because you are not restricted by the basic moral code that the good guys are expected to have. You are free to explore the

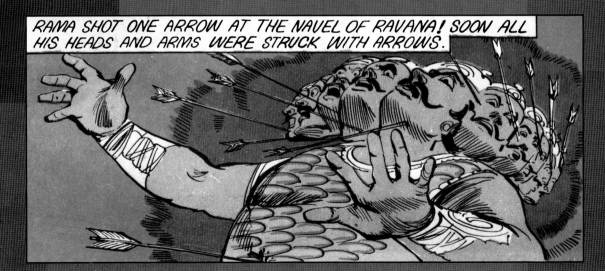

RAMA SHOT ONE ARROW AT THE NAVEL OF RAVANA! SOON ALL HIS HEADS AND ARMS WERE STRUCK WITH ARROWS.

▶ OVER TO YOU

▶ If you have already developed a Hero, list his positive qualities, then list their opposites and explore them as a Shadow character.

▶ Make a note of what you perceive to be negative character traits, or what you define as evil, then create a villain with some of them. Apply some of these to a Hero and create a character that manifests them.

shadows within your own psyche to create obnoxious, dangerous or just plain evil characters. Heroes have flaws and so should the villains. They have to have a weakness or some other quirk that stops them from being an insurmountable black hole of badness. It can also give you a chance to explore some dark humour.

Although supervillains are the most conspicuous type of Shadow, the archetype is meant to represent those suppressed feelings or dark secrets that haunt people. It can also be the repression of positive qualities, where someone won't accept their abilities or fate. This is quite a common trait among Heroes, which not only humanizes them but also reinforces the purpose of their quest.

If your stories don't have a clear-cut definition between Heroes and villains, more complex characters can be investigated and developed. Heroes in whom the Shadow is intrinsic are always interesting. These can be antiheroes – essentially bad guys on a Hero's journey to some sort of catharsis. Alternatively they can still be do-gooders who have to wrestle with their own internal demons from their past – Batman, Wolverine and The Hulk fit that profile.

However you want to approach it, the Shadow is a vital element in your story, not just as a counterpoint to the Hero, but also as the catalyst that, once overcome, elevates the Hero to a new level and closer to his ultimate goal.

NATHAN
Ziya Dikbas
Often the most dangerous type of Shadow is the one that cannot be seen, especially if it is hidden in the guise of an innocent.

DEATH
Edmund J Sullivan
An illustration for Quatrain XXXV of the *Rubáiyát of Omar Khayyám* shows death drinking from the cup of a "bon vivant". Death can be seen as the ultimate Shadow that no hero can overcome.

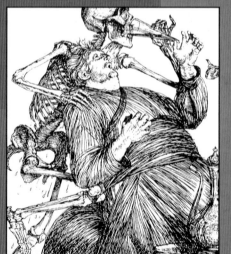

VIEJO
Jesus Barony
Alien creatures make formidable adversaries for sci-fi heroes as their powers are often unknown.

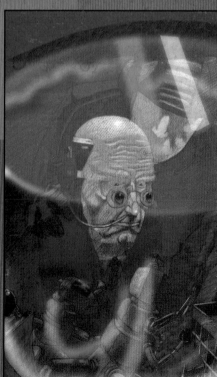

Artist: Emma Viecelli, Sweatdrop Studios

Have you ever noticed how popular the bad guys are, especially when they are really sinister? Darth Vader had a huge following even before his past was discovered, and in *Star Wars Episode 1* Darth Maul was hardly in the film, yet most kids had some merchandise displaying his face. The bad guys are supposed to be the ones we love to hate, those on whom we can vent all our pent-up animosity – they are to be reviled, not applauded.

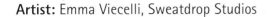

VERANCE

THE BLACK DRAGON

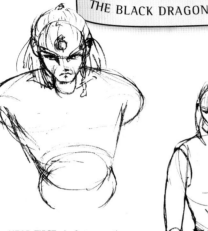

HEAD FIRST: *As faces are the easiest way of distinguishing one person from the next, start by making sketches of the head.*

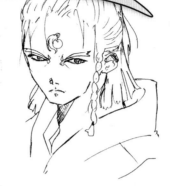

HEAD AND SHOULDERS: *More detail in the head, in order to build the character. Given the nature of the character, a ronin samurai look was chosen, mostly represented by the hairstyle.*

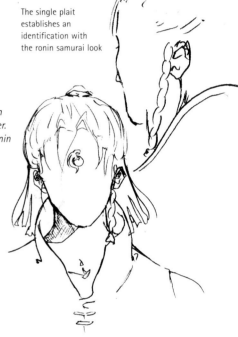

The single plait establishes an identification with the ronin samurai look

Making an underlying structure on which to build your character will help with getting the proportions consistent. The characters devised for this story do not have the classically recognized head-to-height ratio, but adhere to rules of their own. An initial idea for a costume was also sketched.

FACE OFF: *Simplicity of line is one of the things that identifies this style of manga. Conveying emotions with minimal pencil strokes requires plenty of practice to get maximum impact.*

A reference sketch to show the placing of the dragon spirit mark, which is the reverse of the "white" Dragon Heirs.

 VERANCE

Age: *21*

Height: *2 m. (6 ft. 8 in.)*

Hair colour: *Silver*

Eye colour: *Gray*

Distinguishing marks: *The black dragon spirit sign on his forehead*

CHARACTERISTICS: Dark and malicious by nature; he has a limitless determination to see his plans through by whatever means necessary.

ROLE: To oppose the Dragon Heirs, the prophecy and Spiratu itself, but Verance himself was unaware of the cost of his defiance.

ORIGIN: Born into a life that should never have been, in a world that looks very harshly on defiance.

● **BACKGROUND:** The dragon's soul was split into eight pieces, instead of the intended four. The spirits dubbed the true dragon "white" and the false one "black". Verance was believed to be the black half of the spirit and was given the chance to return the dark soul inside him and become mortal again. But Verance was born into a life that defied the spirit world, and would not submit to their will or their rules.

● **POWERS:** Incredibly powerful mental abilities, coupled with mastery of sword skills.

● **ASSOCIATES:**
Herald: Neissus, a spirit binder who brings news of the prophecy to Ella and also acts as her Mentor to teach her about being the key bearer. See page 70.

Hero: Ella, the key bearer, who has to complete Neissus' mission should he fail. See page 38.

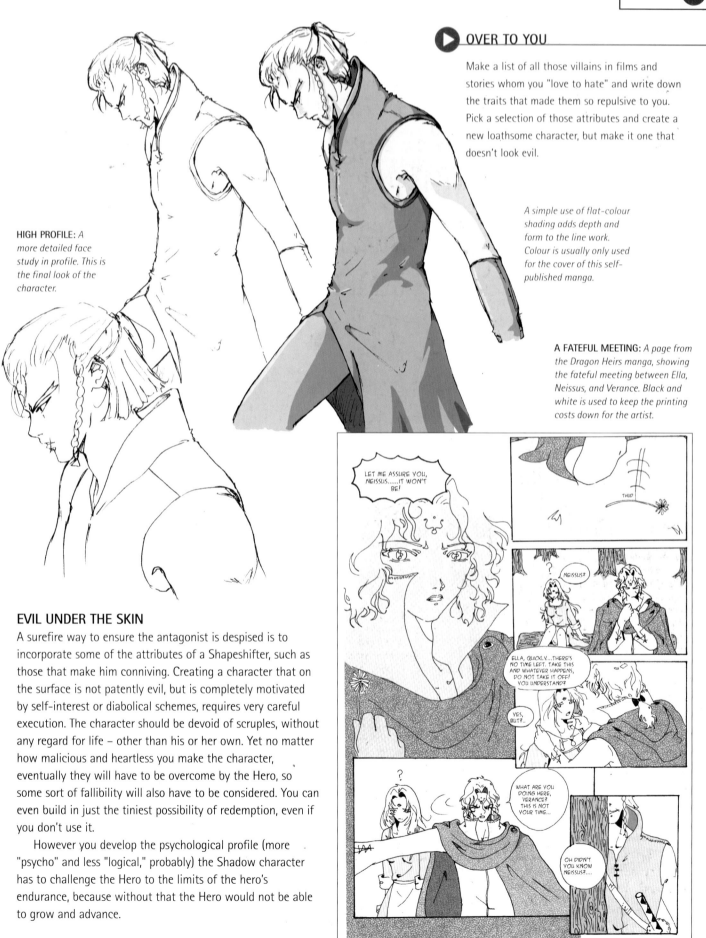

HIGH PROFILE: *A more detailed face study in profile. This is the final look of the character.*

▶ OVER TO YOU

Make a list of all those villains in films and stories whom you "love to hate" and write down the traits that made them so repulsive to you. Pick a selection of those attributes and create a new loathsome character, but make it one that doesn't look evil.

A simple use of flat-colour shading adds depth and form to the line work. Colour is usually only used for the cover of this self-published manga.

A FATEFUL MEETING: *A page from the Dragon Heirs manga, showing the fateful meeting between Ella, Neissus, and Verance. Black and white is used to keep the printing costs down for the artist.*

EVIL UNDER THE SKIN

A surefire way to ensure the antagonist is despised is to incorporate some of the attributes of a Shapeshifter, such as those that make him conniving. Creating a character that on the surface is not patently evil, but is completely motivated by self-interest or diabolical schemes, requires very careful execution. The character should be devoid of scruples, without any regard for life – other than his or her own. Yet no matter how malicious and heartless you make the character, eventually they will have to be overcome by the Hero, so some sort of fallibility will also have to be considered. You can even build in just the tiniest possibility of redemption, even if you don't use it.

However you develop the psychological profile (more "psycho" and less "logical," probably) the Shadow character has to challenge the Hero to the limits of the hero's endurance, because without that the Hero would not be able to grow and advance.

Artist: Wing Yun Man

DRACONIS

HE'S NO ANGEL

Just how evil do you make a character destined for a young audience? Traditional fairy tales are filled with some of the impressionably scariest villains ever created. They may not be in the Hannibal Lecter or Alien league, but how many adults can still recall the wicked witches from *The Wizard of Oz*, or Disney's *Snow White*? The villain has to be obviously evil, but not to the extent that children are left traumatized. Admittedly children nowadays are a lot more resilient, but they nonetheless see things in a different way to adults.

WINGING IT: *The appearance of wings tells something about the character that was not obvious from the drawings with his coat on. They are definitely not angel wings. Drawings such as this don't have to be incorporated into the finished story, but serve as a way of building the personality.*

THE EYES HAVE IT: *Anime/manga characters, particularly in the chibi style, are recognizable by their large round eyes. One of the conventions is that the "good guys" have the round eyes and "bad guys" have narrow eyes. Compared to the other characters Draconis's eyes, though still large, are much narrower.*

STYLE: *A lot of anime/manga has a standardized style of drawing based around simple lines with very little detail. If you pursue this type of illustration you should practise conveying ideas with the minimum of pencil work, restricted to clear outlines. Even the shading, added at the colour stage, should be simple.*

 ID: *DRACONIS*

Age: *Possibly in his 20s*

Height: *1. 7m. (5 ft. 7 in.)*

Hair colour: *Black*

Eye colour: *Red*

Distinguishing marks: *Red eyes, black coat all year round*

CHARACTERISTICS: Evil and clever with a big dose of megalomania.

ROLE: To cause chaos in Baka Town, and try to take over the world at the same time.

ORIGIN: Definitely not from Baka Town.

● **BACKGROUND:** Little is known about his past. He arrived in Baka Town and started hanging around at the Black House with President Greg. He makes no pretence about his animosity toward the president – or children.

● **POWERS:** Some people believe he can control minds and turn into a bat.

● **ASSOCIATES:**
Herald: Shinra is Draconis' pet bat-cat who helps his master come up with evil plans to take over the world. He is very sarcastic and hates stupid people.

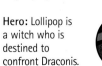

Hero: Lollipop is a witch who is destined to confront Draconis. See page 28.

FEAR AND LOW THINGS

One way of diffusing the sinister aspect is by introducing some humour and creating a melodramatic villain. Make him so evil that it is no longer plausible for him to be real – and of course, if you make the Hero and other protagonists find his behaviour laughable, you are also adding some moral content to your story. If you are aiming to create something for different age groups then you will have to rely on a sophisticated level of writing that will appeal to adults yet still maintain enough simplicity for children to understand. Probably the easiest way to capture the attention of children is with visual gags, whilst knowing dialogue can be used for the grown-ups.

Draconis and his pet Shinra are the evil forces in the *Telephone Icecream* anime series, but they don't seem to be frightening – despite the vampire look – possibly because of the chibi-style drawing.

▶ OVER TO YOU

Devise some evil characters for children's stories, then try them out on some kids in the target age group – cousins, nieces and nephews, and their friends – but don't try hanging around the gates of the local primary school with a portfolio of drawings.

BAT AND MAN: *When characters are in a symbiotic relationship, such as between Draconis and Shinra, it is advisable to spend time working on establishing how it is going to work, not just through drawing but also through dialogue.*

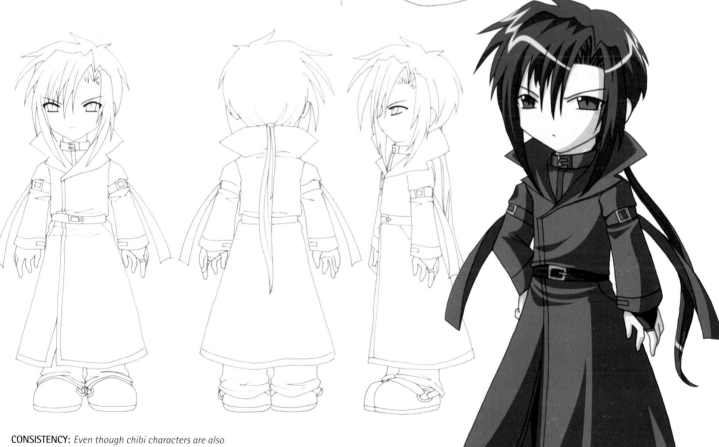

CONSISTENCY: *Even though chibi characters are also known as "Super-Deformed", with unnatural proportions, it is important to keep all the characters consistent, with similar ratios used for all of them. As always, model sheets are the best way to establish standards for your characters.*

BLACK IS BEAUTIFUL: *Villains in black may be obvious, but it does work, especially when humour is involved. When working with colour it is best to use shades of grey rather than pure black, which is best kept for the outlines. If you want consistent colour over large areas then digital is the best method.*

Artist: Jade Denton

BLACK ICE

WHERE VICE IS, VENGEANCE FOLLOWS

In its simplest form a Shadow character is the antithesis of the Hero: the one that acts as a counterpoint for the Hero's actions, to prevent them from achieving their goal. This can be effected either in head-on conflict or by drawing him away through subtler means. A much more complex character is created if the Hero and the Shadow are made to be part of the same person. This is usually represented as an antihero (see Oran on page 34), essentially a protagonist who has issues to resolve and who does so successfully. An antihero, or even a Hero, who is defeated before achieving their goal and returning transformed with the reward (whatever it may be) can no longer be the Hero – at least not according to mythical story structure.

EARLY DAYS: *One of the early versions of Black Ice, before the addition of the fishnet body stocking. Most of the other details are already well defined.*

IN THE SHADOWS: *Visualizing Black Ice's ability to move stealthily through the shadows is an important part of creating the character. It is always a good idea to make visual notes of your character's peculiarities.*

Creating strong and original facial features is important for any character as this is where most of the emotion will be expressed, but Black Ice's trademark eye make-up required more study. The more you work on these aspects the more naturally you will be able to draw them.

FILLING IN: *The character's basic design was soon established, but there were still some specific details that needed finalizing, such as hair colour.*

ID: *BLACK ICE*

Age: *23*

Height: *1.8 m. (5 ft. 11 in.)*

Hair colour: *Black*

Eye colour: *Green*

Distinguishing marks: *Black markings above and below both eyes*

CHARACTERISTICS: Black Ice is vengeful, aggressive, ruthless and quick to anger.

ROLE: Metes out retribution to those she believes were responsible for killing her family when she was young.

ORIGIN: Born in the USA and brought up in the Cuban jungle.

BACKGROUND: After her family was killed in Cuba (during a kidnapping scam that went wrong) she escaped to the jungle where the indigenous people brought her up. Fifteen years later she returned to the USA to hunt down the government agents responsible for her family's deaths.

POWERS: She can move with great stealth, especially at night and in shadows, rendering her practically invisible. Her great strength and lightning reflexes make her a formidable adversary.

ASSOCIATES:
Mentor: After her family was killed, Kroll took Black Ice in. He taught her how to fight and how to survive, and educated her in the workings of the local political systems. See page 50.

Shapeshifter: Byhalia taught Black Ice the art of stalking, an invaluable skill for any warrior. See page 90.

A SHADOW OF HER PREVIOUS SELF

When a character is defeated by the Shadow (even if by falling prey to their own inner demons), they assume that role themselves. Though the function of the Shadow is clearly defined, you may have to make certain subjective moral judgments for your own characters. Could the character of Black Ice be considered very heroic in her unswerving quest for justice, or is she simply a murderous vigilante driven by an insatiable desire for revenge? You have to think about the motivations of your characters, to what end they are performing their actions, and whether or not the consequences of these have a profound effect on them.

If you intend your character to be part of a continuing series (and who wouldn't?) you have the option of changing their role at a later date. There is nothing to say a villain can't achieve redemption and become a Hero, or a Hero fall and become the bad guy. Just make sure you can justify it within the bounds of your story's world.

▶ OVER TO YOU

Devise a character whose initial good intentions have been perverted, turning him or her into a Shadow archetype. Outline how the Shadow aspect manifests itself and also consider ways that aspect could be overcome. Draw the character in the two different roles, looking at which attributes distinguish each one.

PUTTING THE BOOT IN: *Recurring items, such as Black Ice's boots or her weapon of choice, a blade specially made for her by customizing a circular saw blade from a lumber mill, can be drawn in detail to act as references.*

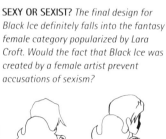

SEXY OR SEXIST? *The final design for Black Ice definitely falls into the fantasy female category popularized by Lara Croft. Would the fact that Black Ice was created by a female artist prevent accusations of sexism?*

An all-round view of Black Ice's killer physique

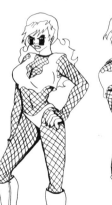

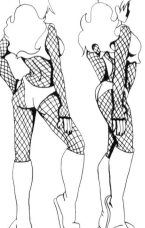

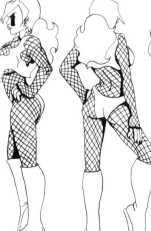

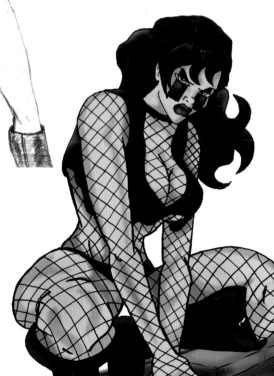

FANCY DRESS: *Costumes have always been a part of character design and don't always have much to do with practicalities (I mean, yellow spandex?). It has always been about the look, and Black Ice's garb is no exception. It's a good thing she's a master of stealth because she'd certainly attract a lot of unwanted attention otherwise.*

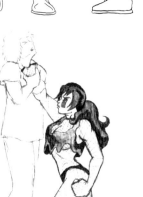

He wished he'd never whistled...

Artist: Ruben de Vela

MALTHUS

THE HALF-FALLEN ANGEL

The idea of fallen angels has long held a fascination for writers, not to mention psychologists and theologians. The devil, Satan, Beelzebub – or any of the many other names he trades under – is by far the most popular one with storytellers and religions, who lay the blame for the world's ills on him. In recent years, of course, a new icon for the fall from grace has emerged – Darth Vader. Although not technically an angel, Vader was still supposed to have been one of the champions of good. Malthus' origins lie in these historical and fictional backgrounds.

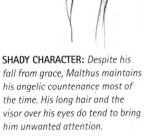

SHADY CHARACTER: *Despite his fall from grace, Malthus maintains his angelic countenance most of the time. His long hair and the visor over his eyes do tend to bring him unwanted attention.*

WALKING THE LINE: *Make your turnaround model sheet as complex or simple as you think you will need. If working alone pencil sketches such as this will work fine, but if you are working with other artists it has to be finished to final artwork standard.*

 ID: *MALTHUS*

Age: *Unknown*

Height: *3 m. (10 ft.) in angel form*

Hair colour: *Black*

Eye colour: *Hidden behind a visor*

Distinguishing marks: *Visor over eyes, six digits on each hand*

CHARACTERISTICS: Arrogant and judgmental. Not evil, but his motives aren't pure or selfless either.

ROLE: Interferes in human affairs, playing with their lives and free will to keep them from knowing the Absolute Truth.

ORIGIN: The celestial realms.

BACKGROUND: He was once an Ofanim who, allegedly, found a flaw in the Divine Plan concerning human behaviour and free will. Since then he has walked the earth, living among mortals in various forms and guises but without taking sides.

POWERS: Physical strength and celestial/occult powers.

ASSOCIATES:
Threshold Guardian: Abasdarhon is a mid-ranked angel sent to watch Malthus and monitor his activity. He has also been given orders to destroy Malthus if he becomes too dangerous.

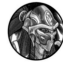

Herald: Ajehl is the only person who trusts Malthus in what he is doing. She was the first person to whom he divulged his purpose and plan, and is his primary agent in carrying out those objectives.

EXPRESS YOURSELF *Drawing extreme expressions, such as this demonstration of anger or anguish, helps add extra depth to the character's personality. Try using reference shots or a mirror to get the full feeling.*

▶ **OVER TO YOU**

Look at the place of angels in different world religions and cultures and devise a character based on one of these beings, then devise an opposing or negative version of the same character.

PAINTED NAILS: *Malthus has an extra finger on each hand to show that he may not be human. Drawing hands well is notoriously difficult and requires a lot of practice to perfect. Adding an extra digit only compounds the problem. A commissioning editor will specifically look at your character's hands in order to assess your creative abilities.*

THE BIGGER THEY ARE, THE HARDER THEY FALL

Angels are depicted in all sorts of forms, from the cute (see page 54) and cherubic to genteel winged messengers, or imposing divine warriors. Malthus was based on the latter group, though his appearance has been further adapted for the purpose of the story. Building characters using such familiar and recognizable forms can make them more easily acceptable to your readers. The disadvantage is that certain accepted "facts" and modes of behaviour are attached to them, such as the laws governing the destruction of vampires by means of wooden stakes, sunlight or decapitation.

Angels are traditionally messengers of God who act as intermediaries between the manifest world of humans and the divine realms. Even as a fallen angel Malthus continues in the same role, except that he has developed his own agenda and spreads his own version of "the Word", a version based in the Truth, but which creates confusion and doubt in the minds of those who listen to him. The character is used to symbolize the role of modern organized religions.

WINGS AND A PRAYER: *Malthus with his wings held in full span. These are not always visible, and when they are, they appear seem to be made of smoke and shadows.*

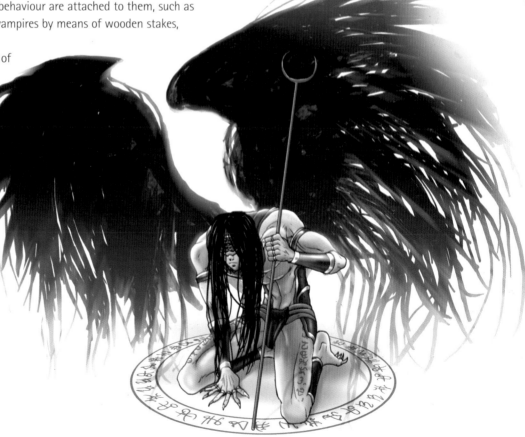

Artist: Nubian Greene

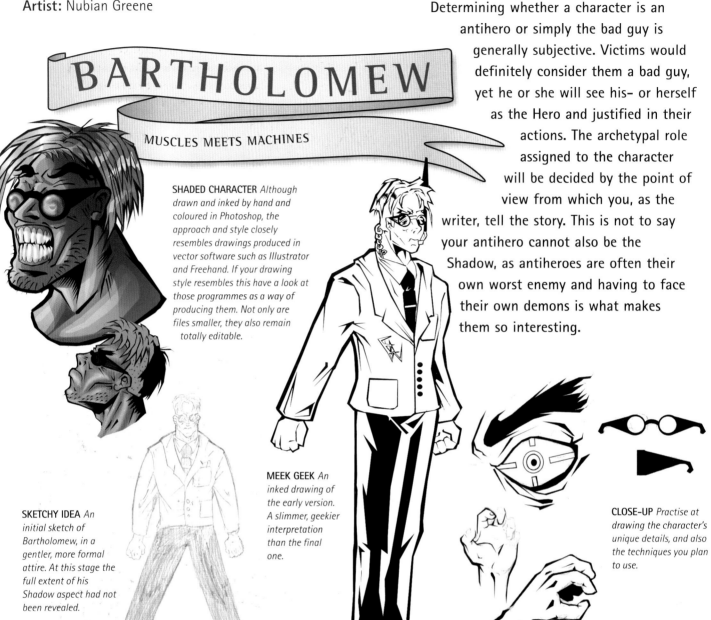

BARTHOLOMEW

MUSCLES MEETS MACHINES

Determining whether a character is an antihero or simply the bad guy is generally subjective. Victims would definitely consider them a bad guy, yet he or she will see his- or herself as the Hero and justified in their actions. The archetypal role assigned to the character will be decided by the point of view from which you, as the writer, tell the story. This is not to say your antihero cannot also be the Shadow, as antiheroes are often their own worst enemy and having to face their own demons is what makes them so interesting.

SHADED CHARACTER *Although drawn and inked by hand and coloured in Photoshop, the approach and style closely resembles drawings produced in vector software such as Illustrator and Freehand. If your drawing style resembles this have a look at those programmes as a way of producing them. Not only are files smaller, they also remain totally editable.*

MEEK GEEK *An inked drawing of the early version. A slimmer, geekier interpretation than the final one.*

SKETCHY IDEA *An initial sketch of Bartholomew, in a gentler, more formal attire. At this stage the full extent of his Shadow aspect had not been revealed.*

CLOSE-UP *Practise at drawing the character's unique details, and also the techniques you plan to use.*

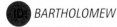 *BARTHOLOMEW*

Age: *23*

Height: *1.8 m. (5 ft. 11 in.)*

Hair colour: *White*

Eye colour: *Pale blue*

Distinguishing marks: *Round sunglasses, cyborg arm*

CHARACTERISTICS: Misguided messiah complex that makes him believe his knowledge will save humanity from certain extinction.

ROLE: His beliefs put him at odds with humans and cyborgs, and start to create a chaos that he tries to control.

ORIGIN: Born at the end of the third millennium on a peace enforcement base in the United Sweatshops, an area formerly known as China. He was raised by his paternal grandfather after his father disappeared during an attempted coup. There is no record of his mother.

BACKGROUND: As a student, supported by his grandfather, a leader in the field, he showed a flair for cybernetics. He was apprenticed to a stealth ninjitsu master. He started building his own cyborg (cybernetic organism) army when he realized that humans were no longer the dominant species. His initial motive was defence, but this turned to malice when his desire for revenge for his parents' disappearance started to obsess him.

POWERS: Martial-arts adept. Cybernetic and computer-programming knowledge allow him to hack in to systems to control manufacturing and communications services as well as cyborgs.

ASSOCIATES:
Threshold Guardian: OE1 (Original Experiment 1) was the first cyborg he made. It was endowed with great strength and unswerving dedication. Acts as a bodyguard.

Mentor: Frederick, his grandfather, who disassociated himself when he found out Bartholomew was using his knowledge for violence.

SUPER MODEL *Model sheet clearly showing the exaggerated physique. A good indication of the drawing style is also visible.*

The glasses are to protect his cyber-eye from damage and excessive light.

In an early experiment he replaced his own upper arm with some cybernetics.

Being an inveterate showoff, Bartholomew likes to stand around exposing his pecs. Training and a little genetic manipulation produced the body. To draw such physiques, use body-building magazines for reference.

The tattoo was part of his initiation into ninjitsu.

OVER TO YOU

Developing a unique style can take many years to perfect, but experiment with different techniques and keep everything in a folder to track your progress. As an exercise, try working exclusively in black and white. The graphic novels *Batman Black and White* (volumes 1 and 2) are filled with excellent examples of possibilities.

Developed as a protagonist, Bartholomew is more in the antihero mould, but the lack of altruistic motives in many of his actions does cast a shadow over his personality. The role of Bartholomew's nemesis is more that of a Herald, because his actions (killing his father) are what set him on his destructive path, the overriding force preventing him from fulfilling his destiny.

CHARACTER-BUILDING EXERCISE

Because the story is set in the future many restrictions on physical appearance could be overlooked. Exaggerated musculature is acceptable, especially as the story involves cyborgs, and the drawing style enhances the sci-fi mood. When originally conceived the character was going to be more "geeky" in nature, but as the storyline developed it was decided to opt for the action-hero look.

Experimenting with the appearance of a character is an important part of the development process. Even when working with archetypal roles, playing around with stereotypes can produce interesting results, especially if you try working with opposites. Give your antihero the look of a typical or exaggerated superhero, without slipping into parody. Even if it doesn't work it is all good practice, and may be useful at a later date.

ADDING TONE TO MUSCLE *The finished, colour version of Bartholomew brings out further detail in his musculature. A good test of your skills is to see if the drawing works just as well before the colour is added as it does afterwards. Effects, such as the metal on his arm, won't show in black and white, but working with only line and little or no tonal shading is a very good exercise.*

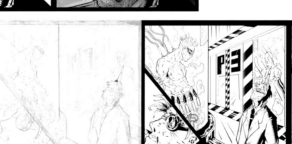

PANEL BUILDING *The progression of a finished comic panel from pencil, to ink, to the finished colour image, with speech bubbles waiting for the lettering artist to add the dialogue. In these digital days letterers create type fonts of their hand-drawn letters, which is very useful for translation and international publication.*

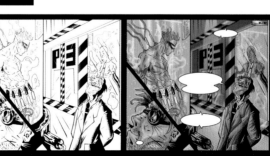

Artist: Jennifer Daydreamer

OLIVER

THE LITTLE DEVIL

One of the most surprising aspects of creating characters is how they take on a life of their own. Not in an entirely sinister way – although there must be a good story in that premise – but how they develop in an unplanned way. Designing a character using a profile sheet is really to give you a guideline and aide-mémoire to maintain consistency but, just as with real people, your character can behave unexpectedly. This may sound a bit ethereal but it does happen and you can only verify it when you experience it. Allow the characters to grow naturally and see where the story goes. If it doesn't work you can always scrap it and go back to where you started.

Just an innocent boy in a playsuit?

TROUBLED CHILD: *Here the character has evolved into Oliver, a real boy in a costume. The drawing style was changed to reflect this.*

OLD DEVIL: *The first version of Oliver as a devil (before he was called Oliver), as he appeared in a comic. He was a traditional-looking devil, and still a man rather than a child.*

LITTLE DEVIL: *These panels come from a later story where he becomes a small child, but still with a goatee, pointy ears and the addition of motorcycle boots. The naïve drawing style adds to the surreal nature of the story. Having confidence in your style is often more important than making your drawings "correct", but this should not be seen as a substitute for learning proper craftsmanship.*

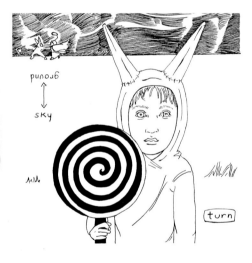

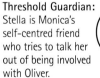

ID: *OLIVER*

Age: *3*

Height: *0.9 m. (2 ft. 10 in.)*

Hair colour: *Black*

Eye colour: *Green*

Distinguishing marks: *Red suit with horns and tail*

CHARACTERISTICS: An innocent child who is shy and a bit mischievous, but his shadow has an evil aspect.

ROLE: To create confusion as no one can decide if he is innocent or evil.

ORIGIN: Came from a netherworld of devils.

BACKGROUND: Arrived in the world as a devil that wasn't evil and turned into an imp that later became an innocent boy in a costume. All the trouble is caused by his long shadow, that has developed an evil shadow of its own.

POWERS: All the negative power lies with his shadow's shadow. Oliver's power is his innocence, which stops the evil of his shadow taking him over.

ASSOCIATES:
Hero: Monica finds Oliver in a restaurant and wants to protect the innocent child from the influence of the shadow.

Threshold Guardian: Stella is Monica's self-centred friend who tries to talk her out of being involved with Oliver.

BEFORE: *A study of Oliver with his hood pulled back off his head to reveal a full head of hair. The artist was relieved to find that Oliver was not bald.*

AFTER: *An updated version of the last image, with colour added. Red watercolour was used over the inked drawings. Working with a single colour (other than black) is a good exercise in discipline, and can be a cost-saver if you are publishing your own comics. If you are working with paint and paper, you will have to use acetate for one (or both) of the colours, as with cel animation. Digitally you only need to specify the second colour as a spot colour and the software will take care of the rest.*

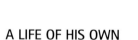

Small studies of Oliver's head-dress.

OVER TO YOU

▶ Create a character with a clearly defined personality, then experiment by taking it into situations it would not normally experience and see how you make it react. Don't force it to be different.

▶ Draw several stages of an evolving character, changing the character's appearance as its personality alters in response to different situations.

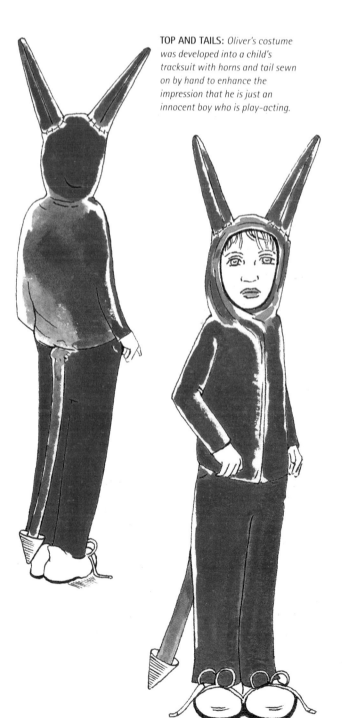

TOP AND TAILS: *Oliver's costume was developed into a child's tracksuit with horns and tail sewn on by hand to enhance the impression that he is just an innocent boy who is play-acting.*

A LIFE OF HIS OWN

The character of Oliver appeared in a story as a little devil that wasn't really evil; it was just an ancillary character in a somewhat surreal narrative. The character evolved from an obvious devil to an innocent boy with a costume. The boy's shadow, however, had its own shadow that was long and evil.

As the character evolves and heads off on various tangents it is vital that you remain in control of the story, unless you intend to produce a stream-of-consciousness epic that never completely resolves itself. Explore different possibilities: let the shadow characters become as dark as your mind will let them, or your protagonists as heroic as is feasible. Ultimately, though, you have a responsibility to the character and your reader to bring the story to a satisfactory conclusion.

TRICKSTERS

RABBITS
In folklore, rabbits are often used to represent tricksters. Even in contemporary Western culture Bugs Bunny and Br'er Rabbit epitomize the prankster element of the Trickster.

This final archetype is a bit of an anomaly. Basically it is the comic relief used to break the tension in a story. It is the deprecating part of our personalities that lets us laugh at our own folly or self-importance, or that of others. It is the mischief-maker that bugs people and upsets the status quo. In fact, the best known is called Bugs, as in Bunny. He epitomizes everything the Trickster represents. Coincidentally, the rabbit is used in mythology throughout the world to represent the Trickster. This is great proof of the universality of the archetypes and how they manifest through the unconscious.

As with other archetypes, the Trickster role can also be adopted by another character. The Trickster Hero is one that uses his wit and humour to overcome his enemies. The Mask (Dark Horse Comics) is a perfect example. Interestingly it is the mask of Loki (the Norse god of trickery and deceit) that causes the wearer to transform into the Hero. It is said that the Trickster's role is worn by other characters, like a mask.

HIDDEN PERSONALITY
Clowns hide behind masks, whether it is face paint or an invented persona that can play jokes or create chaos without revealing their true personality.

HANUMANA
Hanumana usually represents the Herald archetype but being a monkey he is also full of tricks.

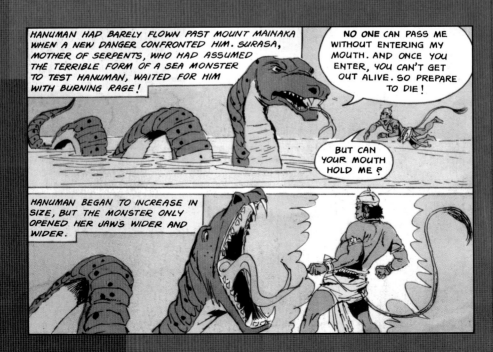

Watch Bugs Bunny cartoons (not to help you understand the
Trickster, but because they are brilliant and very funny, a welcome
relief from this book's high concepts!)

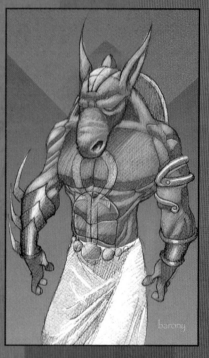

SETH
Jesus Barony
The brother of Osiris is
more of a Shadow
character, but he uses
trickery to capture his
brother. As the Trickster's
role is to create chaos, it
doesn't always have to
involve humour.

The Hindu god Hanumana serves as a Herald but is able to
overcome his enemies, not just through his strength but mostly by
tricks and mischief. He can also demolish an ego with his sense of fun.
This is another of the Trickster's roles – bringing others back to reality
by making fun of their pomposity.

So the Trickster is not always vital to the moving along of the
story, unless as a principal character, but will add a lighter note to it.
To create a dynamic Trickster character will require good writing skills.

While there are few who can match the wit of
Oscar Wilde, the Trickster excels in the art of the
put-down, using his rapacious tongue to cut his
foes down to size.

Physical humour is another part of the Trickster's
armoury and can be portrayed using the animator's
tool of exaggeration, not just via
physical characteristics but also in
reactions to situations.

The real skill is knowing when, and
if, to use the Trickster. It is probably
left for resolving situations where you,
as the writer, get stuck. You can pull it out of
the hat when a tense situation needs diffusing,
or conversely when you reach an impasse that
needs a jump-start.

As for looks – working with extremes is a
useful approach. Think of completely
exaggerated comical characters that are either very fat or very thin (such as Laurel
and Hardy) or very plain and sardonic, with no obvious sense of humour. Intuition
will tell you what works best in your story and with the other characters; you can
always just incorporate the Trickster's attributes into one of the existing cast. As
usual, the choice is yours.

RAVEN STEALS THE DAYLIGHT
Varga Studios/S4C
Ravens are another animal that are
used to represent Tricksters. This is
taken from an Alaskan folktale.

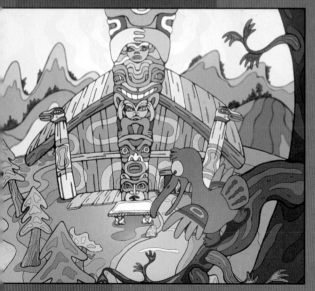

Artist: Brad Silby

TRENT

PUNK, DRUNK AND BEAT CRAZY

The main reason for basing characters on archetypes is to try and avoid obvious stereotypes. One of the problems is that we tend to stereotype ourselves. The way we dress and behave is dictated by our peers and our place in society. Skaters have a certain appearance, as do surfers, artists, bankers and punks. Because of these "uniforms" you can caricature the subculture to which your character belongs, to allow the inner archetypal personality to develop. This is especially true when creating the comical aspect of the Trickster.

Each new version required experimentation with expressions

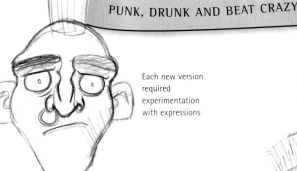

AGGRO: *A "harder", more aggressive version of the character, which was also rejected.*

IN THE MOOD: *A series of sketches made during the development of his personality exploring various expressions, from sombre to ridiculous.*

TOON PUNK: *One of the earliest versions of Trent in a cartoon style.*

SKATE PUNK: *Another early version – experimenting with a different identity.*

DAZED: *Creating personality through facial expression.*

HAND JIVE: *Hands are notoriously hard to get right so practice drawing as many different poses as possible, especially if gestures are an important part of the character.*

ID: *TRENT RIVERS*

Age: *21*

Height: *1.9 m. (6 ft. 1 in.)*

Hair colour: *Green (natural colour brown)*

Eye colour: *Blue*

Distinguishing marks: *Green mohican hair, nose ring*

CHARACTERISTICS: Trent is a young punk and drummer for the punk band "Knuckle Sandwich". He's a bit of a slacker and not the sharpest tool in the box, but his simplicity gives him a different perspective on the world. Likes drinking beer.

ROLE: He provides comic relief for the rest of the band who – as with most drummers – laugh at him not with him (which he usually doesn't notice).

ORIGIN: Born in 1984 and raised on urban council estates in a northern English city.

BACKGROUND: Works in a local record store that gives him access to over 30 years of punk rock and its influences, providing inspiration for him and the band. Took up the drums because no one else wanted to, but proved to be a natural.

POWERS: He can drink a pint of beer in 5.6 seconds and can drum for hours, even though the band has yet to play their first gig.

ASSOCIATES:
Mentor: Johnny is an old punk who was there at the beginning of the movement back in the seventies. He is the lead singer of "Knuckle Sandwich".
He teases Trent but recognizes his talent.

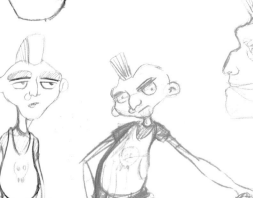

Herald: Christie, a good-looking and confident girl who looks out for Trent. She convinced Johnny to let Trent join the band. She is the only one who listens to Trent and understands how he sees things.

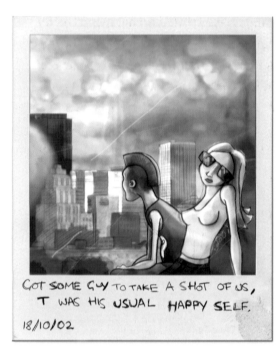

SNAP: *A snapshot of Trent with his friend Christie as they watch the grey clouds blowing over the urban landscape that is the driving force behind the music.*

GOT SOME GUY TO TAKE A SHOT OF US, T WAS HIS USUAL HAPPY SELF.
18/10/02

▶ OVER TO YOU

Take a subculture – such as punks, surfers or goths – and make some caricatures and sketches of what you consider to be stereotypical representations. Develop them into characters with personalities that defy the stereotype while maintaining the appearance.

COLOR TEST: *As he developed his appearance became less caricatured. Flat toon or cel colouring was used to try out colour schemes.*

IN LINE: *The final line version, ready to be scanned and coloured in Photoshop. The pencil sketch lines were deliberately left on the image to give it "edge".*

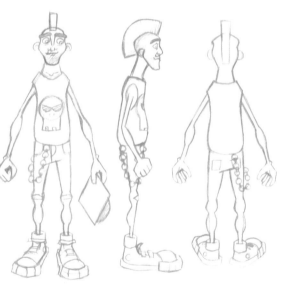

USUAL SUSPECT: *The model sheet shows all the aspects of Trent's great physique.*

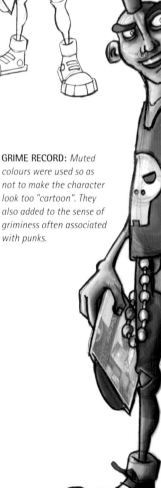

GRIME RECORD: *Muted colours were used so as not to make the character look too "cartoon". They also added to the sense of griminess often associated with punks.*

STEREOTYPE TO ARCHETYPE

These ideas were taken into consideration during the creation and development of Trent, who started out as a quick sketch that was almost abandoned. Taking inspiration and references from the punk scene, comics, animation and film, the final version shown here was the result of weeks of redrawing and redesigning. Trent's personality and role in the story were also developed and defined during the drawing stage to help create a complete character that would be believable, despite his appearance.

Artist: Jon Sukarangsan

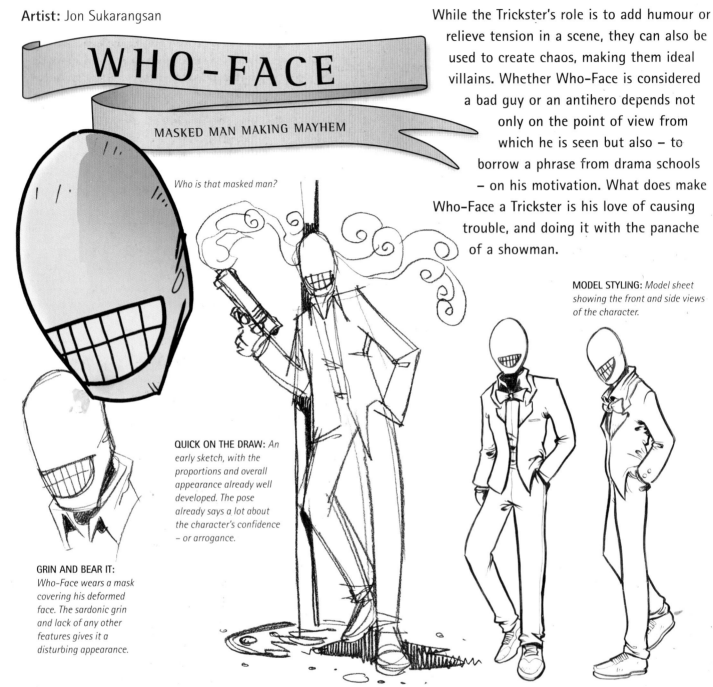

WHO-FACE

MASKED MAN MAKING MAYHEM

While the Trickster's role is to add humour or relieve tension in a scene, they can also be used to create chaos, making them ideal villains. Whether Who-Face is considered a bad guy or an antihero depends not only on the point of view from which he is seen but also – to borrow a phrase from drama schools – on his motivation. What does make Who-Face a Trickster is his love of causing trouble, and doing it with the panache of a showman.

Who is that masked man?

MODEL STYLING: *Model sheet showing the front and side views of the character.*

QUICK ON THE DRAW: *An early sketch, with the proportions and overall appearance already well developed. The pose already says a lot about the character's confidence – or arrogance.*

GRIN AND BEAR IT: *Who-Face wears a mask covering his deformed face. The sardonic grin and lack of any other features gives it a disturbing appearance.*

ID: *WHO-FACE (Ritchie Dougal)*

Age: *40s*

Height: *1.9 m. (6 ft. 1 in.)*

Hair colour: *Unknown*

Eye colour: *Unknown*

Distinguishing marks: *Mask, with big grin, that covers his face*

CHARACTERISTICS: Diabolical sense of humour. Intent on upsetting the status quo.

ROLE: Who-Face is a self-proclaimed king of crime who plays both sides of the law off against each other. In the ensuing confusion he is able to carry out his own very profitable crimes.

ORIGIN: Raised in the circus by his uncle after his parents died in an accident. Became ringmaster at a young age, but wasn't popular with the performers or audiences.

BACKGROUND: A disgruntled clown threw a pie containing toxic chemicals in his face, hideously disfiguring him. After exacting revenge (with the aid of trapeze wire and some hungry lions) he disappeared and became the nefarious mobster known as Who-Face. Despite his notoriety no one knew who he was or where he came from. He would always publicly announce the crime he was about to commit, but was never caught.

POWERS: A full complement of circus skills including acrobatics and control of animals.

ASSOCIATES:
Hero: Jack Barnaby is an ex-detective, who was humiliated by Who-Face repeatedly eluding him. He was driven to the brink of insanity by this and now runs his own rival gang but he remains unable to outwit Who-Face.

Herald: Marty Gallagher, the IRA-trained leader of Who-Face's forward squad, specializes in everything from explosives to disarming entire SWAT units. She is responsible for Who-Face's extravagant entrances.

MAKE 'EM LAUGH

When creating such a dark Trickster it is important to develop a humour of throwaway lines, much like the dialogue Quentin Tarantino uses in his films. This will help diffuse the intensity of any violence or extreme situations that you invent.

How you draw your characters will also influence the overall effect. Exaggeration always works in animation and comics. This can affect both actions and appearance, with the use of vibrant colours adding a sense of the ridiculous. Who-Face's clothes were made bright to counterpoint the dark nature of his personality, as does the cheesy smile on his mask. A mask is often used with the Trickster as it is easier to make mischief when his true personality is disguised. Clowns famously wear make-up, and lots of comedians hide their anguish behind their comic personae.

▶ OVER TO YOU

▶ Explore the use of masks and disguises in creating comical sinister characters. Experiment with colour palettes that will make the characters stand out in the context of the story.

▶ When devising a Trickster character, keep notes of mischievous ideas that occur to you or that you hear about. (It's probably better if you let your characters do the pranks, though...)

FIRE POWER: *Part of the exaggeration is portrayed by Who-Face's outlandish arsenal of weapons, such as the flame-thrower shown here. Overdoing such details produces humour by pushing the bounds of credibility while emphasizing aspects of the character.*

QT HOMAGE: *A sketch showing Who-Face in a Reservoir Dogs moment. Drawing on other references helps to develop the personality – this one being rather ruthless and sadistic. Confident pen strokes create a clear impression that does not need a lot of extra detail or shading.*

WHO LOVES YOU?: *Exaggerated proportions, brightly coloured clothes and the grinning, featureless mask give the character its comical, yet sinister, appearance. As for the smoking gun...*

BLACK GYPSY JACK

MYSTERIOUS VANISHING TRICK

The character of Black Gypsy Jack belongs to the same story world as Hamid (see page 72). He is a peripheral figure who is more of a legend than an influential part of the invented history. As with all legends, he adds colour to the fabric of the world, imagined or otherwise. Whether you develop characters like this beyond the basic conceptual notes will depend on how you intend to present the finished project or, more realistically, how much freedom your potential publisher will give you.

Artist: Nic Brennan

PORTRAIT: *A finished portrait that captures the gentleness and melancholy of the character, together with the complexion of his race.*

SHARP: *Another interpretation of Jack as an outlaw. The look was too sinister, considering his gentle and cultured origins.*

HERITAGE: *Coming up with the right look for characters is always a question of trial and error, using a process of elimination. This is a sketch of Stefan Lindau, the gypsy, before he became Jack the highwayman. It was drawn directly into Illustrator using a Wacom tablet (as were all the other images here).*

NEW LOOK: *This was getting closer to the desired final look. The gentleness is visible in the face, but the style is still a little crude and not flamboyant enough.*

ID: *BLACK GYPSY JACK*

Age: *23*

Height: *1.7 m. (5 ft. 9 in.)*

Hair colour: *Black*

Eye colour: *Brown*

Distinguishing marks: *Always accompanied by his dog, Mertshak*

CHARACTERISTICS: Initially gentle and peaceful, he became a vengeful highwayman.

ROLE: To create chaos amongst the officials and people of Gladensbury and Anstedshire in order to avenge the massacre of his people.

ORIGIN: Born Stefan Lindau, he was a member of the Gladenshire gypsies in the north of Karkistan.

BACKGROUND: He is said to be the only survivor of the slaughter of the Gladenshire gypsies, a peaceful and prosperous tribe of master craftspeople and horseriders. Following the massacre he took the name Black Gypsy Jack and, together with a small gang and his trusty dog Mertshak, wreaked havoc in the

Gladensbury and Anstedshire area for two years. Eventually he was betrayed by the lover of one of his gang members. He was captured, tried, and hanged along with his gang and his dog. After two days on the gallows his corpse, and that of his dog, disappeared.

POWERS: Some mystical powers of foresight and mind reading that proved useful in card games.

ASSOCIATES:
Herald: Mertshak was his constant canine companion, who saved his life more than once.

Shadow: Dragan, Baron of Gladensbury, who ordered the massacre of the gentle gypsies.

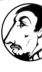

ALTERNATIVE HISTORY

Having devised so many characters and stories, along with a complex history and sociology, their creator was faced with the daunting task of finding the best way of collating them into a coherent whole. One of the options was to create an illustrated history of Karkistan, filled with information about key figures and events, along with maps and timelines. It could be viewed as a printed equivalent of the "mockumentary".

The alternative was to produce a series of comic books, each featuring the story of one particular character. From the point of view of mythical story structure, this presents an interesting exercise in establishing archetypal roles. While Black Gypsy Jack is presented here as a Trickster, he would also be the Hero, or antihero, of his own story. And so it would be for all the other characters. To make it even more fascinating, all the stories are linked to a central Hero character using a core story and the principal of the six degrees of separation, thereby expanding the whole concept of archetypal roles.

▶ OVER TO YOU

Devise a few alternative presentations for a publisher, designed to sell your idea for a complex multicharacter story. Consider ways to maintain the longevity of a series, as well as the best one-off options.

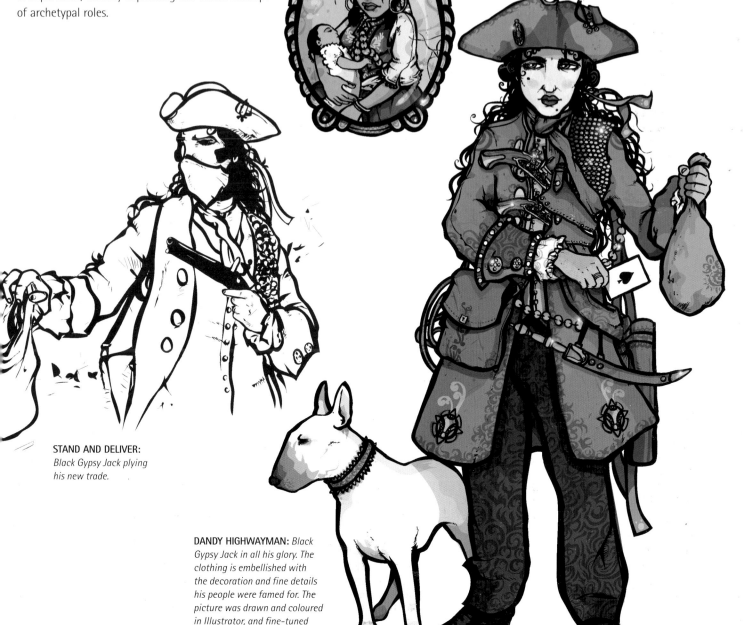

MEMENTO: *Black Gypsy Jack always wore this brooch, bearing the picture of his lover and their child who were killed in the massacre. The brooch disappeared after he was hanged.*

STAND AND DELIVER:
Black Gypsy Jack plying his new trade.

DANDY HIGHWAYMAN: *Black Gypsy Jack in all his glory. The clothing is embellished with the decoration and fine details his people were famed for. The picture was drawn and coloured in Illustrator, and fine-tuned in Photoshop.*

Artist: Ruben de Vela

ANEMO

BLOWING IN THE WIND

As any Englishman will tell you, the weather makes a great topic of conversation – so why not use it as the basis of a character? Most cultures have gods, minor deities or spirits that control the elements and these are usually endowed with human attributes and forms. Some have even made it into comics, the most famous being Marvel's The Mighty Thor, based on the Norse god of thunder. In that series Thor was often at odds with the Trickster god Loki, so why not combine the two aspects into one character?

CALM BEFORE THE STORM: *These stripped-down portraits show Anemo in a less formal mood. You can see the mischief and youthful innocence in her face, with no indication of the trouble she can cause.*

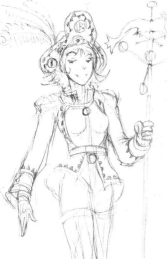

EARLY WARNING: *From the outset the artist had a clear idea in his mind of how the character was going to look. Even though some of the details changed there is no mistaking the finished character in this initial concept sketch.*

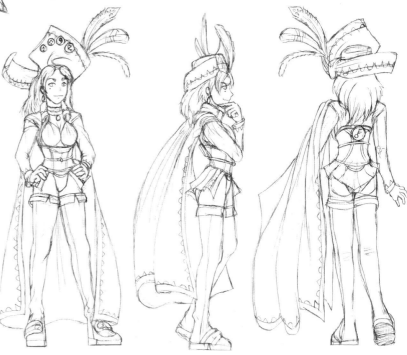

CHANGEABLE: *Generally turnaround/model sheets show the same pose from different angles as references for other artists working on the project. Working alone you can experiment with different simple poses and still show, at the same time, the front, side and back views of the character in its costume.*

 ANEMO
(Orynko Zorina Dveldte-Kasicha)

Age: *26*

Height: *1.7 m. (5 ft. 7 in.)*

Hair colour: *Pale blonde*

Eye colour: *Gray*

Distinguishing marks: *Weathervane staff, mole under right eye*

CHARACTERISTICS: Talented renegade who maintains strong affiliations with her extended family.

ROLE: Prankster capable of effecting chaos on complex moving systems such as weather, economies and social groups.

ORIGIN: The Northern Plains.

BACKGROUND: She was trained by the Order of the Chaos Butterfly, a group of weather mages. Her experiments on controlling people, which caused hallucinations, mood swings, and social unrest led her to being respected by her peers but shunned by society. Although a fugitive her primary aims were still aimed at improving the weather conditions on her family's farms.

POWERS: Able to control weather patterns and people's minds.

ASSOCIATES:
Herald: Fejwen, Anemo's second cousin who acts as her diligent assistant and is usually seen carrying large bags of equipment. His main job is trying to keep Anemo out of trouble and standing up for her in various arguments, which hasn't helped his popularity.

Threshold Guardian: Trendal Gravan is the roguish leader of a small airship armada who provides transportation and shelter for Anemo whenever he can, in exchange for the occasional chaotic effect, such as favourable weather or large communication errors to assist his mercenary fleet.

WEATHER OR NOT?

As mentioned earlier, the role of the Trickster, apart from providing comic(al) relief, is to create chaos, and extreme or unexpected changes in weather will certainly do that. Control of the weather has long been the desire of mankind, with shaman, sorcerers and other mystics of varying cultures claiming the ability. Even scientific experiments have been conducted to that end, the most successful being Nikola Tesla's investigations into the use of scalar waves for drought relief, not to mention his experiments with creating lightning. X-Men's Storm uses her weather-controlling powers for the good of the group or to fight the forces of evil. Unfortunately not everyone's motives are altruistic. Anemo's original motivation was to help her family by preventing blizzards from destroying their farms and crops every year, but she became enamoured with her power and used it for her own nefarious amusement.

Part of the development process involves understanding your character's motivations and why they change during the course of the story. You also need to justify them in the storytelling by creating the events for these changes to occur naturally.

▶ OVER TO YOU

Design a character based around one of the five elements (earth, air, fire, water, ether). You could integrate the element into their appearance, or maybe give them control over that element. Consider their appearance and how it relates to that element.

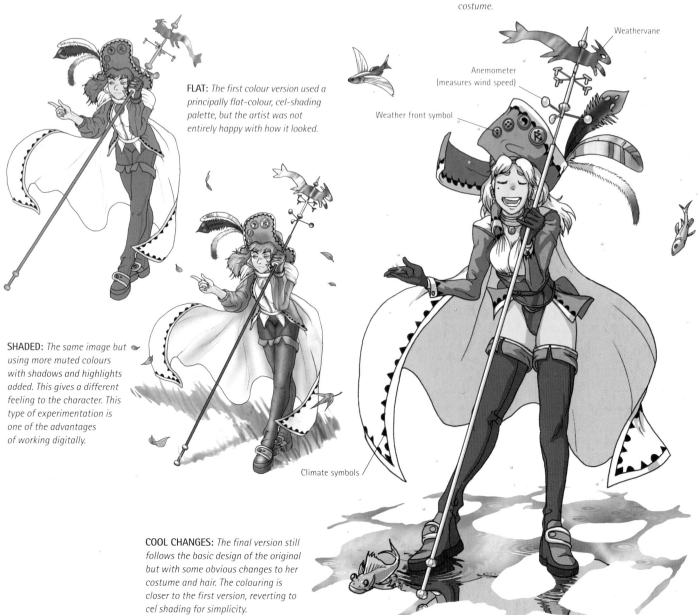

SYMBOLS: *Various meteorological instruments and symbols were used in Anemo's costume.*

Weathervane

Anemometer (measures wind speed)

Weather front symbol

FLAT: *The first colour version used a principally flat-colour, cel-shading palette, but the artist was not entirely happy with how it looked.*

SHADED: *The same image but using more muted colours with shadows and highlights added. This gives a different feeling to the character. This type of experimentation is one of the advantages of working digitally.*

Climate symbols

COOL CHANGES: *The final version still follows the basic design of the original but with some obvious changes to her costume and hair. The colouring is closer to the first version, reverting to cel shading for simplicity.*

Artist: Elwood Smith

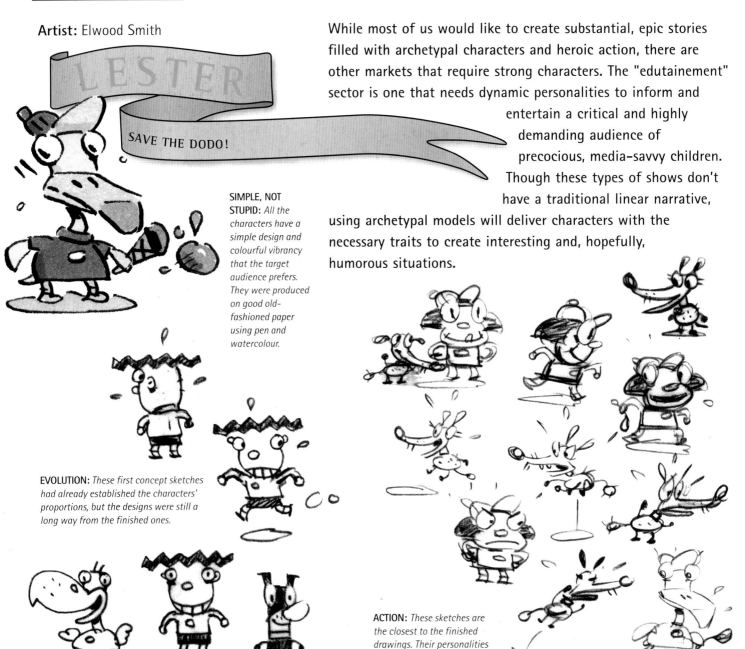

While most of us would like to create substantial, epic stories filled with archetypal characters and heroic action, there are other markets that require strong characters. The "edutainement" sector is one that needs dynamic personalities to inform and entertain a critical and highly demanding audience of precocious, media-savvy children. Though these types of shows don't have a traditional linear narrative, using archetypal models will deliver characters with the necessary traits to create interesting and, hopefully, humorous situations.

SIMPLE, NOT STUPID: *All the characters have a simple design and colourful vibrancy that the target audience prefers. They were produced on good old-fashioned paper using pen and watercolour.*

EVOLUTION: *These first concept sketches had already established the characters' proportions, but the designs were still a long way from the finished ones.*

ACTION: *These sketches are the closest to the finished drawings. Their personalities are revealed through their actions and expressions.*

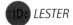 **ID:** *LESTER*

Age: *I thought dodos were extinct?*

Height: *Larger than life*

Hair colour: *Birds have feathers!*

Eye colour: *White (don't shoot)*

Distinguishing marks: *Yellow beak*

CHARACTERISTICS: Simple, sweet and honest to a fault, and often rather tactless. Although a little cautious, he loves a good adventure.

ROLE: Gives the trio the ability to travel wherever they want, thanks to his magic nose – "It's a beak!"

ORIGIN: The back of Edith's freezer.

BACKGROUND: Over to Edith: "I found him way in the back of my freezer and thawed him out. Some people think Lester's a figment of my imagination, but he's real, all right. In fact he's more than real. He has a magical nose". Lester is actually oblivious to his magical beezer. As far as he's concerned, it belongs to Edith.

POWERS: How many times do I have to tell you – he has a magical nose! "It's not a nose, it's a beak!"

● **ASSOCIATES**
Hero: Edith is mercurial little girl who can be upbeat one moment and depressed the next. She is impatient and bossy and regularly reminds Lester and Mr. Big that it is her show – but she loves them. She uses Lester's magical power to travel and get the things she needs for her show.

● **Herald:** Mr. Big is Edith's dog, who is neither big nor a mister. She's a small, female mutt with the gift of speech and a thirst for adventure. She loves to talk but Edith insists that dogs can't talk, so she is obliged to bark, although she sometimes forgets and joins in the conversation. Not given to introspection, she occasionally sees situations more clearly than her cohorts.

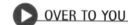

TWO'S COMPANY, THREE'S A REACTIONARY GROUP DYNAMIC

Edith, the main character in *Lester, Mr Big and Me*, is a young girl who, in this age of public access TV, hosts a show that is broadcast from her home. The main premise of the show is, "We do stuff", but its humour, and many of its lessons, derive from Edith's inability to be a sweet host. Her impatience with her two companions was conceived to reflect the emotions and frustrations children experience in their own lives and relationships, and hopefully get them to laugh at them. The irreverent and often gritty script is cleverly balanced out by the simple and colourful design of the graphics, characters and settings. Apart from the show's subtle lessons, it also has the standard educational stuff, thanks to Lester's ability to magically transport the trio through time and space.

▶ OVER TO YOU

Choose a subject you are passionate about and design a character (or characters) to talk about it. Consider your potential medium – broadcast, Web or CD-ROM – when deciding on the look and formatting of your presentation.

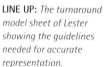

LINE UP: *The turnaround model sheet of Lester showing the guidelines needed for accurate representation.*

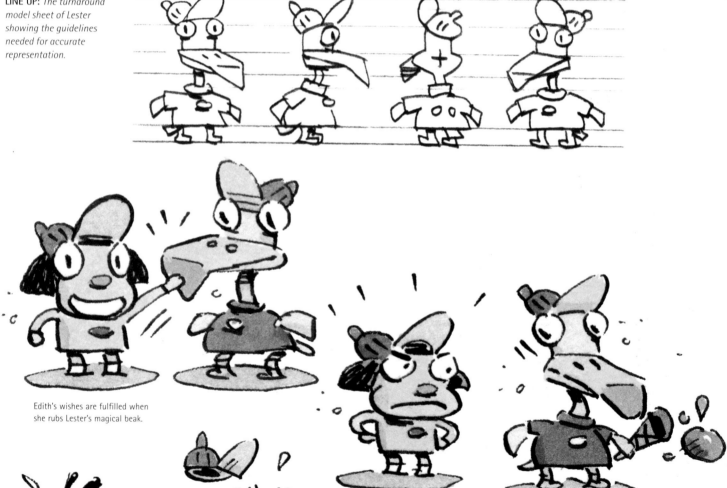

Edith's wishes are fulfilled when she rubs Lester's magical beak.

Facial expressions and body language match the dialogue.

INTERACTION: *Exaggeration of appearance and movement is one of the key tools an animator uses to convey ideas and, more importantly, humour. In this show the strength and humour lies in the relationship and interaction between the characters.*

PUTTING IT TOGETHER

You have your full cast of characters, and your story, so what do you do with it now? Naturally you will want to translate it into some sort of practical format so that you can share your vision with others. This book's main focus has been on producing characters for comics and/or animations – both huge subjects – and though there isn't space to cover either in great detail here, we can look at the basic principles.

Whether creating comics or animations, you are essentially dealing with what is known as "sequential art", the telling of stories using pictures in a sequential order. Line or 2D animation (commonly called "cartoons") uses lots of drawings in sequence – 24 for every second shown on film (usually fewer with other media, such as the Internet). Every minutia of a movement has to be drawn to make it look smooth and convincing.

FRAME BY FRAME

Before all these hundreds of drawings are produced, a series of drawings known as "keyframes" is made that shows the extreme points of any movement or action. Going back even further in the process brings you to storyboards. These are used to show major events, scenes, camera movements and angles that advance the story, and are used for live action films as well as animations. These storyboard panels look very similar to the comicbooks with which we are all familiar. The relationship between comics and animation is a close one, on many levels.

Where comics and storyboards start to differ is in presentation. Storyboards are used as guidelines for the director and therefore can be anything from crude scribbles to highly finished panels (those used for *The Matrix* being a prime example) that generally retain a fixed-grid format. Comics, on the other hand, are the finished product, thus requiring more detailed and inventive layouts. The way you lay out your panels is going to influence how your story unfolds.

Dialogue. In this case the words will be integrated into the overall page design and not in speech bubbles. When characters speak, their names appear before the dialogue. Sometimes the dialogue is preceded by some narrative text that briefly tells a part of the story in a box on the page.

COMIC SCRIPT: *Though not as standardized as movie screenplays, comic scripts still need to follow a format that will give the artist all the information he or she needs. One page of script is used to represent one page of the comic, even if it contains only one drawing.*

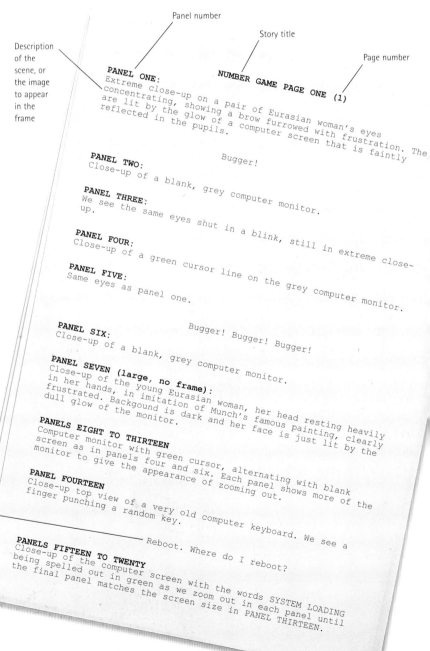

Panel number

Story title

Page number

Description of the scene, or the image to appear in the frame

PANEL ONE:
Extreme close-up on a pair of Eurasian woman's eyes concentrating, showing a brow furrowed with frustration. The are lit by the glow of a computer screen that is faintly reflected in the pupils.

NUMBER GAME PAGE ONE (1)

Bugger!

PANEL TWO:
Close-up of a blank, grey computer monitor.

PANEL THREE:
We see the same eyes shut in a blink, still in extreme close-up.

PANEL FOUR:
Close-up of a green cursor line on the grey computer monitor.

PANEL FIVE:
Same eyes as panel one.

Bugger! Bugger! Bugger!

PANEL SIX:
Close-up of a blank, grey computer monitor.

PANEL SEVEN (large, no frame):
Close-up of the young Eurasian woman, her head resting heavily in her hands, in imitation of Munch's famous painting, clearly frustrated. Backgound is dark and her face is just lit by the dull glow of the monitor.

PANELS EIGHT TO THIRTEEN
Computer monitor with green cursor, alternating with blank screen as in panels four and six. Each panel shows more of the monitor to give the appearance of zooming out.

PANEL FOURTEEN
Close-up top view of a very old computer keyboard. We see a finger punching a random key.

Reboot. Where do I reboot?

PANELS FIFTEEN TO TWENTY
Close-up of the computer screen with the words SYSTEM LOADING being spelled out in green as we zoom out in each panel until the final panel matches the screen size in PANEL THIRTEEN.

SCAMP: *Making a rough sketch of your layout will help to make sense of your script if you are giving it to someone else to draw, or just act as a reminder for when you start drawing. This was done to accompany the adjacent script.*

GRID POWER: *When creating your own comic layouts it is a good idea to devise a grid system to work over. One of the most flexible ways is to divide your page into twelve, both vertically and horizontally. Twelve is divisible by 1, 2, 3, 4 and 6 if you want to work within a rigid grid, but breaking out of the grid is still an option. If you are lucky enough to be able to work for a major publisher they will supply you with their own boards with their own grid system.*

Film, animation or comics: for all of them you need to start with your story in script format, and each medium has its own specific, standardized layout style. If you are doing everything yourself you may get away with writing to your own layout, but if you want to work professionally with others at some time in the future it is best to learn the industry-favoured formats. This will also make your work a lot easier.

In the comicbook script you have to outline both the number of panels you need per page and the contents of each panel – a description of the scene, the narrative and the dialogue. Making quick thumbnail sketches of each page will help you decide how many panels you need. The number of panels on the page, and their size and spacing, dictate the pacing and rhythm of your story, just like the notes on a music score. Of course, it being a visual medium you don't have to maintain a rigid grid system, or even keep everything in individual frames. However, you must remember that it should have a logical order that the reader can follow to make sense of the story. Don't forget to leave space for the words – they have to fit into the whole layout design too.

One important thing to consider when creating your layouts is the number of pages. This will be dictated to a certain extent by how you are going to be published, but you should think in multiples of four – two sides of a folded page. Other options are covered on page 120, but everything printed works in fours.

The next step is to get your work seen by publishers and, more importantly, readers – so read on!

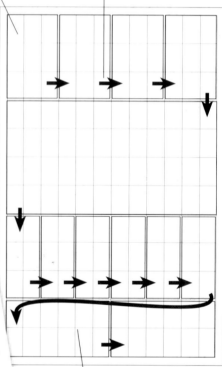

Most comics tend to follow a standard page size.

The arrows show the accepted order the panels appear for Western readers – left to right, top to bottom.

Draw the grid using a non-repro blue pencil, or create it on the computer using 50% cyan and print it on a colour printer.

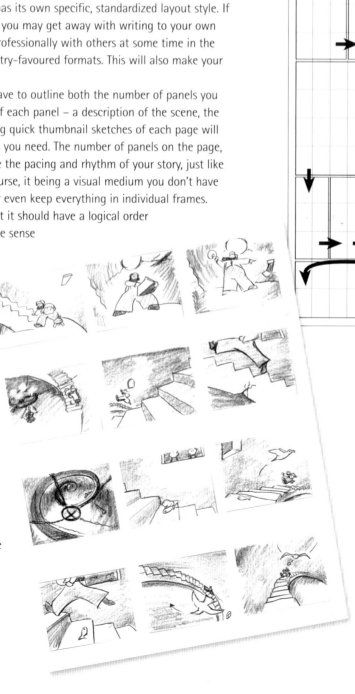

STORYBOARD: *Animation generally requires a simple and utilitarian approach to the storyboard. Each panel is drawn to the same ratio as the finished movie, here 4:3 of a standard television or 35mm film, and contains either a peak moment of action, or a change of scene or camera angle. Below the panel notes, direction or dialogue is added. Another style of storyboard can be seen on page 53.*

GETTING PUBLISHED

Having created characters and stories and put them into dynamic pages, you will want someone to read them. This means getting them published, often the hardest – and least creative – part of the whole creative process. The comics and animation industries are both extremely competitive, with thousands of very talented people vying for slices of a very small pie.

The major comic publishers – such as Marvel, DC, Dark Horse and 2000AD – already have a well-established stable of properties. Although it is possible to apply to these companies with the aim of working on their existing titles, getting them to look at new characters is a lot harder; the same goes for the major animation studios. This leaves you with two options.

THINK SMALL

You can approach some of the many smaller companies that manage to eke out an existence supplying more adventurous comics and animations. There are a lot of advantages to these smaller concerns, not the least of which is their sense of humanity. They will often give you a lot more freedom to produce your work. The large, corporate-owned studios often demand the rights to all the work you produce while in their employ and will not necessarily pay you better than the smaller companies, as they balance prestige vs. financial reward.

You must present your work to any publisher or studio, large or small, in an acceptable format. Check their web sites to see if they have submission guidelines. Some will take digital files, while others will insist on seeing hard copies. If you follow their suggestions you will increase your chance of being seen. Sending material in "on spec" through the post isn't likely to get you very far. The personal approach is often the best (although stalking the commissioning editor is not likely to gain you any favours). Only ever send copies of your artwork; if they want to see your original boards you can make an appointment to show them. Of course, if you are working digitally, that is not an issue. If you do manage to get a commission you will send digital files, as these are what the printers require.

Comic conventions or festivals are a good way of meeting the right people and getting some feedback. The larger the show, the more

PRESENTATION: *Detailed character sheets and finished story panels should make up your portfolio, along with some sort of leave-behind such as a CD-ROM presentation of your work or a postcard with a sample and your contact details.*

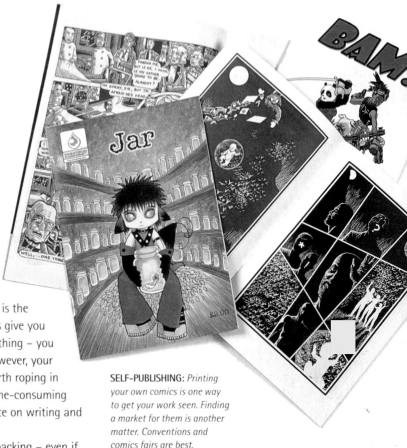

CONVENTIONS: *Trade shows often set aside time for budding artists to show their portfolios to publishers on a one-to-one basis. Keep your very best at the top as you may only get a limited time.*

important the companies and people attending, but there will also be a lot of "wannabes" sharing the queue. Web sites – such as comicon.com and awn.com – list most of the events and who is attending, so you can find one that suits you.

GO SOLO

After lots of "great work, but it's not what we're looking for at the moment" rejections, you may decide that self-publishing is the way to go. It can be hard work, but sometimes lucrative. It does give you total control over your work (which may not always be a good thing – you need to get feedback from more experienced professionals). However, your sales figures will soon tell you how good you are. It may be worth roping in someone not involved in the creative aspects to take care of time-consuming production and business matters, leaving you free to concentrate on writing and drawing the next issue.

SELF-PUBLISHING: *Printing your own comics is one way to get your work seen. Finding a market for them is another matter. Conventions and comics fairs are best.*

Publishing your own comic is going to take some financial backing – even if just from your credit card company – to pay for the printing costs. Working in black and white does mean lower costs, and comics can even be produced on a desktop laser printer, but they will look homemade. Digital printing and print-on-demand (POD) are continually dropping in price and are a good option if you want an affordable and professional-looking colour job, without being left with a garage full of unsold comics.

INTERNET: *The soft solution. You have a greater potential market. If the story is good it will soon create a buzz. Broken Saints is one of the great success stories.*

The other alternative is to go completely digital and put everything on the Internet: no printing or distribution costs, and a potentially huge international audience. Comics can be saved as PDF files that can be viewed by the free Adobe Acrobat Reader. One of the advantages of PDF is that you can make versions in different resolutions – one for screen (which you can protect so it won't print) and another for printing. These can have different prices, and because your overheads are minimal you can charge a much lower price for your comic and make more from it than from a printed version. A company like bitpass.com will promote your work and handle payments.

If you are talented and persistent, you will eventually get a break, but luck – and, more importantly, contacts – is going to get you there faster. Try to meet up with other artists. Despite the huge competition, comic and animation artists are very supportive.

These are just some suggestions for getting your work seen. I wish you good luck.

GLOSSARY

3D SFX:
3D Special Effects, as used in Hollywood movies. These are usually realistic animations created with 3D software.

3D SOFTWARE:
Computer programmes that allow you to create models in a 3D space. Poser is a very useful 3D programmes for character designers.

A SIZE:
The ISO international metric measurement for paper. An A0 sheet has an area of 1 square metre and is halved along its height to produce the next size down. The height divided by the width of all formats is the square root of two (1.4142). The standard letter size is A4 (297 x 210mm).

ACETATE:
Transparent sheet of cellulose acetate film used for painting and drawing, especially in traditional animation. Also known as cel.

AIRBRUSH:
A small, precision spray gun that runs on compressed air and uses inks to produce soft graduated colours.

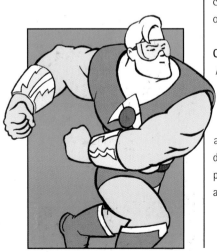

ANALOGUE:
Often used to mean the opposite of digital but is still concerned with computers, using electrical current rather than numbers. Pen and paper are not really analogue media.

ANIME:
Japanese animation. Also known as Japanimation. Any animation created in the style of Japanese animation. There is no one style.

ARCHETYPES:
The ideal form of a personality type.

BITMAP:
A text character or graphic image comprising dots or pixels in a grid. Together, these pixels make up an image.

BRISTOL BOARD:
A fine, double-sided, lightweight pasteboard with a smooth, usually unglazed surface intended for long-term use and archival preservation. The most commonly used medium for comic art.

BROADBAND:
Fast Internet connection. For home users, this is usually either DSL or cable and requires a special type of modem.

CRT (CATHODE RAY TUBE):
A type of computer or television screen that uses a vacuum tube in which a beam of electrons are fired through a high voltage anode, which are focused or deflected before hitting a phosphorescent screen to create an image.

CEL-SHADING:
Using flat colour to simulate graduated tones. Gets its name from painting flat colours onto acetate sheets in traditional animation.

CHARACTER PROFILE:
Building a personality history of a story character to help make them appear more believable.

CHIBI:
A style of anime or manga where the characters resemble children and have very big eyes.

CLEAN-UP ARTIST:
In animation, the person who retraces the animator's drawings into single, clearly defined lines ready for inking.

CMYK:
Cyan, Magenta, Yellow and black. The four colour inks used in colour printing. K is used for black so as not to confuse it with Blue.

CONTINUOUS TONE:
Where there is no discernable line between different shades of a colour, like in a photograph.

CROSS-HATCHING:
Two groups of parallel lines which are drawn close together across each other, especially at an angle of 90°, to show differences of light and darkness.

DIGITAL:
Anything created on computers and other devices using information stored as ones and zeroes. Digital information does not deteriorate when duplicated.

DRAWING BOARD: A large flat wooden surface, usually with some sort of hinging mechanism to allow changing of the working angle. Some have parallel motion rulers for accurate line work. Animators' tables have a rotating device onto which the paper is attached, that is lit from behind for tracing.

DSC: Digital Still Camera for taking photographs that are saved into the camera's memory and can be transferred to a computer.

FAN ART:
Pictures of established characters interpreted and created by readers and fans.

FLASH:
A computer programme by Macromedia for creating vector-based animations.

GOUACHE:
A type of watercolour paint mixed with a whitener, such as chalk, and gum arabic to make it opaque. The pigment dries slightly lighter than it appears when wet, which can make it difficult to match colour. It is sometimes called poster paint.

GRAPHIC NOVEL:
A story told as sequential art. These are usually longer than standard comics or made up of a collection of a multipart story into one volume.

GRAPHICS TABLET:
A computer peripheral that allows you to draw, paint and write using a stylus, a penlike instrument that simulates working with pens and brushes. Most are pressure sensitive to give variable lines.

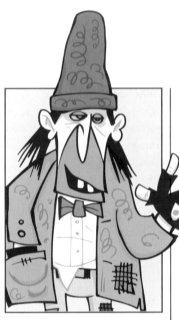

IN-BETWEENER:
In animation, the person who draws all the movements between different keyframes. The process is known as tweening.

INDIA INK: A black pigment consisting of lamp-black mixed with a binding material. Originally formed into blocks it is more commonly found in liquid form. Despite its name it used to be made chiefly in China and Japan.

INKER:
The person who draws over the original pencil drawings to give clean black lines.

INKJET:
A high-resolution printer that makes the image by spraying miniscule drops of ink onto paper.

KEYFRAME:
In animation, drawing that shows the extreme position of an action or movement.

LIGHTBOX:
A box containing a powerful light source, covered with translucent glass or plexiglass, used for tracing.

MAGIC MARKERS:
Felt-tipped pens with a variety of nib sizes and huge colour range, usually used for visualization in advertising studios.

MANGA:
Japanese comics.

MODEL SHEET:
A reference sheet to help maintain consistent proportions and appearance of characters for comics and more generally animation. Usually show front, side, back and three-quarter views, plus other details such as expressions.

NON-REPRO BLUE:
A very pale cyan blue that does not show up when photographed by a printer's camera.

PERIPHERAL:
An external device attached to a computer to add extra functionality.

PIXEL:
(from PICture ELement) The smallest unit of a computer image, it is a square of coloured light that creates a picture when combined with other adjacent pixels. The picture's printing quality is dependent on the resolution or number of pixels that make up the image. Photoshop and Painter are pixel image editors.

PRESENTATION PANEL:
A highly finished drawing or collection of drawings that show a character in action without necessarily telling a complete story. Used when selling an idea to a publisher.

PROTAGONIST:
The lead character in a story.

RAM (RANDOM ACCESS MEMORY):
Computer memory that stores the working data before it is written (saved) to the computer's hard disc as a retrievable file.

RAPIDOGRAPH:
A proprietary name for precision, technical pens invented by Rotring. Now used as a generic name for these types of ink pens.

RGB:
Red Green Blue. Subtractive colours used by electronic devices such as computer monitors and scanners to create colours. White is made up of all three colours while black is the absence of them. RGB colours appear very vibrant on screen but when converted to CMYK for printing are quite different, especially greens.

SCANNER:
Computer peripheral for transferring printed images into the computer.

SPOT COLOUR:
A single, special colour printing ink made up from a mixture of other colours. Pantone Match System (PMS) is the best known.

STEREOTYPES:
A generalized view of a group of people.

STYLUS:
A pen-shaped input device for a computer that is used in conjunction with a graphics tablet.

TEXTURE MAP:
A digitized photograph or painting of a texture that is applied to a 3D object to give it a realistic appearance.

THREE-ACT NARRATIVE:
A story with a clearly defined beginning, middle and end.

TOON SHADING:
See cel-shading.

UNDO:
The ability to go back one or more steps in a computer program.

VECTOR:
Illustrations created using lines and colour fills created with mathematical equations rather than pixels, making them resolution independent.

RESOURCES

RECOMMENDED READING:

DRAWING

Understanding Comics – Scott McCloud

Comics and Sequential Art – Will Eisner

Graphic Storytelling – Will Eisner

Cartoon Animation – Preston Blair

The Animator's Survival Kit – Richard Williams

The DC Comics Guide to Pencilling Comics - Klaus Janson

The DC Comics Guide to Inking Comics
- Klaus Janson & Frank Miller

How to Draw Comics the "Marvel" Way
- Stan Lee & John Buscema

Comic Book Lettering the Comicraft Way
- Richard Starkings & John 'JG' Roshell

Cartooning the Head and Figure - Jack Hamm

Bridgman's Life Drawing – George Bridgman

How to Draw Manga: Series - Society for the Study of Manga Techniques
and Hikaqru Hayashi

Hayao Miyazaki: Master of Japanese Animation: Films, Themes, Artistry
- Helen McCarthy

Batman Black and White (Vols 1 & 2) – DC Comics

Alex Ross – Wizard Millennium Edition

Alex Toth – Alex Toth

America's Best Comics – Alan Moore and Various Artists

Kabuki series – David Mack

Drawing and Painting Fantasy Figures – Finlay Cowan

WRITING

Hero with a Thousand Faces – Joseph Campbell

The Writer's Journey – Chris Vogler

Story – Robert McKee

Worlds of Wonder – David Gerrold

The DC Comics Guide to Writing Comics - Dennis O'Neil

Writers on Comics Scriptwriting - Mark Salisbury

Alan Moore's Writing for Comics - Alan Moore & Jacen Burrows

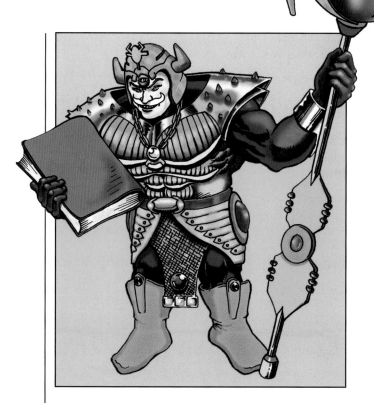

Brewer's Dictionary of Phrase and Fable

How to Self-publish Your Own Comic Book - Tony C. Caputo

WEBSITES:

SOFTWARE

www.adobe.com
- Home of Photoshop and Illustrator (M&W)

www.apple.com
- Home of Macintosh computers, the creative's choice

www.deleter.com/eng/
- Manga art suppliers including Comicworks software (Windows only)

www.macromedia.com
- Home of Freehand and Flash (M&W)

www.corel.com/painter
- The best pixel-based software that emulates natural media (M&W)

www.curiouslabs.com
- Creators of Poser, the original 3D character software. (M&W)

www.daz3d.com
- Creators of the best Poser models and Daz|Studio software for character generation (M&W)

www.microsoft.com/expression
- Vector-based natural media drawing software (M&W)

www.portalgraphics.net
- Open Canvas software, an inexpensive alternative image editing software (Windows only)

www.deneba.com
- Canvas, another popular image editing programme that uses pixels and vectors. (M&W)

www.wacom.com
- Producers of the best range of graphics tablets and styli

INDUSTRY RELATED

www.awn.com
- Animation World Network site for everything related to animation

www.2000adonline.com
- Home of Judge Dredd and an excellent resource for advice and comic scripts.

www.comicon.com
- The premier online comics convention

www2.comicbookfonts.com
- Typefaces for digital comicbook lettering (M&W)

www.balloontales.com
- A guide to comic lettering and production

www.blambot.com
- Comicbook fonts (some free) and other useful info. (M&W)

www.sweatdrop.com
- UK-based manga publishers and network

www.howtodrawmanga.com
- Suppliers of the books and art materials

www.friends-lulu.org
- Friends of Lulu is to encourage female participation in reading and drawing comics

www.sequentialart.com
- Another site for female comic artists

CONTRIBUTING ARTISTS

Al Davison: www.astralgypsy.com

Nic Brennan: www.shugmonkey.com

Ami Plasse: www.amiplasse.com

Andrew West: www.brokensaints.com

Anthony Adinolfi: www.bandaranimation.com

Brad Silby: www.bradsilby.co.uk

Cult Fiction Comics: www.cfca.com.au

Elwood Smith: www.elwoodsmith.com

Emma Vieceli: www.sweatdrop.com

Jade Denton: www.jdemation.com

Jennifer Daydreamer: www.jenniferdaydreamer.com

Jon Sukarangsan: www.fortunecookiepress.com

Thor Goodall: www.thor.goodall.btinternet.co.uk

Wing Yun Man: http://ciel-art.com

Simon Valderamma: www.lumavfx.com

Ruben de Vela: www.rubendevela.com

Duane Redhead: duaneandjen@pennybridge.fsnet.co.uk

Richard T White: SEspider@yahoo.com

Nubian Greene: www.noobian.deviantart.com

Ziya Dikbas: ziya108@hotmail.com

Jesus Barony: www.metautomata.com/barony

INDEX

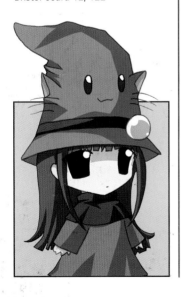

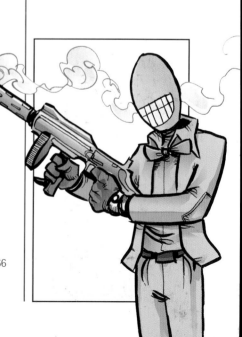

CREDITS

Quarto would like to thank and acknowledge the following for images reproduced in this book:

Key: t = top, b = bottom, l = left, r = right, c = centre.

Adinolfi, Anthony: 7t, 46-47, 82-83
Adlard, Charlie: 20b
Amar Chtira Katha/India Book House: 94bc, 106b
Apple Computer, Inc: 10tr
Barony, Jesus: 25br, 43cl, 57tl, 81tr, 94br, 107tr
Brennan, Nic: 19r, 72-73, 112-113
Broken Saints: 121cr
Cade, Alistair: 78-79
Cartoon Saloon: 94tr
Alex Faurote/www.dangerousuniverse.com: 121tl
Davison, Al: 1tr, 14tl, 18tr, 18bc, 19l, 30-31, 1 74-75, 80bl, 84-85, 121tr
Daydreamer, Jennifer: 104-105
de Vela, Ruben: 6bl, 18tc, 18br, 19bc, 58-59, 100-101, 114-115
Denton, Jade: 50-51, 90-91, 98-99
Dikbas, Ziya: 3, 18bl, 19c, 26-27, 44-45, 62-63, 94tr, 124
The Disinformation Company Ltd: 15r
Fuji Photo Film: 11br
Goodall, Thor: 6tl, 6br, 40-41, 76-77
Greene, Nubian: 7c, 102-103
O'Reilly, Shaun: 64-65
Plasse, Ami: 36-37, 48-49, 120br
Redhead, Duane: 19br, 60-61, 88-89
Robinson, Cliff/2000AD: 21tr, 24tl
Seiko Epson Corp: 10cl
Silby, Brad: 2, 108-109
Smith, Elwood: 7b, 116-117, 125
Sukarangsan, Jon: 66-67, 110-111, 120tl
Valderrama, Simon: 18tl, 32-33, 52-53, 57br,
Varga Studios/S4C/Right Angle: 107cl
Vieceli, Emma: 14tl, 38-39, 70-71, 94-95
Wacom Technology Co: 10br
West, Andrew: 18tc, 34-35, 69tr,
White, Richard T: 86-87,
Wing Yun Man: 6tr, 28-29, 54-55, 96-97

I would like to thank: Joseph Campbell for his study of our myths, and all the artists without whose fantastic artwork this book would not have been possible; my wife, Caroline, for her love and support and for being so pedantic; the editors at Quarto for their continued support and patience; and Sri Mataji Nirmala Devi for her unending love.

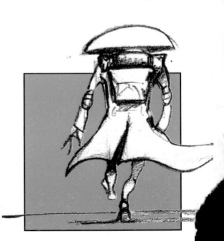